TENNIS
- ❏ racquet
- ❏ short-sleeved polo shirt
- ❏ tennis shoes
- ❏ tennis shorts
- ❏ visor
- ❏ white athletic socks

Makeup

The minimum
- ❏ lip balm

Minimal
- ❏ lip balm
- ❏ loose powder

More
- ❏ lip balm
- ❏ loose powder
- ❏ foundation
- ❏ mascara
- ❏ brow definition (if necessary)

Five-minute makeup
- ❏ lip balm
- ❏ foundation or concealer
- ❏ loose powder
- ❏ blush
- ❏ soft liner
- ❏ mascara
- ❏ sheer lip color
- ❏ brow definition (if necessary)

Full Makeup
- ❏ lip balm
- ❏ foudation
- ❏ concealer (if necessary)
- ❏ powder
- ❏ blush
- ❏ brow definition (if necessary)
- ❏ eyeliner
- ❏ eye shadow
- ❏ lip liner
- ❏ lip color

Because the lighting is usually

> 66 A new dress doesn't get you anywhere; it's the life you're living in the dress, and the sort of life you had lived before, and what you will do in it later. 99
>
> **DIANA VREELAND,** *D.V.*

dimmer at evening events, wear slightly more makeup than in daytime, and emphasize either the eyes or the lips—both would be overkill.

Evening makeup basic
- ❏ red lipstick—for quick dress-up, unless it clashes with your outfit

Evening makeup extra
- ❏ red nail polish (fingers and toes)

Evening fragrance
- ❏ if you don't wear it during the day, you will feel dressier with it on at night; if you wear a light scent each day, use a more heady or exotic one for evening

On Tired Days or Bad Face Days

First try to revive yourself with a shower. Lie down and place cotton pads soaked with cold chamomile tea on your eyelids. Give yourself a revitalizing mask. Don't emphasize your eyes if you're tired. Use:
- ❏ a tinted moisturizer or foundation
- ❏ concealer if necessary, but light enough to avoid emphasizing lines

- ❏ just enough blush to give you a healthy, just-ran-around-the-block glow
- ❏ mascara to open up your eyes
- ❏ a light, neutral eye shadow to even out skin tone on eyelids

Exercise Class

If you go to one of those classes where everyone is required not only to work out but to look fabulous while doing so, use:
- ❏ gel blush, which works well on bare skin and is usually waterproof and long-lasting
- ❏ sheer lip color
- ❏ water-resistant mascara

Beach or Pool

- ❏ waterproof mascara
- ❏ lip balm
- ❏ gloss, if you want

That's it.

Skin usually loses its summer color, so adapt your foundation. Skin is also drier in winter. Use a richer moisturizer, or switch to a moisturizing foundation. Stronger lip colors look good in winter.

Basic Travel Kit

- ❏ adapter kit

- ❏ antiseptic lotion
- ❏ aspirin
- ❏ Band-Aids
- ❏ big baggies for spillables
- ❏ cleanser
- ❏ cold remedies
- ❏ cologne
- ❏ condoms
- ❏ contact lens cleaners
- ❏ cotton balls/cotton sticks
- ❏ deodorant
- ❏ diarrhea medication
- ❏ emergency contacts
- ❏ eyedrops
- ❏ foot powder
- ❏ hair care: comb, dryer, shampoo, conditioner
- ❏ identification bracelet
- ❏ insect repellent
- ❏ lip balm
- ❏ medical information (allergies, medications, blood type)
- ❏ moleskin for blisters
- ❏ mouthwash
- ❏ physician's name, address, and telephone number
- ❏ prescription medications
- ❏ sewing kit
- ❏ shaving supplies
- ❏ skin lotion
- ❏ sleeping mask
- ❏ soap (in soap box)
- ❏ sunscreen
- ❏ Swiss army knife
- ❏ thermometer
- ❏ throat lozenges
- ❏ tissues
- ❏ tooth care: brush, toothpaste, dental floss, dentures, case, cleaner
- ❏ tweezers, nail clippers

66 Appearance is a powerful thing.
I know sometimes people
can't remember a word you've said,
but can tell you
exactly what you were wearing. **99**

ANN RICHARDS

CHIC
SIMPLE

WHAT SHOULD I WEAR?
Dressing *for* Occasions

Alfred A. Knopf New York 1998

THIS IS A BORZOI BOOK
PUBLISHED BY ALFRED A. KNOPF, INC.

Copyright © 1998 by Chic Simple,
a partnership of A Stonework, Ltd., and Kim Johnson Gross, Inc.

All rights reserved under
International and Pan-American Copyright Conventions.
Published in the United States by Alfred A. Knopf, Inc., New York,
and simultaneously in Canada by Random House of Canada Limited, Toronto.
Distributed by Random House, Inc., New York.
www.randomhouse.com

KIM JOHNSON GROSS JEFF STONE
WRITTEN BY LINDA GILLAN GRIFFIN
DESIGN BY VALERIE TRUCCHIA

PHOTOGRAPHS BY DAVID BASHAW
STYLING BY HOPE GREENBERG
ICON ILLUSTRATIONS BY AMY JESSICA NEEDLE

Library of Congress Cataloging-in-Publication Data
Gross, Kim Johnson.
What should I wear? : dressing for occasions / [by Kim Johnson Gross and Jeff Stone :
text by Linda Gillan Griffin ; photographs by David Bashaw].
p. cm. — (Chic simple)
Includes index.
ISBN 0-375-40245-4
1. Clothing and dress. 2. Fashion. 3. Etiquette. I. Stone, Jeff, 1953– . II. Griffin, Linda. III. Title. IV. Series.
TT507.G73 1998
646' .34—dc21
98-37902
CIP

Printed and bound in Great Britain by
Butler & Tanner Ltd, Frome and London

First Edition

To Jane, who is the occasion I dress for,

and to Dr. Michael Sacks, whose late-in-life discoveries have added a poignancy to his stylish apparel—no matter the occasion. J.S.

To my sisters, Susan and Jill—one knows how to make a great party and the other knows the right thing to wear—each with great style. K.J.G.

For my mom, Cora Engel, who makes every day an occasion. L.G.G.

A special thanks to our number one girlfriend, Noriko Maeda, whose generosity and unerring stylish eye have been a constant education and delight.
Time spent with Noriko is a time of laughter, good food, and beautiful clothes.

Jeff & Kim

"The more you know, the less you need."

AUSTRALIAN ABORIGINAL SAYING

CHIC SIMPLE is a primer for living well but sensibly. It's for those who believe that quality of life comes not from accumulating things but from paring down to the essentials. Chic Simple enables readers to bring value and style into their lives with economy and simplicity.

CONTENTS

read this book

ALL YEAR LONG

THIS IS A BOOK ABOUT LEARNING TO DRESS FOR LIFE. THAT MEANS DRESSING APPROPRIATELY for both the changing seasons and the planned and unplanned occasions that take place in the course of a year. Dressing for the seasons is about learning to use the basics in a Chic Simple wardrobe and then adding the pieces that are appropriate to the time of year; it's also about helping you continue to develop your sense of style and add versatility to your wardrobe. Most important of all, it's about allowing yourself to look and feel great.

Resources • page 201

DRESSING FOR YOUR BODY

Dressing is the art of camouflage and misdirection. Learn how to make the eye go where you want it to, choose the best styles to flatter your body type, and solve the quintessential crisis of picking the right bathing suit. And find out where to go to get what you're looking for.

 WHERE CAN I FIND MORE INFORMATION ON BUILDING A WARDROBE? So glad you asked. *Chic Simple: Women's Wardrobe* covers in depth the ideas and suggestions for creating and maintaining a wardrobe for today.

USE THIS BOOK

It's deliberately simple—otherwise we would feel kind of foolish. You look at the photos and read the text, no downloading involved. However, to aid in quick reference, we've developed a few icons to flag specific information. Listed below are the ideas behind the icons.

Why another book on clothes? Because everyone kept asking for it. We receive constant inquiries, through the mail and much more frequently via e-mail, that each begin "What Should I Wear...?" As we answered more and more of the same questions, we realized there was an obvious need for a title that would address the major and minor occasions that happen all through the year. As with all of our Chic Simple titles, the ideas are suggestions—starting points for you to begin your own dialogue—because, as with everything else in life, it's what feels comfortable to you that's important. **Kim & Jeff**

Body. This outfit is flattering to a certain BODY type but perhaps not to others. As with all broad generalizations, there will be exceptions to the rule—and you may not care—so read with one eye cocked toward the mirror.

Color. Adding brights, pastels, earthen hues, and every shade in between can bring breadth to your wardrobe, whether you're dressing up or down.

Dress Codes. With dress-down Friday becoming a week-long phenomenon, DRESS CODES are now more about appropriateness. Life's not about dictation, but everyone can use a little guidance in this department.

FAQ. Who? What? Why? When? Here are the answers to the most frequently asked questions (acronym courtesy of the Net).

How To. Where concept hits the gritty asphalt of reality. This icon says, "Enough talk. How do I do it?"

Profile. Throughout the long journey of style, certain individuals, companies, and even products have stood out as important design milestones.

Simple Truths. To restate Occam's razor, the simple answer is more likely to be the right answer. Wisdom and simple snippets of advice to help solve wardrobe crises.

Versatility. Essential for a simple wardrobe. How easily can an item mix and match with a variety of wardrobe fundamentals? We'll show you how your basic wardrobe tools can take you from Friday's office party to the boardroom.

SIMPLE SOLUTIONS
Simple Solutions. These are items or outfits that answer such a wide range of needs and are such a foundation to a wardrobe that we have flagged them as easy answers to many clothing problems.

January

February

March

For everything its season
and for every activity under heaven
its time:

a time to be born
and a time to die

a time to plant
and a time to uproot

July

August

September

a time to mourn
and a time to dance

a time to scatter stones
and a time to gather them

a time to embrace and
a time to refrain from embracing

66what

chapter one

Choices, Choices, Choices

At the age of two, we know what it means to dress up: patent leather shoes and a velvet dress in winter; white organdy in summer. Throughout our teens we experiment, wearing our metamorphosis and rebellion on the outside. In our twenties, we know how to dress for basic day-to-day occasions, but special ones with dress codes can render us clueless: What is appropriate for a formal morning wedding? Is urban chic a style or a Demi Moore character? To add to the confusion, fashion etiquette seems to be a moving target. It was not long ago that wearing black or white to a wedding was frowned upon. Today it's common, yet still considered shocking in some parts of the country. But where? When should head coverings be worn, and what about bare arms and legs? Is it proper to wear beading before sundown, and must we wear black to funerals? These are some of the subjects we delve into while exploring how to build and maintain a wardrobe that allows us, in the blink of a closet light, to dress for any special occasion with confidence and style.

April

May

June

a time to kill
and a time to heal

a time to pull down
and a time to build up

a time to weep
and a time to laugh

October

November

December

a time to seek
and a time to lose

a time to keep
and a time to cast away

a time to rend
and a time to mend...

ECCLESIASTES 3:1–7

should I wear?

66WHAT ARE YOU WEARING?99

A 365-Day Wardrobe

You have lots of clothes but think you have nothing to wear? Then chances are you haven't built a wardrobe that suits you. Consider it a luxury that you can't afford to be without. It's about having the minimal amount of clothes to get you through the maximum number of occasions at any time of the year, in great style. It means less stress and avoiding the costly wardrobe mistakes that usually ensue when you run frantically to the mall to deal with last-minute fashion emergencies. It's about using the real estate in your closet wisely. Building a wardrobe is knowing you will always look your best, as it is designed to work for you—your lifestyle, your personal style, your body, and your budget. It's an ongoing process, and with care and practice, it's a process you will master. Over time, you can develop a wardrobe that gives you the luxury of spending more time enjoying life, and less time worrying about your clothes.

SHOP YOUR CLOSET. While classics remain constant, our weight may not. The better the garment, the better the chance that there is enough fabric at the seams to be let out. Check with your tailor.

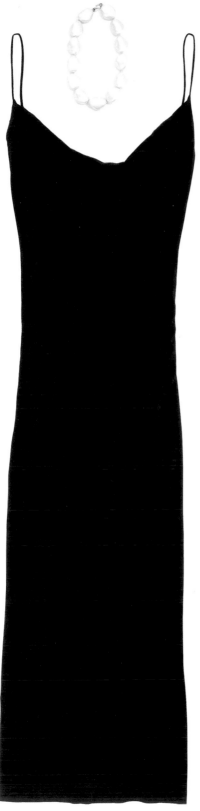

COMFORT CLOTHES.
We each have personal
favorites—clothes we
have discovered early
in our adult life that we
reach for repeatedly.
These are the bones
of a wardrobe and our
personal style.

BLACK ?
The height of
classic elegance,
it's an investment
that you can
count on to let
you and your
accessories
shine.

HOW TO **BUILD A WARDROBE.** Creating a wardrobe is understanding your lifestyle needs and your aesthetic preferences, discovering what you have and what you are missing, and then filling in the blanks. You'll need some tools: a pad and pen, some boxes, a full-length mirror, time, and some honesty. It's a three-step process: **SURVEY & ASSESS.** What are your life needs? Are you working in the city or out of your house, going to school or raising a family, or all the above? What are your style preferences? Do you like bright colors or earth tones, soft or shiny, old or new? Do you have all the basics? **DEJUNK & RECYCLE.** Pull out all your clothes and try them on. Determine what no longer fits your body, your needs, or your taste. Donate these items to charity, friends, a local theater group, or a thrift shop. **RENEW & REINVEST.** What's left? Presumably clothes you enjoy wearing. You've discovered a great beaded top, yet the pants no longer fit. Terrific dress, but the shoes are wrong. Maybe you have five ballgowns, but nothing to wear to your niece's christening. This is when your wardrobe list starts. Fill in the gaps with clothes that can be worn in multiple ways. Invest in fine fabrics, simple shapes, and neutral colors. Buy less, but buy better. Repeat this process each season. As your life evolves, so may your wardrobe.

spring

summer

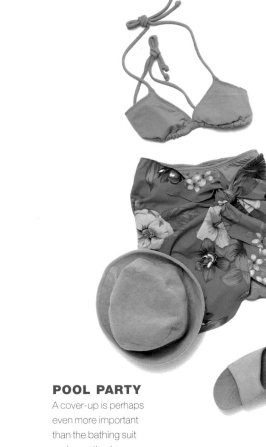

WEDDING SHOWER

After a winter wearing dark layers of clothing, come spring we welcome color and feminine dressing. A simple sheath is lovely for special daytime occasions, from wedding showers to graduation.

POOL PARTY

A cover-up is perhaps even more important than the bathing suit underneath when partying or vogueing around the pool.

S P E C I A L O C C A S I O N S

Dress suit or pants? Silk knits or sequins? You won't know what you need until you sit down with your calendar each season and list the special occasions you anticipate. As seductive as a long beaded dress may be, it's unnecessary if your social highlight is Christmas caroling or an early afternoon wedding.

Next consider your lifestyle needs. Do you frequently go out with friends or clients after work? How do you entertain, if at all? Buffet dinners, grilling on the patio, or more formal sit-down affairs? (Black-tie dinners at home are popular again, perhaps a reaction to more casual dress codes in general.)

Then there is the question of etiquette. Our desire to dress appropriately shows our respect for others. Take into account the season and the time of day—this will help determine appropriate fabrics and styles. Is the event religious? You should

autumn

winter

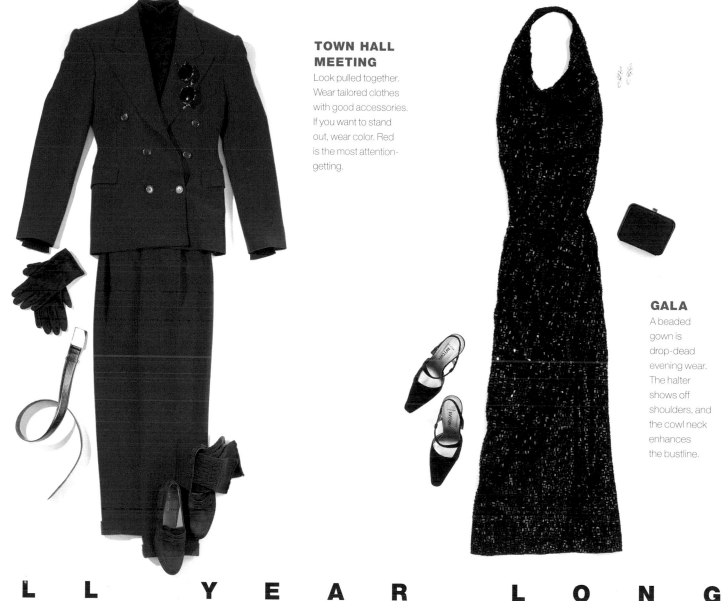

TOWN HALL MEETING
Look pulled together. Wear tailored clothes with good accessories. If you want to stand out, wear color. Red is the most attention-getting.

GALA
A beaded gown is drop-dead evening wear. The halter shows off shoulders, and the cowl neck enhances the bustline.

A L L Y E A R L O N G

probably wear some sort of cover-up within the sanctuary. A bacchanal? Then something more revealing may be desired. And where are you? Your understanding of the local culture—regional or peoplewise—can determine whether you will look like a tourist or the belle of the ball.

Once your list of occasions is complete, you can begin to consolidate. You won't need different outfits for each occasion. A

pastel suit just right for a cousin's spring wedding may also be perfect for Easter Sunday. But in order to take a dark business suit to an after-work cocktail party, you may need to add some feminine touches, such as a beaded top and a pair of strappy sandals. Your list will provide an outline for a wardrobe of special-occasion clothes—some specific to a season, others helpful all year long—that you can depend on and enjoy for years to come.

BAGS

Before you buy that new pair of navy slacks, check the navy suit with the ugly shoulder pads you're recycling and salvage the pants. Violà, one less item to buy, one more basic taken care of. Now let's explore the rest of your closet. What else awaits discovery?

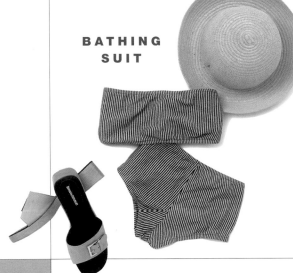

BATHING SUIT

1. SURVEY & ASSESS

2. DEJUNK & RECYCLE

3. RENEW & REINVEST

JEANS

shopping your closet

ALL YEAR LONG

Your year-round closet is made up of wardrobe basics. These are the foundation on which you build your own personal look—whether it's spring or winter. Matching sweater sets. Good white shirts and black pants. A blazer, a knit dress, and a skirt, all in seasonless fabrics with quality accessories.

BASIC ACCESSORIES

❏ bag	❏ glasses	❏ ring
❏ belt	❏ gloves	❏ scarf
❏ bracelet	❏ hair gear	❏ shoes
❏ buttons	❏ hat	❏ socks
❏ cuff links	❏ necklace	❏ stockings
❏ earrings	❏ pin	❏ watch

SHOES

"Everything changes in life."

DONATELLA VERSACE

 faQ MUST A BASIC WARDROBE ALWAYS BE BASED ON BLACK? Certainly not. Some people feel funereal in black. Alternatives are other neutral colors including navy blue, gray, taupe, beige, and perhaps even white or off-white if you live in a tropical climate.

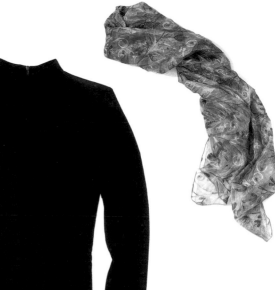

ACCESSORIES

TWINSET

DRESS

You have more than you think, but something is always missing.

SEASONLESS OCCASIONS

birthdays... business dinners... movie dates... showers... Saturday brunch... anniversaries... bar mitzvahs... weddings... weekend getaways... dinner for two...

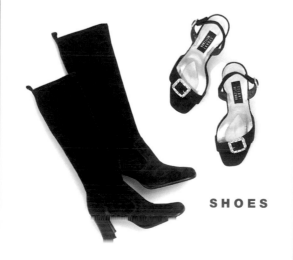

SHOES

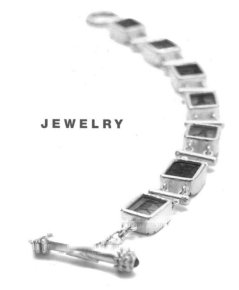

JEWELRY

SELF-TRUTHS

Dressing up is the quickest way to reveal aspects of our personality. Finding a style that suits us is a process that takes confidence and experimentation. We have all witnessed Courtney Love's transformation from grunge to siren. Marilyn Monroe knew how to dress her part. So do the celluloid characters Annie Hall and Ally McBeal. They project an individuality that isn't dictated by fashion's fickle trends. You may feel comfortable in the classics (black, white, and pearls) or prefer dressing with attitude (black leather and stilettos). Chances are you may like a little of both. Get to know yourself and your style, then go with it rather than fighting it.

WHAT LOOKS GOOD...

LOOK YOUR BEST. Part of determining your style is identifying the great and not-so-great parts of your body. Sometimes we see ourselves better in a photograph. Have a friend photograph you front, back, and sideways wearing a variety of clothes. You may find that the styles no longer suit your age or body. (It is believed that 80 percent of women over forty think they look younger than they do.) Or look in a three-way mirror with brutal honesty. Examine all angles without sucking in. Recognize your best features and commit to playing them up. It may be your dainty wrists and narrow ankles. Accent them with shirts that feature beautiful cuff links and pants that taper at the ankles, or dresses with hemlines that fall to mid-calf. A nice smile and good posture can draw attention away from a pear-shaped body, as will bold accessories in the neck area. A bias-cut full skirt in motion disguises full hips. Learning to manipulate accessories, color, pattern, line, and texture will help you look your best while you define your personal style.

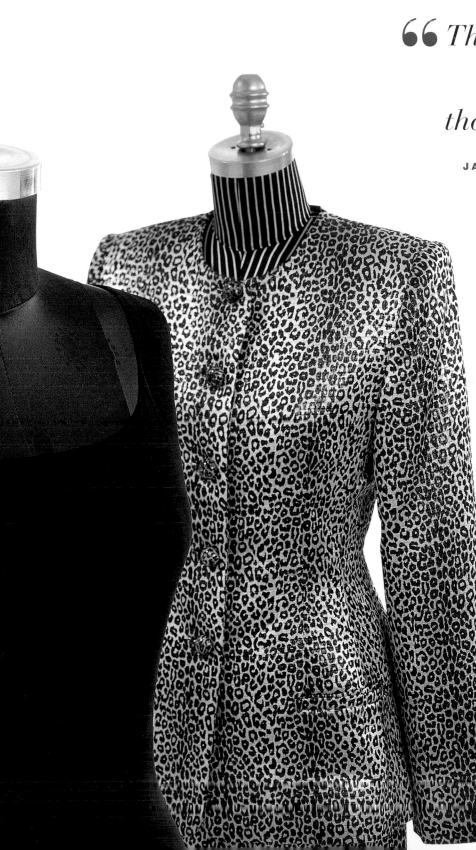

> ❝ *This dress exacerbates the genetic betrayal that is my legacy.* ❞
>
> **JANEANE GAROFALO**
> in ***Romy and Michele's High School Reunion***

. . . O N M E ?

HEAR ME
Few women recognize
the power of a voice.
Kathleen Turner's is
seductive. Katie
Couric's is trusting.
Jackie O's whisper
invited men to listen a
little closer. You may
look dazzling but
sound shrill. Listen
to yourself on tape.
If you don't like what
you hear, skip the new
dress and talk
to a voice coach.

SEE ME
Want to stand out or
fit in? Set a trend or
be a trend? Clothes
communicate. Do you
want to dress the
part of the trophy wife
(a common aspiration
in New York, Los
Angeles, and Texas),
or not upstage your
husband (more
characteristic of the
rest of the country)?
Your choice may
depend more on
where you live than
on who you are.

*She knew someday
her life work.
as she got back*

have

chapter two

Wardrobe workshop

Perhaps the most important reason we wish to dress properly for every occasion is that our clothing affects—and reflects—our own moods. Consciously or subconsciously, we dress for happiness or sadness, celebration or mourning, low-key or top-of-the-world. And only when we know that we are dressed appropriately for an event and look our best do we feel we can enjoy ourselves. Easing into a life of stylish simplicity requires understanding the basics. And ourselves. Which textures feel nice next to the skin? How do certain colors, cuts, and patterns make us feel? Can we finesse a day look into night? If God is in the details, what does she whisper in our ears when it comes to accessories, makeup, intimates, and fragrance? Knowing the guidelines, trusting our instincts and our senses can make the difference in what we will enjoy wearing. How we wear it is another issue. We'll tawk.

she would find the exact right outfit that would make
Maybe not her whole life, she thought,
in bed, but at least the parts she had to dress for. "

CARRIE FISHER, *Postcards from the Edge*

nothing to wear!

" DOES THIS GO WITH THIS? "

1·pattern

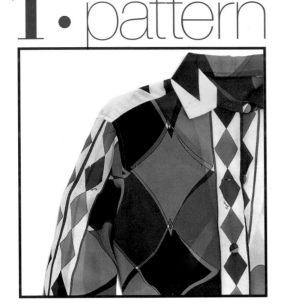

Pattern piques interest, tweaks the funny bone, and makes a statement. Bold geometrics can jazz things up. A leopard print is slightly racy, while flowers are feminine and somewhat demure. Mixed with your basics, patterns add vitality. An outfit that is patterned becomes more memorable—which may limit the times you choose to wear it.

> **"I want my clothes loose enough to prove I'm a lady...**

2·cut

The cut of a garment can reveal or conceal, make us look svelte or 10 pounds heavier. It can render a garment sexy or businesslike. Even a top cut slightly off the shoulder becomes inappropriate in an office or a serious setting unless worn under a jacket. The cut of a shoe can also create a mood: high-heeled and strappy is seductive, sturdy and low is sensible.

The subtleties of our clothing—the color, cut, and texture—are as important as the type of garment. Ever notice how the same beige suit can render a woman a wallflower or a fashion plate, depending on whether it's worn on New Year's Eve or for Easter service? And the way we mix and remix fashion elements helps us create our very own look. What we wear can set the tone for an entire party and, like a photograph, live in memory long after we are gone. Who doesn't know what Marilyn Monroe wore when she sang "Happy Birthday" to JFK at Madison Square Garden?

3 · color

Color can scream or whisper. It marks the tourist and the cognoscente, the villain and the vixen. It can help skin look glorious or make it appear washed out. It slims, it's gay, it's mournful. But too much color will be confusing unless you start by building your wardrobe around neutral colors.

...but tight enough to show 'em I'm a woman. **99**

MAE WEST

4 · texture

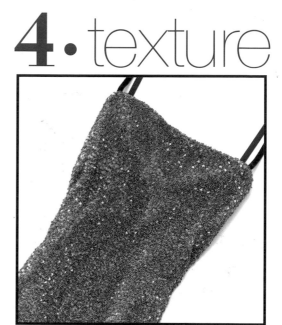

Texture can differentiate day clothes (corduroy) from night (beaded), work (wool flannel) from party (satin), summer (piqué) from winter (velvet). It can give clothing a richness and visual allure, especially when you mix opposites: a nubby wool with the sheen of satin. The best part: Some textures feel luxurious on the skin.

6 ELEMENTS OF STYLE

5·fabric

It can render something just right for an occasion or all wrong (and can also dictate price). Think about it: You go out on New Year's Eve in a T-shirt—albeit a sequined T-shirt. You might wear pants to a christening, but in a fine-quality wool with a matching jacket. Certain fabrics have traditionally been worn only for day, or only for night, or only in the winter, or just in the summer. But now stylish women are bending the rules, and you may see a splash of velvet in the summer or silk shantung in the winter. New ways of weaving, treating, and blending fibers have also created more seasonless fabrics, which adds to our comfort in increasingly climate-controlled environments.

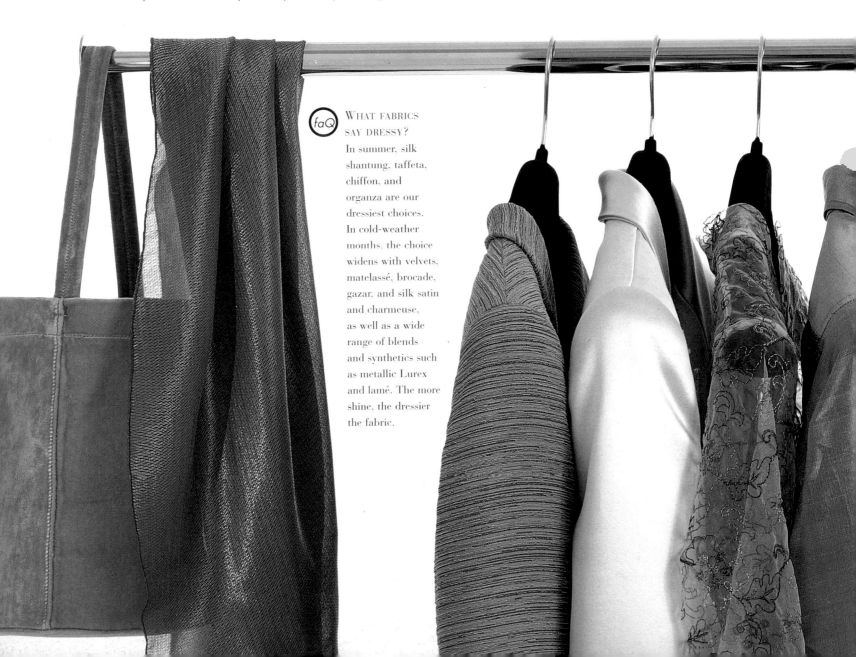

(faQ) WHAT FABRICS SAY DRESSY? In summer, silk shantung, taffeta, chiffon, and organza are our dressiest choices. In cold-weather months, the choice widens with velvets, matelassé, brocade, gazar, and silk satin and charmeuse, as well as a wide range of blends and synthetics such as metallic Lurex and lamé. The more shine, the dressier the fabric.

HOW TO **ORGANIZE YOUR CLOSET.** One of the secrets to stressless dressing is knowing that you have the right clothes in your closet for the event at hand. Another is being able to find them. A closet should be a sanctuary, not an encounter session. What you don't see you probably won't wear. Arrange garments in designated categories; style, color, and occasion are all sorting devices. Store shoes in labeled boxes for fast retrieval. Pay attention to fabrics—keep knits folded and flat. Store away off-season items. Get rid of plastic bags; they protect against dust and moths, but their chemicals can damage silk, linen, and white fabrics.

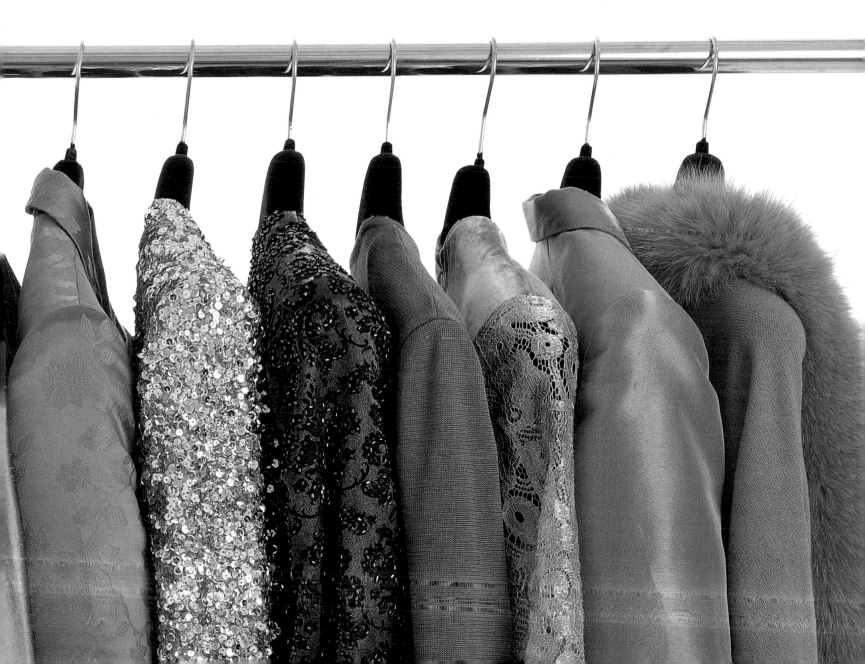

6 · telling details

Details—whether on a tank top,

shoe, or lining of a coat—can

elevate the item from ordinary

to extraordinary, to something

that says high style or is meant for

special occasions. Satin edging

on a ribbed cotton top, suede

edging on the pockets of linen

pants, handmade buttons, or

shoes with beading or scalloped

edges help underscore

the stylishness you may want

to convey for an important event.

Couturiers turn to François Lesage to embellish garments with exquisite beading and embroidery. His staff typically hand-sew almost 7 million beads for runway designs in the month before the collections. Any wonder why couture is so chère?

Bouclé, first produced in the 1880s, is a fabric with a looped or nubbed surface, the result of using a curly or looped bouclé yarn. Coco Chanel popularized it with her spring suits, using coordinated braid trim or self-fringe made from the fabric, and decorative buttons.

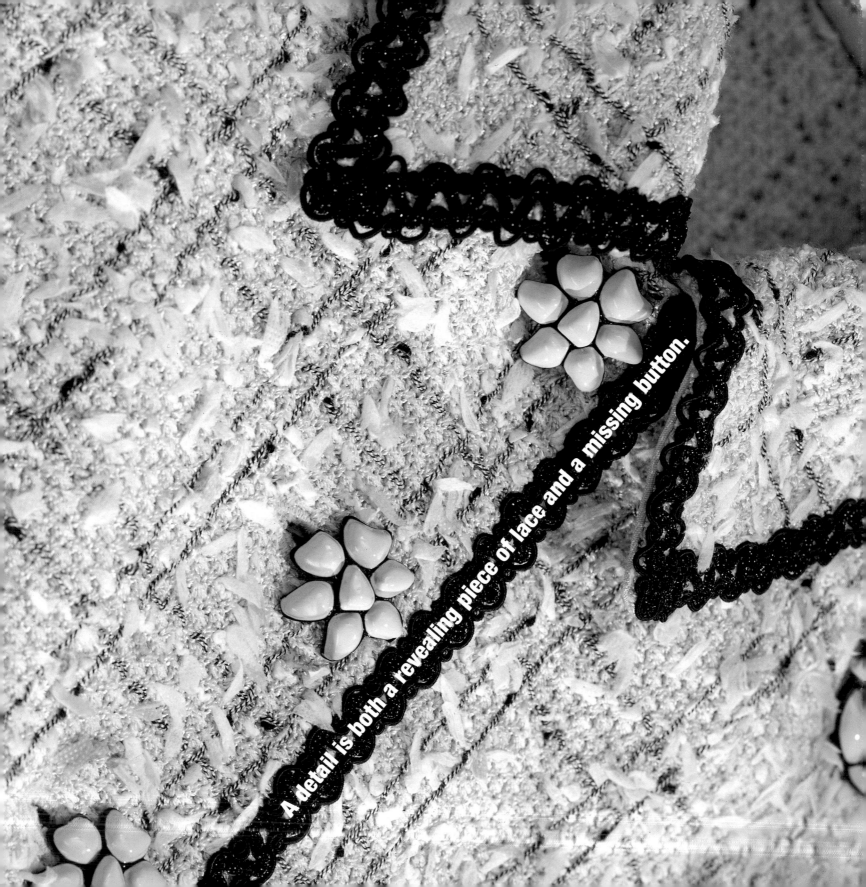

A detail is both a revealing piece of lace and a missing button.

THE SIMPLE WARDROBE

SIMPLE SOLUTIONS Imagine having only a few things to get you through most wardrobe emergencies. Clothes that you enjoy wearing. Clothes that can be worn in a variety of ways —to suit the mood and the occasion. You know you have a successful wardrobe when an invitation no longer sends you into a tailspin, but allows you to say with confidence, "I don't know what I'll wear, but I know it's in my closet."
REMIX Getting the most from your clothes means learning how to successfully mix a few key pieces for a variety of occasions. Start building your wardrobe around a neutral color. Black is easiest to dress up and down or mix with other colors and patterns. Besides being slimming, it's elegant and can be worn anywhere—including most weddings.

A good black suit or black dress with matching jacket gives you a foundation on which to build. When the cut is simple, pieces can be easily worn with other clothes in your closet. Add color—a red sweater set looks great with a black skirt. Mix attitude—a black suit jacket can dress up white jeans. And a change of shoes or jewelry can transform a look dramatically. Seasonless fabrics, like lightweight wool crepes and silk knits, can be wardrobe solutions most of the year. Don't worry about fabrics not matching. Varying textures can add rich visual interest, especially if the weight or sheen of the garments is contrasting. And the bonus: No matter how much your original investment is, the more you wear these clothes, the more of a bargain they become.

SIMPLE SOLUTIONS

❏ Black dress

❏ Black suit with pants and skirt

❏ White shirt

❏ Good black leather day bag

❏ Black leather pumps

❏ Small fabric evening bag

❏ Peau de soie evening pumps

❏ Sheer black or nude stockings

❏ Festive flats or mules

❏ Pearl necklace

❏ Diamond or pearl earrings

❏ Dress watch

❏ Sweater set

❏ Dressy top

❏ Evening skirt or pants

❏ Long evening dress

❏ Large decorative scarf
or evening wrap

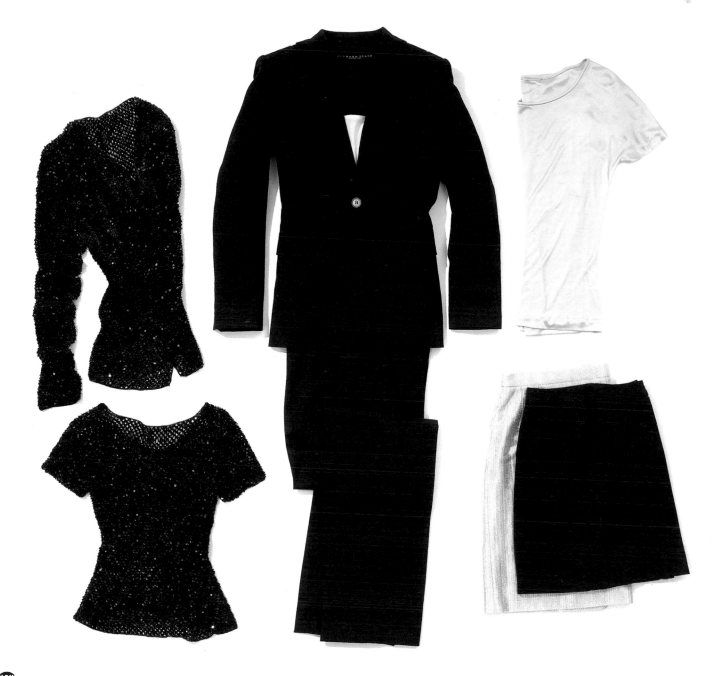

BUY A BLACK SUIT THAT'S RIGHT FOR YOU. A basic black suit should consist of jacket with skirt and pants. (After all, we live in a more casual world, so pants are appropriate for many dress-up occasions.) Before purchasing it ask yourself, Where will I be wearing this? Dressy charity events, cocktail circuit, work to dinner, travel, funeral, all of the above? The more shapely the cut, the more dressy yet less versatile the suit. Consider choosing one with a jacket that can also be worn without a blouse. What's the weather like? Do I need a year-round fabric, or one suited to extreme weather conditions? Wool crepe is probably the most versatile fabric, easy to dress up or down, and wears well most of the year. Special details like decorative buttons and trim dress things up but also make them less versatile. You may decide you need more than one suit.

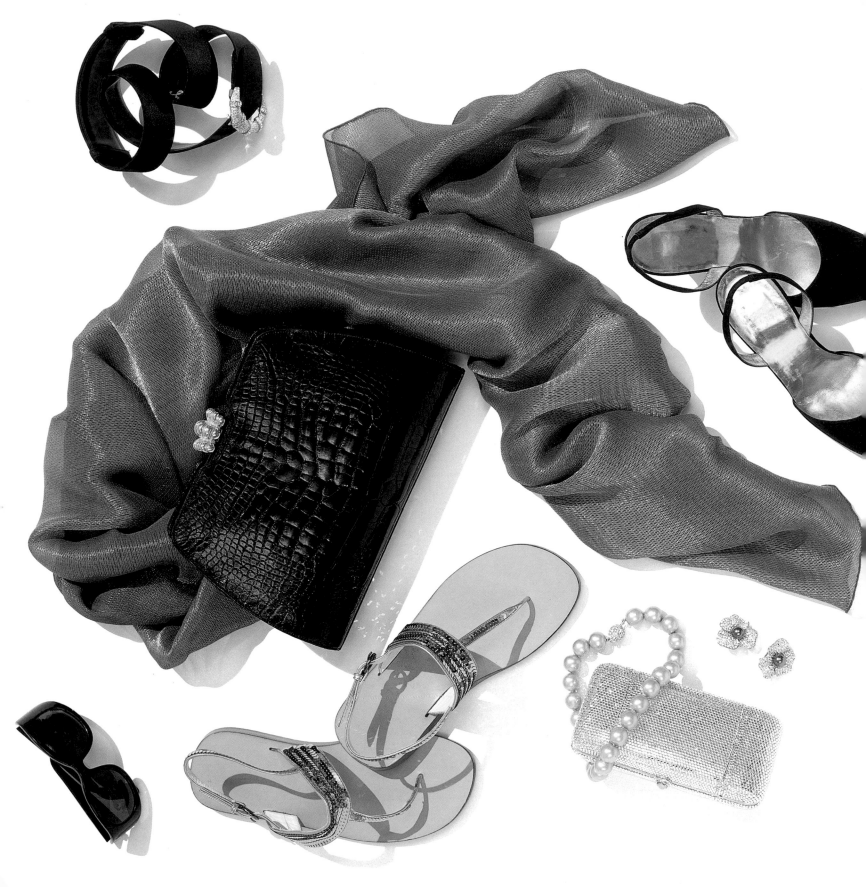

ENHANCEMENTS

Part of the magic in creating a versatile wardrobe that works for a variety of occasions is understanding the power of accessories. An interesting belt, a necklace of beads, a beautiful scarf, or a dramatic bracelet can transform an outfit, making it appropriate for varying times of day, seasons, and events. Simply changing our shoes, bag, and lip color can mean the difference between board meeting and cocktail party.

As modern clothes have acquired mass-produced uniformity, the way we enhance our uniform is also what distinguishes our personal style. Whatever the mood (practical—low-heeled pumps; sexy—stilettos; classic—pearl necklace; whimsical—leopard-print bag) or season (big hoop earrings—summer; cashmere gloves—winter), if you wear something often enough, it becomes your signature. Think of Dorothy's ruby slippers, Jackie O's sunglasses, Barbara Bush's pearls—marks of personal style.

HOW TO **DRESS UP A SUIT.** **TOP:** Remove blouse from under the jacket or replace the jacket with a sweater set or blouse in a sexy cut or luxury fabric (sheen, sparkles, beading). **BOTTOM:** Change into something loose and flowing (palazzo pants, evening skirt) with sheen or a dazzling color. **BELT:** Decorative buckle, dressy fabric, rhinestones, metal links, or animal print. **SHOES:** Black satin or silk pumps, stilettos, something strappy, mules in silver or gold.

BAG: The smaller the dressier, a silky cloth finish, luxurious alligator, jeweled, beading, or fine leather with gold clasp. **SCARF:** Large or small wrap in silk, sheer organza, cashmere, with embroidery, beading, color, pattern. **JEWELRY:** Dramatic earrings or necklace, a bold cuff, a decorative pin, or a pendant. Pearls or gold are classic, diamonds and gemstones are dressiest, silver least dressy. **COLOR:** Gold, silver, white, and red are dazzling; black is basic.

THE LITTLE BLACK DRESS

It is simply the one wardrobe item that makes every woman feel great—and look great—any time of year. In fact, the black dress has qualified as an entire wardrobe (when worked with accessories) ever since Coco Chanel created it in the 1920s. You can count on it to wear to your college reunion or when meeting your husband's new boss. It has been a classic choice for funerals, and now, with relaxed dress codes, is often worn to weddings. Despite the fact that dresses are so easy to wear, black is the real reason for its success: The only truly basic color, at once formal and informal, it puts the focus on the face, slims the body, and conceals imperfect tailoring. Under a jacket it can appear suit-like, yet it's sexy on its own—perfect for day to night and for the holidays. With a change of accessories, make it fun or sober, sexy or classic, powerful or understated.

BRUNCH **TEA** **COCKTAILS** **DINNER**

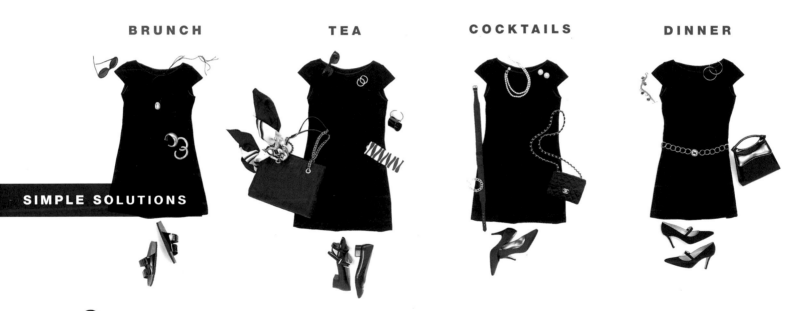

SIMPLE SOLUTIONS

HOW TO **SHOP FOR YOUR PERFECT BLACK DRESS.**

Plan your mission knowing it may take more than one outing. First, consider which fabric weights are suitable for your climate, where you want to wear the dress (everywhere, of course), and how much you can spend. Length should be a consideration, as well as neckline and sleeves. The best investment is to choose a dress with fabric and cut that assure versatility. Simple lines and no sleeves or short sleeves allow you to wear the dress 12 months of the year, as well as to cocktail parties or under a jacket for more staid occasions. Beware of necklines that expose too much cleavage, hemlines that show too much leg, and overly tight skirts; they will limit where the dress can go. If in doubt, picture yourself wearing the dress to be presented to the Queen of England (at cocktails, of course). When you find the black dress of your dreams, make sure the fit is perfect and the cut flatters your figure. At home, try it on with different accessories. Figure out your classic look, your evening look, your luncheon look, and, just in case, your somber look.

The black dress is the ultimate wardrobe basic. It brings focus to the face. It makes limbs, neck, and collarbone elements of adornment. The rest is gravy, transformed by accessories.

Scarves and jewelry are the simplest ways to add color and sparkle to the black dress.

A bag announces the setting, and the frame of mind of the carrier. It can be small and flirtatious, or big and accommodating. And It never quarrels with the perfect black dress.

66 That's quite a dress you almost have on. 99

GENE KELLY,
An American in Paris

Shoes are largely responsible for the credit-card debt of the average woman. A black dress allows you to wear your most whimsical or extravagant. But know that your choice of shoe will signal the mood of the occasion.

T A B U L A R A S A

UNDER AND OVER

We may have gotten our wardrobe together, but something is missing.
We sense it when we walk through a restaurant, or just before we enter a black-tie gala.
It's about what we are wearing under and over our special clothes.
If you don't have them right, your outfit won't matter. Your over- and undergarments will be
the first and last impression you make, so pay attention.

CHOOSE UNDERGARMENTS. When you try on your clothes or purchase new ones, make sure your undergarments are flattering (check for panty line and puckering across the chest). If not, take the garment to a lingerie department and try on alternatives until you get it right. New technology has created a variety of fabrics and fits designed to help our bodies look their best.

It may be necessary to have different undergarments for different cuts of clothing. Build a wardrobe in colors that won't reveal themselves to the outside world unless by choice. Black, white, and nude are safe bets. And don't forget stockings. Now they can tuck in tummies, thighs, waists, and midriffs, not to mention adorning our legs with varying degrees of shine and sheerness.

WEAR UNDER OVER. Your slip is showing—many women have had the dream...or nightmare: Undergarments can be so beautifully constructed that long-line bras might be worn as bustiers and slips as dresses. But

never underestimate the shock value of wearing underwear as outerwear. If you have the urge, give the look a trial run with a group of intimate friends before letting it loose at a party where you don't know everyone.

BRAS

❑ **Strapless**

❑ **Those that push up or pull in**

❑ **Clean finish (nude)**

❑ **Decorative**

PANTIES

❑ **Thong**

❑ **Tummy control**

❑ **High-cut leg**

❑ **Thigh slimmer**

> **8:35 a.m.** *Begin selection of underwear. Laundry crisis means only available underpants are vast white cotton. Too unattractive to contemplate, even for work (psychological damage). Go back to ironing basket. Find unsuitably small black lacy pair—prickly but better than giant Mummy-pant horror.*
>
> **8:45 a.m.** *Start on opaque tights. Pair one seems to have shrunk—crotch is three inches above knees. Get second pair on and find hole on back of leg. Throw away. Suddenly remember had Lycra miniskirt on when returned home with Daniel last time. Go to living room. Triumphantly locate skirt between cushions on sofa.*
>
> **8:55 a.m.** *Return to tights. Pair three has hole only in toe. Put on. Hole transforms into run which will protrude tellingly from shoe. Go to ironing basket. Locate last pair of black opaque tights twisted into ropelike object speckled with bits of tissue. Untangle and purge of tissue.*

HELEN FIELDING, *Bridget Jones's Diary*

 CHOOSE THE RIGHT COAT.

Travel? Look for a coat that you can wear when dressed up or down (a reversible coat or one in black, which also won't show the dirt). As with your suitcase, think lightweight (microfibers!). Length? If your hemline changes as quickly as your lip color, a longer length will cover options worn underneath. Glamour? Go for rich textures (cashmere, fur, velvet, silk, suede). Don't be afraid of colors and patterns—just wear them over solid colors that don't clash.

Sport classic: the camel-hair coat

New classic: microfiber shell

Simple solution: a long black wool coat.

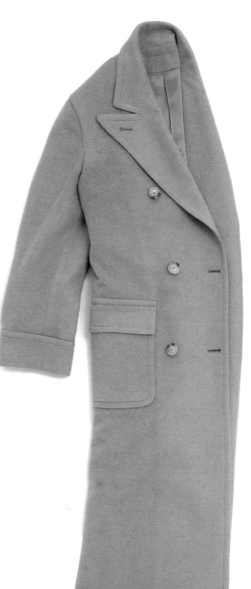

A favorite of designers who glorify the classics, camel-hair coats' laid-back prestige was popularized by polo players in the 1920s, who wore them while resting between periods. Soon women adapted the look too.

OUTERWEAR WARDROBE

Spring	Summer	Autumn	Winter
❏ **Sweaters**	❏ **Swimsuit cover-ups**	❏ **Polarfleece vest**	❏ **Ski parka**
❏ **Blazers**	❏ **Sweater**	❏ **Suede or leather jacket**	❏ **Wool coat**
❏ **Lightweight jacket**	❏ **Lightweight blazer**	❏ **Peacoat**	❏ **Fur (faux or with trim)**
❏ **Microfiber raincoat**	❏ **Microfiber shell**	❏ **Barn jacket**	❏ **Shearling**
❏ **Evening wrap**	❏ **Evening wrap**	❏ **Evening jacket**	❏ **Evening coat**

> *They hadn't tampered with her natural beauty, yet somehow they had succeeded in heightening it. Before it used to creep up on you. Now you noticed it immediately. She wore eye makeup and her hair was fuller, like a lion's mane. She still looked every inch the lady, but she was exciting now.*

JACQUELINE SUSANN, *Valley of the Dolls*

Dressing up is about more than just the clothes we wear. Putting up our hair or letting it cascade down our back can be elegant or coquettish. Painting our eyes can make us appear softer and more feminine, or strikingly dramatic. The lip color we choose can change our look according to the season, the time of day, or the dress. These subtleties are integral parts of the style equation. It's more than good grooming; it's how we decide to paint our portrait. And while looking good should be part of our everyday lives, we want to look even better for more special occasions, but not unrecognizable.

UPDATE YOUR LOOK. Unlike a clothing wardrobe, which is built up over time, makeup gets old fast. The good news is that it is a relatively inexpensive and quick way to update our look, and new technology gives us better formulas to choose from. · To stay fresh-looking, update your makeup seasonally. Try two new shades of lipstick, and check your foundation (as seasons change, so may your coloring). · Avoid pairing strong eyes with intense lip color—do one or the other. · Red lips dress things up. · Apply makeup in daylight, near a window. The results will look more natural. Otherwise use light cast by a Chromalux bulb, which is the closest thing to natural light this side of the sun. · A sheer loose powder is a necessity for setting foundation or concealer and for prepping the skin so makeup won't melt as quickly. Used by itself, it will give the skin a smoother look and minimize pores. · Most of us don't realize the impact our eyebrows have on our overall look. Make sure they're not unruly. If they're very light, you may want to darken them with a soft brow pencil. · An eyelash curler will make eyelashes look longer and curlier. · Applying makeup should take no more than five minutes, seven if it's for a special event. · For last-minute makeup emergencies, stop by your favorite cosmetic counter. Most experts are happy to apply makeup for free, although they will anticipate a purchase. · If you are having makeup done professionally for a special event, have a run-through in advance. · Having a good haircut is important. Learn how to dress up your day-to-day style and how you can revive a tired hairdo at the end of the day.

Makeup

66 Her presence raised the vibration of the most commonplace event. 99

MERCEDES DE ACOSTA, describing her sister, Rita Lydig

MAKING IT LAST

The difference among various types of fragrance is strength: The higher the ratio of perfume to alcohol, the more long-lasting the fragrance. For end-of-the-day touch-ups, carry a purse atomizer.

PERFUME: 5–6 hours

COLOGNE: 2–3 hours

TOILET WATER: 2–3 hours

LOTION: 3–4 hours

&

The scent we strategically splash on can be a reminder of the past or a hint of a promise. Worn frequently, a scent becomes a familiar part of us, a personal signature. It's absorbed into our clothes, our hair, our skin. The right amount becomes part of our aura. Over time we may have built a wardrobe of fragrances. There may be one that we reach for over and over, others that we save for particular occasions or seasons. Or we may be eager to experiment, as with lip color, trying on samples at department store counters. The more adventurous may try layering a variety of scents, creating a unique fragrance. Whether we choose to wear one or not, our personal scent is as individual as a fingerprint. Fragrance can add to a woman's mystique, but too much can destroy it. A woman who wears the same perfume every day tends to grow immune to its fragrance and applies more and more until those around her are gasping for air.

fragrance

That's the problem with spring; it's coats in the morning and sleeveless in the afternoon. A time of transition—in clothes, in your mood, in facing the world. Your whole heart is yearning to shuck off the winter clothes and emerge as from a chrysalis. Spring is our time of revival, of rebirth, and special occasions mirror that: weddings, Easter brunches and Passover seders, and graduations. A difficult, wondrous season that's always fresh.

chapter three

66 It was one of those March days when it is summer in the light, and winter in

" *I stuck my head out the window this morning and spring kissed me bang in the face.* **"**

LANGSTON HUGHES, *Simple Speaks His Mind*

when the sun shines hot and the wind blows cold: the shade. **"** CHARLES DICKENS, *Great Expectations*

COLOR

- ❏ **white cotton shirt**
- ❏ **silk knit sweater set**
- ❏ **dark stretch cotton pants**
- ❏ **denim jeans or khakis**
- ❏ **blazer**
- ❏ **spring suit**
- ❏ **black patent leather shoes**
- ❏ **pastel evening dress**
- ❏ **microfiber raincoat**

PANTS

SHOP YOUR CLOSET

1. Bring out all your pretty silk scarves. Try pairing them with suits and dresses already in your closet.

2. Check out your closet for any pastel- or light-colored woolens. While the weather is still cold, concentrate on wearing these, then graduate to lightweight fabrics.

3. The order of progression: wool to wool blends to silk to cottons and linens. When spring arrives, it comes with a bang, so identify five warmer-weather outfits already in your closet.

DEJUNK

Weed out any clothes that no longer fit and take them to charity thrift shops.

shopping your closet

SPRING

FIRST AID

Pearls add light and a glow to the face when worn at the ears or neck. If they look dingy, wash gently by hand in Ivory Liquid. Inspect knots to see if any are frayed. If so, see a jeweler about having them restrung.

ACCESSORIES

HOW TO **CLEAN, STORE, AND BUG-PROOF YOUR WINTER WOOLENS.** Mothballs work well, but you may prefer the fragrance of cedar, which comes in chips, blocks, or scented paper. Send your furs to cold storage. The lower temperature during warm-weather months will prolong the life of your fur and ensure that the hairs don't curl.

faQ WHEN CAN I STOP WEARING STOCKINGS? Except in semi-tropical areas, spring is too early to go without stockings. If your area has an early heat wave, however, use your best judgment. Never wear stockings with the barest sandals.

> **"** Is fashion important: Well, my dear—you have to get dressed. **"**

CARRIE DONOVAN

Add a splash of color to update your wardrobe neutrals for spring.

BAGS

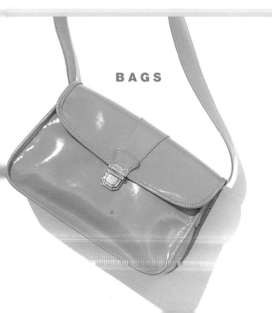

SPRING OCCASIONS

St. Patrick's Day... Easter... Passover... Secretaries Day... Azalea Trail... Dogwood Festival... Baseball Opener... May Day... Mother's Day... Graduations... Memorial Day... Weddings...

SHOES

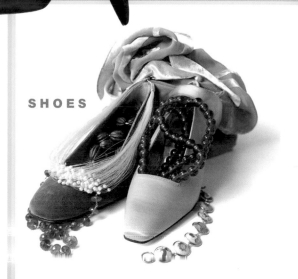

"*Color is like food for the spirit—plus it's not addictive or fattening.*"

ISAAC MIZRAHI

Depending on their size, scarves can be worn in a variety of ways, from beach wrap to evening wrap. They can be tied into an evening pouch, or worn around the neck in lieu of jewelry. On their own, many are beautiful to live with—draped over a couch or made into a pillow cover.

S P R I N G C O L O R

 WHAT COLOR SHOES
AND STOCKINGS
SHOULD BE WORN WITH
NAVY BLUE?

Sheer stockings in black
or nude (try to match
skin tone) with black
patent leather pumps
looks great and is more
reliable than trying
to match your stockings
and shoes to the navy of
your suit. Another option
is to take the garment
with you when shopping
for shoes and stockings.

If you like a color but it
doesn't look good with
your hair or skin coloring,
try wearing it away from
your face. A bag, belt, or
shoes are good options.

Colorful shoes are playful.
They signal that you are
ready for some fun.

Start your wardrobe
with a jacket in a
neutral color. Your
next jacket might
be more colorful,
as it is an easy way
to brighten up your
other wardrobe
basics—as well as
your mood.

HATE WEARING COLOR?

Have you ever been seduced by the beauty of a color? You find a stunning deep-pink suit, it looks great on, and you have the occasion to wear it. You buy it. But the celebratory day arrives, and you find yourself rummaging through your closet for something else to wear. The suit color doesn't work with your hair, complexion, accessories, personality—it's just not your style. Yet in the bright light of spring, too much black appears mournful, brown feels muddy, and corporate gray dampens spring fever. Try navy. It's a springtime classic, offering just enough color to lift the spirits but dependable enough to be elegant and always appropriate, and to mix easily in a crowd. Bear in mind that not all navies are created equal. There's midnight blue (the darkest and dressiest), and a variety of dark blues. Trying to match them can be a nightmare. Stick to one navy throughout your closet and take a color sample with you when shopping.

BRIGHT SPOTS	
LIP COLOR	SHOES
T-SHIRT	BAG
BLAZER	JEWELRY
SWEATER SET	JACKET
SCARF	BELT

faQ WHAT FABRICS TRAVEL BEST?
Knits, Lycra blends, and lightweight worsted and crepe wools are comfortable in most climates at least eight months a year, and they travel extremely well.

66 I like to walk down Bond Street, thinking of all the things I don't want. 99

LOGAN PEARSALL SMITH

SPRING WEIGHTS

Lightweight wool

Tweed bouclé

Cashmere

Wool knit

Wool crepe

Thick silk

Silk knit

Synthetic fibers

Cotton

Chiffon

Organza

Tulle

Lace

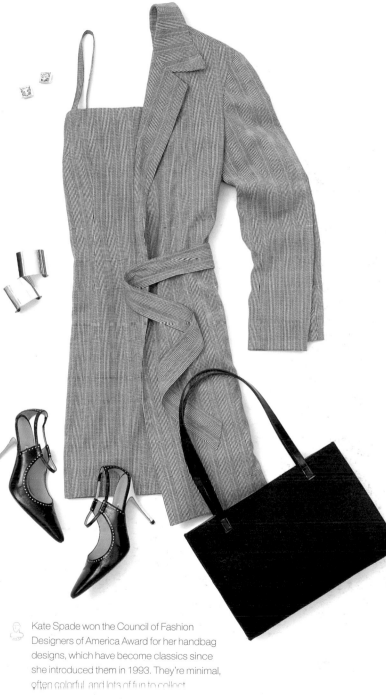

Layering garments helps deal with the rapid swings in temperature common in spring and fall. Even in a businesslike fabric, a strappy dress is not appropriate for work unless it's worn under a tailored jacket. It is acceptable to remove your jacket in your private office or for after-work functions.

W arm winds may blow in during spring, but often we have to endure many cool, damp days until the temperature rises. In wardrobe terms, this means transitional clothing. The heavy layering of bulky fabrics is no longer appealing. Fur, corduroy, even velvet feel all wrong. Color signals that we have made the move into spring, and so must our choice of fabrics. Bouclé wool and pale tweeds have plenty of warmth and a pleasing nubbiness to their textures and come in many soft colors. Lightweight wool and wool crepes are comfortable most of the year. Cashmere is still a good choice for sweaters. When the weather warms up, switch to silk. Lightweight knits are a fashionable option for women on the go who value style and comfort.

In the South and Southwest, linens come out around Easter. In fact, today's casual, washable linens are worn almost year-round in warm climates. In the North and East, hold off on wearing linen until Memorial Day. If it is too warm for wool but too early for linen, try cotton or synthetic fibers like viscose, rayon, and acrylic, in woven fabric or in knits. These fibers have wonderful lightness and fluidity.

Kate Spade won the Council of Fashion Designers of America Award for her handbag designs, which have become classics since she introduced them in 1993. They're minimal, often colorful, and lots of fun to collect.

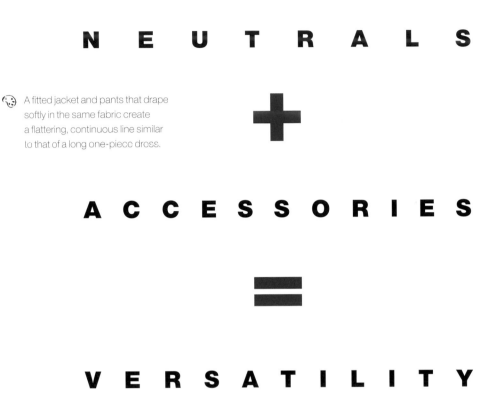

N E U T R A L S

+

A C C E S S O R I E S

=

V E R S A T I L I T Y

A fitted jacket and pants that drape softly in the same fabric create a flattering, continuous line similar to that of a long one-piece dress.

For spring, the traditional neutrals are navy, beige, cream, taupe, and pale gray. But where is it written that you can't treat powder pink, pale blue, or maize as a neutral?

SPRING SIMPLE

If all this talk about fashion rules gives you a headache, you are not alone. The best fashion advice you may ever read is that those renowned for their style usually circumvent any worry over "rules" by sticking to simple solutions. By stocking their closets with a few high-quality, understated outfits in neutral colors, then adding accessories to dress them up or down, they are always assured of being properly and well dressed. And they establish their own personal styles by adding signature accessories—always wearing a hat, a cache of favorite pearls, or the ultra-high heels they love.

Monochromatic dressing is elegant and slimming and makes one appear taller. If you are petite, the mid-calf length may appear overpowering unless the fit is narrow.

Accessories gain importance when they are worn with neutral-colored clothes.

Hemlines are no longer dictated by fashion trends. Wear what you feel comfortable in, and what makes you feel pretty.

Footwear: Function or fetish? Most women would agree it's both. Run or walk? Shoe choices seem obvious, but then again, who insisted that before casual workdays women should wear pumps to work? Rain, snow, mud, and heat motivated our ancestors to build shelters and skin animals for clothing. But when did we make rules about what color shoes should be worn when? Some of it is common sense. As days get warmer, shoes often become skimpier. When days are drier, we can wear materials like patent leather without fear of ruin. And as the sun shines brighter, so does our choice of colors. Some women may admit (but never to their husbands) that a change of season is another excuse for buying what is probably our favorite wardrobe purchase.

The first week of spring weather is the perfect time to put away most of our dark, heavy winter shoes and boots. Unpack the strappy evening sandals and lighter-colored pumps and flats. Suddenly, black patent pumps look fresher than black leather.

For special-occasion dressing, think in terms of a shoe wardrobe as opposed to buying shoes for each outfit. Most women need at least three pairs of dress shoes each season: daytime dress shoes, usually pumps; a pair of evening shoes, perhaps high-heeled sandals for spring and summer; and a pair of feminine or festive flat shoes that can be worn day or night. When it comes to the rules, many we learned as children—no suede in spring or summer; no open toes until after Easter—are broken so often they may as well be ignored. Now it is perfectly acceptable to wear suede year-round and slingback or open-toed pumps summer or winter. Only one rule remains semisacrosanct, one having to do with white shoes: In the East, the rule is no white shoes until after Memorial Day. In the South, it is no white shoes until after Easter.

faQ CAN I WEAR STOCKINGS WITH STRAPPY SANDALS? Try not to. But if you insist, make sure your toe polish is clear, the stockings are nude, and there are no visible seams or reinforcements.

SIMPLE SOLUTIONS

BLACK PATENT LEATHER PUMP

Black patent instantly says spring. It has shine. It has pizzazz. It screams, "I'm out of hibernation and I'm strutting my stuff." Okay, maybe black patent doesn't scream, but it speaks strongly of sunshine and warm days and Style with a capital S. Actually, it is not far removed from the patent leather Mary Janes you wore as a child. A patent pump can update a suit for spring, while a patent flat adds kick to your khakis and brightens up your black trousers.

SPRING IN YOUR WALK

Simple feminine lines. Think ballet slippers, rainbow colors, dinner parties, Capri pants, bare legs, Audrey Hepburn.

Silver shoes look great with pastel evening clothes. They're the next best thing to glass. Just ask Cinderella. Choose toe color with dress in mind.

> ❝ *If high heels were so wonderful, men would be wearing them.* ❞

SUE GRAFTON,
"I" Is for Innocent

The canvas sneaker: Sporty comfort when cheering on your favorite ball team, or shopping for their postgame refreshments.

Comfort shoes that work with pants and skirts alike. Coco Chanel introduced this color combination because she believed it flattered the foot.

DAY-TRIPPING

Spring is the season women naturally yearn for dresses. After heavy winter dressing, when suits and separates are the easiest method of dressing in layers, dresses speak to a need for simplicity and femininity. This is also the time of year that a dress and companion sweater are most valuable in the special-occasion wardrobe. Even with popular sleeveless and tank-style dresses, some type of cover-up may be required for comfort or appropriateness.

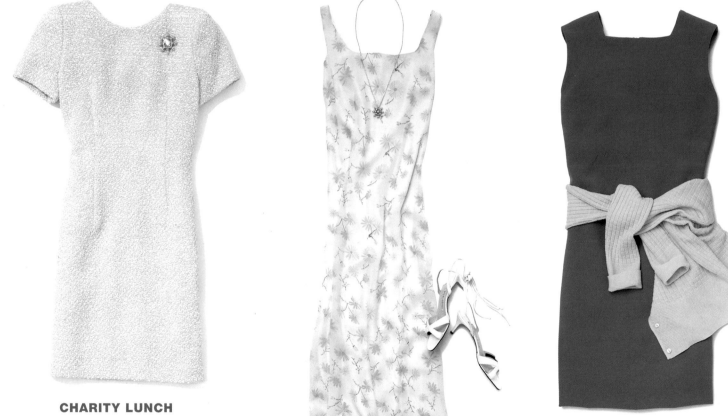

CHARITY LUNCH

A slightly fitted, quality dress with sleeves, grazing the knee and worn with classic accessories, is feminine yet doesn't detract from the occasion.

GRADUATION LUNCH

Long floral-print dresses are innocent by day and romantic at night. Their allure suits most body types, regardless of age.

BIRTHDAY LUNCH

A simple dress works when a suit feels too serious. A sweater wrap adds color—a casual warmth and touch.

If spiritual life seems beyond your grasp, wear Kazuko's one-of-a-kind "healing sculptures," believed by her fans (including Jeff and Kim) to be conducive to peace and well-being. This necklace and other personal "transmitters" are available exclusively from Barneys New York.

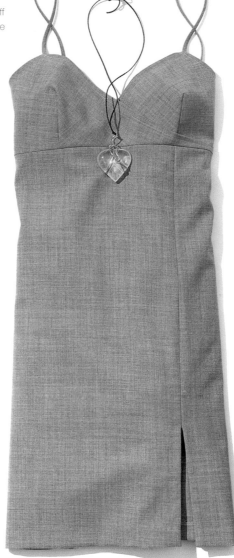

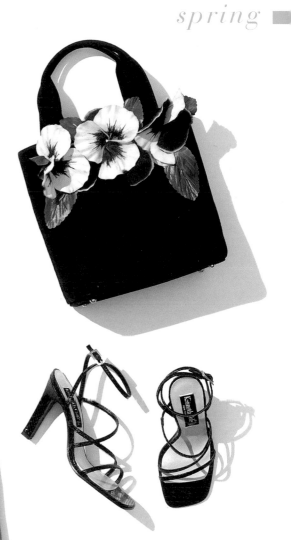

Going out after work? Dress things up by changing shoes and bag. Ankle straps are saucy, but avoid them if ankles aren't your strong point.

BUSINESS LUNCH TO DINNER DATE

One outfit—day to night. With a properly buttoned jacket, a bare dress becomes a dress suit and can go from a business meeting to cocktails after work. For this kind of versatility, the fabric should be neither day- nor evening-specific, and a neutral color is key.

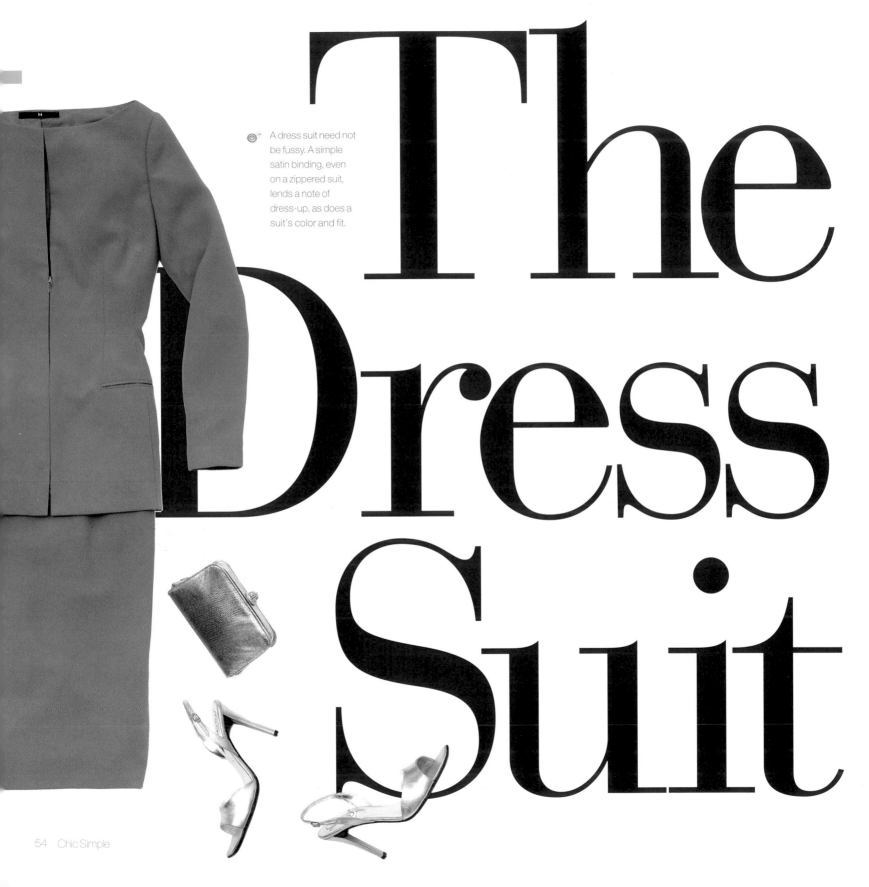

A dress suit need not be fussy. A simple satin binding, even on a zippered suit, lends a note of dress-up, as does a suit's color and fit.

The Dress Suit

Pearls are mysteriously organic: They must be worn to keep their luster and are damaged by perfume.

Excellent fakes are worth more than inferior cultured pearls.

SIMPLE SOLUTIONS

Perhaps it's spring fever, but many of us feel the urge to dress in a prettier, more feminine way at this time of year. While less practical than our more versatile everyday suit, the dress suit makes us feel that we're going to something special when we put it on. It may be a little more fitted, or worked in a fabric or texture that is a little too precious for the office or school board meeting. Perhaps the color is more festive than we're accustomed to, and the details—braiding, decorative buttons, embroidery—clearly show that this suit is not to be mixed with other wardrobe items. Each time the appropriate occasion arises, we look forward to pulling it out from that section of our closet designated for dress-up clothes only.

Pearls are the most sporting of gems, and the easiest to wear. They appear genteel when worn with a good wool suit, and quirky with black leather. Never seriously ostentatious, no matter how many strands are worn, they are favorites that never fall out of style.

INSPIRED

66 You can have on a brand-new suit, but if love is not in your heart, you are a dressed-up mess. 99

REV. KEVIN W. COSBY

Head coverings are required for women in Islamic mosques and in Orthodox Jewish synagogues, as is modest dress. Covered arms and hemlines that fall well below the knee are appropriate.

Passover— traditionally a time to wear something new.

As dress codes have relaxed at work, so they have become more casual at places of worship, even for special holidays. The notion of putting on our Sunday finest or Saturday best (depending on the religion) as a matter of respect has been challenged. More and more women are showing up at services wearing pants, as are men without jackets and ties. The assumption is that religion should be user-friendly, with focus more on worship than the caliber of dress. Others feel that dressing in such a casual manner is inappropriate.

What is right for you depends on your religious community, the event at your place of worship, and your inner feelings. If you are a member of a laid-back congregation, jeans or walking shorts might be acceptable. But if you feel awkward in casual clothes, try wearing your best slacks with a nice blouse. Fine details like a quality watch, polished leather shoes, or a little makeup may help you personally mark the experience as being a little more special. When we make an effort to dress for an occasion, it not only sets our inner mood but communicates respect to others.

CHURCH OR TEMPLE

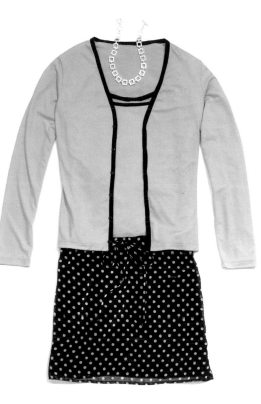

◎ Shoes are not permitted in Hindu and Islamic places of worship, so make sure your socks are in good shape.

◎ While dress codes seem to be getting more casual, traditional aspects of religion are gaining in popularity. In general, the more observant the group, the stricter the dress code.

◎ When Jackie Kennedy was in the White House, she set an example of churchgoing in casual dress with bare legs and arms, and a mantilla atop her head.

HOW TO **DRESS UP CASUALLY.** A sweater set or blazer; jewelry; lip color; good-quality shoes; a silk scarf around the neck; well-tailored slacks; a long, loose skirt; casual styles in quality fabrics. NO-NO'S: Noisy jewelry. Anything revealing—low-cut; slits; see-through; extremely short; bare shoul-ders and legs (except perhaps in summer). Prints and fabrics that are disrespectful in honoring God's creatures (animal prints, leather clothes).

Dress hats require confidence. Not only confidence that the hat is appropriate to the outfit and the occasion but confidence that you look and feel "right" in the hat. Properly worn, hats are the focal point of most ensembles (everyone knows the best reason to wear a hat is a bad hair day, and if you wear a red hat, no one looks at your hips).

The British still wear hats to Ascot for the horse races and to weddings and funerals, the bigger the better (the hats, that is). It is also customary among many African-Americans, especially in the South, to wear hats or ethnic turbans to church or for ceremonies—baptisms, graduations, weddings, and funerals. For most Americans hats have fallen out of favor, but for a big wedding, a garden party, or a christening, women may choose to wear a fancy hat. In Houston, a city heralded as the dressiest place in the world (some women routinely change clothes three times a day), hats make an appearance at River Oaks society luncheons in the early spring.

HAT OCCASIONS:

Weddings

Easter

Synagogue

Derby Day

Ascot

Garden party

Pool party

Adding a beautiful hat to a serious suit can create a romantic ensemble.

hats

 WHAT MAKES A HAT SPRINGY? Straw, pastel colors, springtime silk flowers, and faux fruit.

Strappy sandals, a small
bag, and a beaded top
can transform a quality
day suit into an evening
event.

Dress

Making the call on whether specific clothing
is appropriate for a special occasion can
make a woman feel like a major league
umpire. The fabric makes a suit safely
dressy, but would the pants make someone
call "foul"? The color says basic home run, but do your glittering accessories scream "evening game" loud enough?

Sometimes it's a very tough call. Pants, especially pantsuits, are now considered appropriate wear for more and

Pants

more types of occasions. Chalk it up to dress-down Fridays or our more active lifestyles and the desire to always feel comfortable. Yet there are still conservative areas of the country and affairs at which pants might be out of place. When in doubt, call ahead and ask your host or a trusted friend what the protocol is. If you're new in town, find out about local dress codes by contacting the fashion editor at the local newspaper or the fashion consultant at one of the finer department stores.

WHITE SHIRT

It's a backdrop that can handle anything. With black pants and pearls it's an all-time classic—a uniform stylish women depend on. Think Audrey Hepburn and Sharon Stone. But how do you choose the right white shirt for you? If you're starting to build a special-occasion wardrobe, pick one in a sturdy fabric. This garment will probably require more cleaning than any other. High-quality silk broadcloth and silk crepe are fine choices. Also, consider the fabric's weight. Four-ply silk can be too warm for summer wear. Silk shantung works for dressy-casual occasions during warm-weather months or after five. Cotton is another option, but look for quality, such as Sea Island. Avoid patch pockets, as they look casual and limit versatility.

SPRING
Brunch
Fair
Tennis match
Antiquing

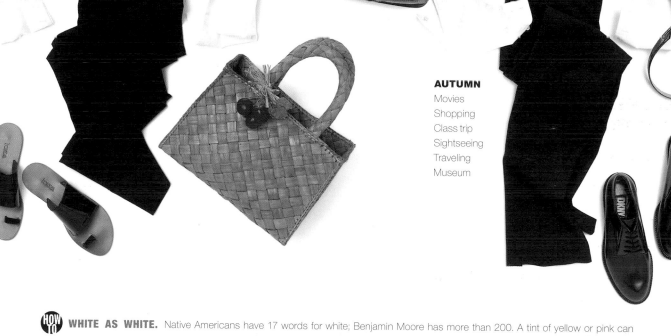

AUTUMN
Movies
Shopping
Class trip
Sightseeing
Traveling
Museum

HOW TO **WHITE AS WHITE.** Native Americans have 17 words for white; Benjamin Moore has more than 200. A tint of yellow or pink can soften the look of the shirt, while a hint of blue or gray can make it look starchier. If you own pearls, take them with you when choosing a white shirt. If they have a creamy tint, choose a white blouse or shirt with the same. Ultrawhite pearls tend to look best with a crisp white cotton shirt.

Matching tops and bottoms look sophisticated. Even casual styles such as sweatpants or a sweatshirt can be made more luxurious if the fiber is special, like cashmere. A slightly off-the-shoulder knit top is one of the most flattering necklines for all women, and somewhat sexy. Bold jewelry and silk flats dress up the simplest knits for a low-key evening of entertaining at home. Wearing knits when traveling helps you sidestep wrinkles. In a knit that's topped with a pashima shawl, quality shoes and bag, and a piece of fine jewelry, you'll look elegant and pulled together from airline check-in to hotel check-in.

Knits pack well, resist wrinkling, and are comfortable and extremely versatile, perfect when you're traveling.

Dressing monochromatically visually elongates the body. Darker colors make one appear slimmer.

Knits

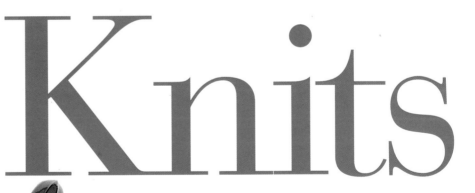

❝ *If you aren't enjoying your clothes, then you really are missing the point.* **❞**

BETTY HALBREICH WITH SALLY WADYKA,
Secrets of a Fashion Therapist

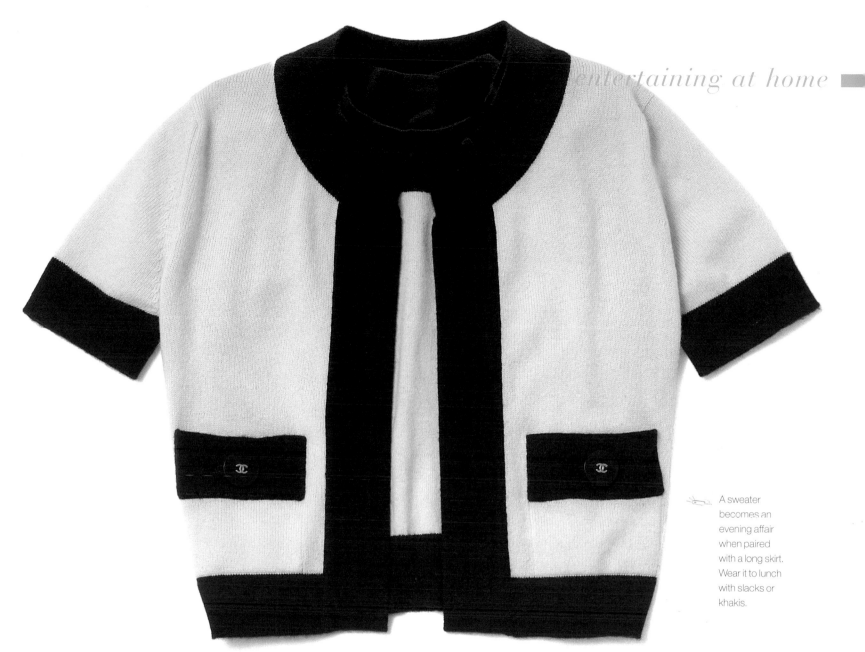

A sweater becomes an evening affair when paired with a long skirt. Wear it to lunch with slacks or khakis.

Once the province of casual wear, knits now fulfill many of our needs for dressing up. A black cashmere turtleneck for sophisticated cool. A colorful sweater set as a feminine alternative to the jacket. A silk knit T-shirt to dress up while dressing down. And roomy handknits to keep us warm. This is the beginning of a knit wardrobe, but the comfort of knits is also found in other wardrobe items such as pants, dresses, skirts, and jackets. Knits pack easily and move sensuously—two worthwhile considerations. Although the term "sweater" comes from the heavy blanket that horse trainers would throw over sweating thoroughbreds, the sweater, when draped over women like Grace Kelly, induced perspiration in a decidedly different population. They were popularized in the 19th century when worn by men for sports, and Coco Chanel later created sweaters for women, most notably the sweater set, and they have since become a basic in a woman's wardrobe.

S E A T T L E

T O S O H O

O ccasions arise when you need to punch up your pants profile. Even the most casual of bottoms can be spruced up when mated with more polished wardrobe favorites—a fine cotton shirt, a cashmere sweater, a tailored jacket. Now is also the time to put your accessories to work. With a few additions, you can transform plain pants into superpants. "Investment" accessories can strut: the quality of a pair of loafers, a special bag with staying power, or good gold or silver jewelry signal that your denim jeans and khakis are not to be taken lightly. And your choice of belt can whisper elegance or sing out in joy. But remember, whatever its pitch, all eyes are listening.

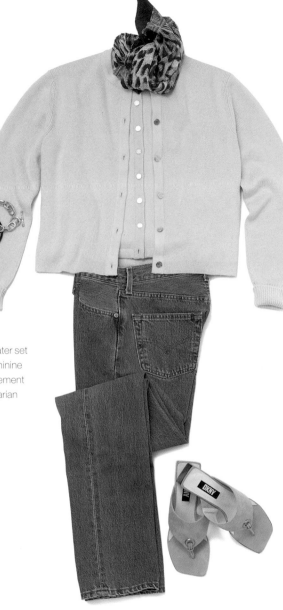

A sweater set is a feminine complement to utilitarian jeans.

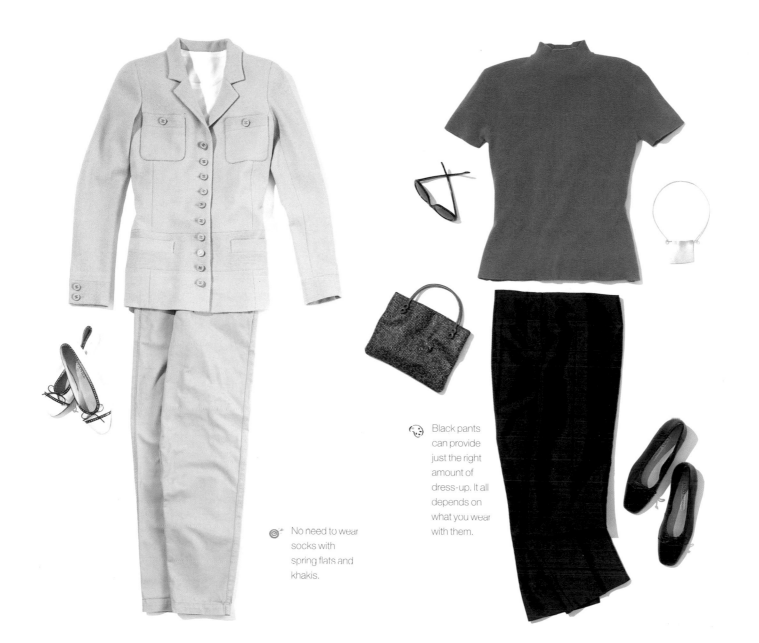

No need to wear socks with spring flats and khakis.

Black pants can provide just the right amount of dress-up. It all depends on what you wear with them.

MUSEUM DATE

Why not dress up your khakis? Feminine shoes and a tailored jacket in a soft color offset khaki's military heritage.

LUNCH DATE

Dress up simple shapes with luxury fabrics or dramatic design—a cashmere T-shirt, bold silver jewelry, leather flats, are wardrobe basics.

FANCY

e ve r

For most of us there aren't many reasons to get very dressed up, unless we're invited to a black-tie wedding. But for women involved with charitable fundraising, these occasions are fairly routine. For them, each season usually calls for at least one big evening of dinner, dancing, jewelry, fabulous dresses, and considerable donations. A dress-up wardrobe is as necessary to these women as sneakers are to a runner. These are events that are often featured in local papers and magazines, and what you wear may determine whether your presence will be immortalized in print. Unless you're very clever about transforming dresses you've worn to other events, you're more apt to buy statement dresses. These are unforgettable and will give editors ample copy to write, and admirers much to think about.

n i n g

If the need to pull out all the wardrobe stops is less frequent, invest in the best black dress you can afford. As the occasion calls for, put your accessories, including hair and makeup, to work. Short dresses are more versatile than long, although you may want one of each. The barer the dressier, but a matching cover-up will be helpful for less formal events. Fabric and detailing also determine degrees of dressiness. Beading on chiffon is fabulous, but has less opportunity to change with the mood than a silk crepe.

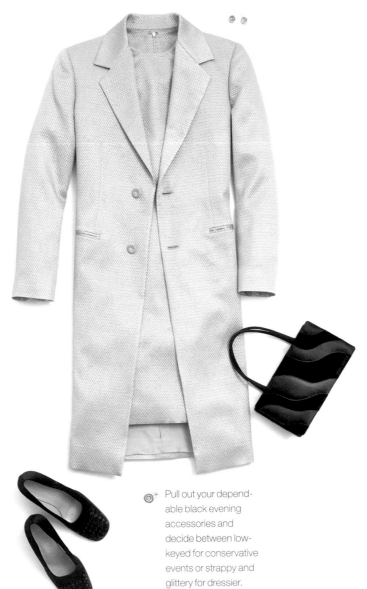

◎ In a dressy fabric like silk, pants become festive enough to wear instead of a cocktail dress.

◎ Pull out your dependable black evening accessories and decide between low-keyed for conservative events or strappy and glittery for dressier.

A short dress with matching coat can be versatile, but in a dressy fabric, like silk lamé, it is restricted to special late afternoon and evening occasions.

Evening pajamas with an alluring top can be formal with the right accessories. Ruffles around the neck frame the face. Enjoy color.

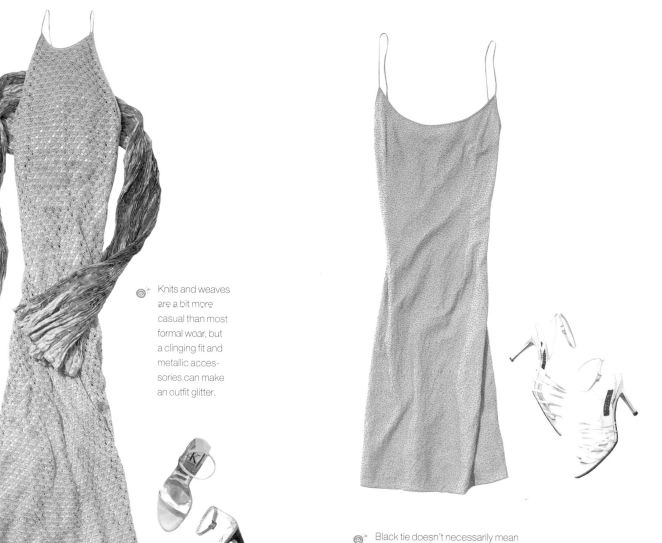

Knits and weaves
are a bit more
casual than most
formal wear, but
a clinging fit and
metallic acces-
sories can make
an outfit glitter.

A small fabric bag
is always dressy.

Black tie doesn't necessarily mean
"long dress." Beading on silk chiffon
jazzes up a short, strappy one.

Metallic weaves are fun for special evenings.
Simple accessories showcase the dress. A wrap
adds drama and offers shelter for bare shoulders.

If you've got it, flaunt it—in a charming short
slip dress. Charming because of the pastel color,
sexy because it looks like...well, your slip.

PUDDLE JUMPER

Planning ahead for rainy days means more than investing in stocks and bonds. It means having the proper gear to stay dry and protect your finest. And because rain-gear items are wardrobe basics, not only do they need to work with the clothes they cover, but you should enjoy wearing them. Raincoats can be practical, yet versatile. The trench coat is a classic, and a zip-in lining will get you through chilling showers or sunshowers. Black is dressier than khaki, and cotton is more casual than nylon or silk. Reversible raincoats offer possibilities—a contrasting pattern or bright color for pizzazz. Microfiber coats are light and easy to pack. They keep the wind and rain out, and warmth in. A long rain-proofed silk coat can double as an evening wrap.

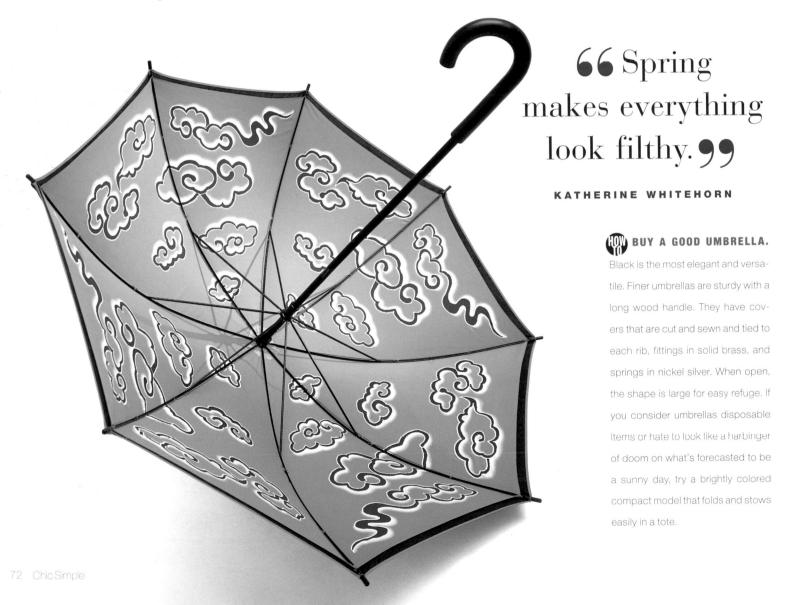

66 Spring makes everything look filthy. **99**

KATHERINE WHITEHORN

HOW TO BUY A GOOD UMBRELLA.

Black is the most elegant and versatile. Finer umbrellas are sturdy with a long wood handle. They have covers that are cut and sewn and tied to each rib, fittings in solid brass, and springs in nickel silver. When open, the shape is large for easy refuge. If you consider umbrellas disposable items or hate to look like a harbinger of doom on what's forecasted to be a sunny day, try a brightly colored compact model that folds and stows easily in a tote.

Nonrubberized rain-coats usually require re-waterproofing after being cleaned. Alert your dry cleaner.

Rain boots can be necessary to your wardrobe, but some-times will not do. When the weather misbehaves, consider wearing your old dress shoes to get to the event and then chang-ing into your good shoes when you arrive.

Consider tucking your business card into the pocket of your raincoat and inside the inner band of your rain hat. When the sun comes out, these items often turn up in the lost and found.

FRESH CUT

As we reawaken our wardrobes in spring, we also need to take a look at our beauty routines. Start with a facial, sloughing off dead cells, declogging pores, and purifying your skin so that you begin the season with a fresh face. Then try a few quick spring pick-me-ups—new makeup colors, a spring haircut, and a change in fragrance. Watch for gift-with-purchase offers from your favorite cosmetics company, or experiment with a new brand. Companies usually offer new colors each season, whether lipstick, eye shadow, or blush. Or visit the makeup counter for a free makeover. Many makeup artists schedule lessons for their clients in spring. And while they generally charge, learning to use new products and techniques and the assurance that you have chosen the best colors for your skin tone and hair may be worth the cost.

Next, rid yourself of the winter hair blahs. This generally means a shorter haircut, and perhaps adding some highlights. For a new style altogether, clip photographs from beauty magazines before you visit your hairdresser, or find a stylist you trust and give him or her free rein. Don't fear: Hair will always grow back.

Your final touch of spring might be a new fragrance. Floral scents are especially popular this time of year; the names of their essences are often the same as those flowers now in bloom—rose, lily, gardenia, lilac, freesia.

> **" *The sudden desire to look beautiful made her straighten her back. Beautiful? For whom? Why, for myself, of course.* "**
>
> **COLETTE**

SMELL LIKE SPRING. Flowers possess nature's most complex scents in terms of chemistry, and they elicit the strongest emotional response. They are flirtatious or cheerful or deeply intoxicating to the point of provocation. Whereas nature designed the scents of greens and wood to repel predators, it designed floral scents to entice pollinators. White flowers are usually the most fragrant. They are the heart and soul of perfumery.

NOT LOOK STUCK IN TIME. Sometimes we cling to the past. We've been there, it's familiar, and we know we once looked great in liquid eyeliner or frosted lipstick...didn't we? Sticking with makeup simply because it's what you've worn since you were prom queen is not a good idea. Each age should be a celebration of who you are today, not a memorial to who you were back then. Your face, your hair, your body—they're all different now, and you need to adjust the way you care for them, and enhance them. But you're not the only one who's evolved. Makeup has, too. The homespun potions of antiquity have paved the way for foundations that protect us from the sun, mascaras that condition and lengthen our lashes, and lipsticks that moisturize while adding color. Makeup accommodates our sensitivities, our breakouts, our contact lenses, and our age. There's a better chance of finding the perfect makup now than ever before. Just read the labels and experiment.

SUMMER *The perception: Ice cream colors...bright safari khakis...ethnic finds...sexy bikinis...country simplicity...*

SUMMER *The reality: Mosquito nets...silk saunas... skin...tourist-trap clothing and accessories...garish greens...*

chapter four

❝ The softness of the summer day [was]

Just after the last spring rain or, in the Rocky Mountains, the last spring blizzard, the planet seems to slow on its axis, a peculiar shift that one can feel all the way to the center of one's being, and suddenly a warm, languid craving for all that is sensual overwhelms one. Food is never so fresh, bare skin grows warm and smooth, afternoon naps become carefree escapes, and at night everyone shines and sparkles. The livin' is easy, and so are your clothes. Sink your teeth into a peach.

prints...ethereal whites...nature-lover greens...Out of Africa cool as a cucumber...romantic firefly evenings...net and silk. frying eggs on the sidewalk...Bikini Atoll...Deepest Africa safari circus prints...limp linens...country bumpkin...nothing to wear.

mer

like an ermine paw. 99 ANAÏS NIN,

The Diary of Anaïs Nin, vol. 2

66 I should like to enjoy this summer flower by flower, as if it were to be the last one for me. 99

ANDRÉ GIDE, *Journal*

SUMMER BASICS

- ❑ Capri pants
- ❑ carryall bag
- ❑ cotton sweater
- ❑ cotton T-shirt
- ❑ evening wrap
- ❑ hoop earrings
- ❑ sandals
- ❑ sundress
- ❑ sunglasses
- ❑ sun hat
- ❑ swimsuit and cover-up
- ❑ white cotton shorts

DRESS

HOW TO FRESHEN UP YOUR JEWELRY.

Pull out your colorful beads, plastics, bold hoops, and cuffs. If you are running low, raid the juniors department for fun, inexpensive summer jewelry and bags. Play with scale, go big, or add multiples—keep it fun.

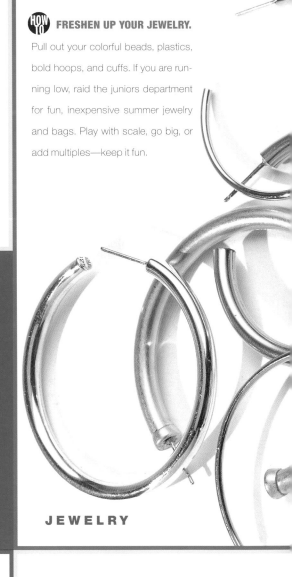

JEWELRY

SURVEY & ASSESS

JUNE Examine your bathing suit and cover-up for fit and condition. Is your beach tote clean? Are your rubber sandals still sturdy? Have your white linen garments turned yellow? Visit the dry-cleaner and tailor before the heat hits and catches you with nothing clean and fresh to wear.

AUGUST Check your closet for lightweight clothes in dark colors that will help you through hot days after Labor Day. Try on autumn clothing for fit. Decide what key pieces you want to invest in to update your fall wardrobe.

shopping your closet

SUMMER

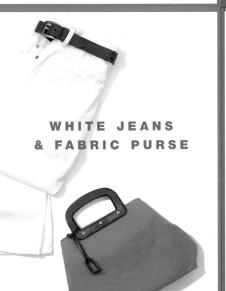

WHITE JEANS & FABRIC PURSE

FIRST AID

Bring out any white, light, linen, and cotton clothing and check for spots or tears. If white items are washable and fairly sturdy, hang or spread them in the sun for a few hours of natural bleaching.

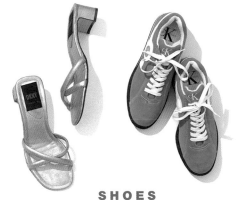

SHOES

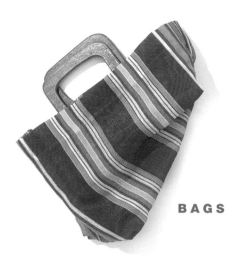

BAGS

> **66** One of
> my mottos is flaunt
> what you've got
> left. **99**

CYBILL SHEPHERD

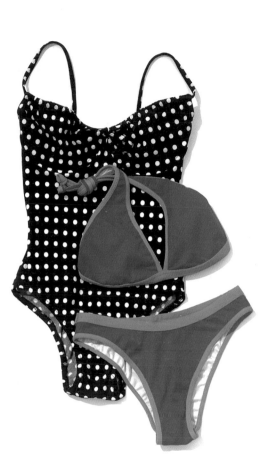

BATHING SUITS

faQ CAN I CONTINUE TO CARRY
MY BLACK LEATHER BAG IN
SUMMER?
Of course, although it looks
very serious and somber.
Otherwise, you would do best
to change to black nylon,
canvas, or woven straw, or
to a lighter neutral color.

faQ NOW CAN I STOP
WEARING STOCKINGS?
Surprisingly, women
in the East go without
stockings more in sum-
mer than women in the
South and Southeast,
where it is still often
considered a breach of
etiquette in the dressiest
situations. No one should
wear stockings with
bare, strappy sandals.

Black looks great
with a tan during
the summer months,
if the fabric is light-
weight, like linen.

SUMMER OCCASIONS

Fourth of July... Debutante

Cotillion... Bastille Day... Father's

Day... Graduations... Barbecues...

Beach parties... Fish fries...

Afternoon teas... Baby showers...

Family reunions... Clambakes...

When you think of summer color, think of sherbet, mangoes, and the candy-colored houses of the tropics. The vibrant tones of summer sparkle in sunlight. They make us smile, whether we wear hot pink to show off a tan or a pool-blue suit to cool ourselves off in the heat of July. If you are color-shy, spread it around in your wardrobe. Top a black swimsuit with a bright-yellow cover-up. Ditch that beige purse for a little something in lime green. Spice up Memorial Day with orange, the Fourth of July with red, white, and blue—and gold stars. Color also extends to hats and shoes. Let fuchsia canvas espadrilles perk up a white sundress. When summer is at its hottest, switch to no-color white or frosty colors—cool pinks, blues, lavenders, and greens with a little sheen or shine. Also, wearing a sundress or sleeveless sheath of black or brown can highlight healthy skin and look terribly sophisticated in the city, even when you feel as though you are melting.

elements of style

 IS IT SAFE TO WASH MY BEST
SUMMER FABRICS IF THE CARE
LABELS SAY IT IS?
Proceed with caution. Fabrics
such as piqué, rayon, and acetate
tend to shrink when washed,
but many cottons, silks, and
washable linens behave well in
water. Start with cold water and
a gentle cycle, or hand-wash.
Hang or lay flat to dry.

LINEN

SHANTUNG

COTTON PIQUÉ

SILK

NYLON

STRAW

POPLIN

SEERSUCKER

SPANDEX

CANVAS

COOL & BREEZY

Summer can mean: sweaty, soiled, sticky, stifling, suffocating, stuffy, sweltering...and the word in fabrics is survival. You want something that comfortably floats against your skin. Cool and breezy is how your clothes should feel, even if it's only in your head.

Perfect for summer's dressy events (and an "s" word), shantung takes its name from Shantung province in China. Shantung's wonder lies in the fact that it takes dye well and maintains a perfect pants crease. But it also wrinkles; for wrinkle resistance, look for shantung that is a blend of fibers. For that most important event—a wedding or formal party—nothing says summer-special more than pure silk.

Linen was long maligned because it wrinkles so easily. Times have changed, and with the rise in today's more casual dressing and the continued interest in natural fabrics, there is much more acceptability in a "softly rumpled" appearance. Linen, like cotton, breathes, allowing your body heat to travel freely through the fabric and not lie trapped beneath your clothes. The finer the weave, the lighter the fabric. Washable linens even have tags that caution against dry cleaning.

Cotton piqué is a doubly woven fabric; it is usually ribbed or woven in a tiny honeycomb pattern called waffle piqué. Bird's-eye piqué has a diamond pattern with a center dot. The texture of piqué adds importance to a natural fiber. All of these fabrics, whether shantung, silk, piqué or linen, have a *hand* to them, a texture that adds a richness.

A pale pastel dress looks best with accessories in a complementary tone.

A closed-back pump is more conservative, yet the T-strap and high heel are flirtatious.

C A S U A L

F R I D A Y

DRESS DOWN AT THE OFFICE. It's summertime and the living is easier, especially when it comes to what we wear. Many businesses get in the spirit by allowing for dress-down Fridays between Memorial Day and Labor Day. But what exactly does corporate casual mean? And how can one continue to look professional? Turns out the usual rules of grooming, fit, quality, and appropriateness apply, but now the emphasis is on comfort. Casual Friday staples include sweater sets, flat shoes, pants, and long, flowing skirts. A tailored jacket can be counted on to provide instant respectability when worn over more casual clothes—handy for unexpected client meetings. As always, it pays to buy clothes you can wear several ways—khakis work with either a blazer or a crisp shirt. As an executive, you may feel uncomfortable going casual, but you won't want to alienate yourself from the rest of the staff. Try wearing suits in casual fabrics like cotton, paired with relaxed accessories like flat shoes and T-shirts. Or coordinate casual clothes, such as a sundress or khakis, with quality accessories.

Your choice of jewelry can be more creative on casual Fridays, but if people start picking up the beat when you walk by, perhaps your jewelry is too noisy.

> " Never offend people with style when you can offend them with substance. "

TONY BROWN

◎ A summer dress can work in the office if not too sheer or clingy. If somewhat bare, wear it under a sweater or jacket.

R E A L
A U T H O R I T Y

HOW TO DRESS APPROPRIATELY. Think of yourself as a business presentation. Would you take seriously—no matter how sober its contents—a report covered in floral motifs, tied together with pink silk ribbons? The same consideration should go into what you wear. Your clothes are part of your personal presentation. Ask yourself: What are you selling to whom? Sometimes wearing a suit in business is as alienating as conducting a meeting with your board of directors while decked out in beach attire. Dress codes vary. To determine what's right for you, take a good look at your office's corporate culture—ad agencies, for example, will differ from banks. Next, consider your role: Are you in sales, or behind a computer all day; the boss, or an assistant? Finally, what's your day like: Are you making a presentation or schmoozing with clients after work? When in doubt, look at someone in the office whose style you admire and check out her choices. Generally, if you have to ask whether an outfit passes muster, the answer is probably no.

◎ To bare or not to bare? Be sure your office dress code sanctions bare legs and sandals. Then check that your legs are clean-shaven and toes are groomed.

sole exposure

In warm weather, with clothing options pared to the bare minimum, shoes are perhaps our most valuable style assets. Our choice of shoes more than any other element determines whether we appear dressed up or dressed down. Low-cut canvas tennies, for example, make a cotton shift perfect for grocery shopping, but a pair of strappy, high-heeled sandals can take the same dress to an important luncheon. And with a pair of floral slippers or metallic sandals, why not a dance at the country club?

Manolo Blahnik doesn't have customers, he has acolytes. Since opening his first shoe boutique in London in 1973, Blahnik has made his name in fantasy and fetish. He is adamant about quality: His production process includes 100 phases and he aims for perfection.

MULES: Although the exact birth date of the mule is lost to history, it originated as footwear for the boudoir, worn by the most fashionable women and the most famous courtesans. In the twentieth century, mules became the silent signal in movies that the wearer was on the make—adorned with bits of fluff perched upon satin, and associated with scenes of seduction. Now mules are considered chic party shoes and are available in myriad colors, fabrics, and heights. An acclaimed style duet when paired with Capri pants, they help simple clothes appear festive, perfect for at-home entertaining. Yes, they're still sexy, possibly because of the recklessness of their open backs. Their intimate nature restricts them to gatherings with friends. Don't wear them to the office, a job interview (unless it's at a nightclub), a funeral, or on a visit to your banker. Wear them only when you want to shout, I am woman.

SIMPLE SOLUTIONS

'Travelin'

A softly tailored jacket in khaki is relaxed enough to wear with the most casual of clothes, while it dresses them up a bit.

CASUAL FRIDAY

Frescoes reveal that one-shoulder garments were popular among ancient Egyptians. The look was revived in the fashion world by Madame Grès in the 1930s and Halston in the 1970s. A one-shoulder bathing suit evokes Tarzan and Jane—a look that is both primitive and sexy. Revealing, yet controlled. Take note: You will draw attention to your upper arms and shoulders.

SATURDAY

HOW TO **PACK LIGHT.** Simplicity. Comfort. Adventure. Relaxation. Characteristics of summer we hope to extend to what we pack for weekend getaways. The goal is to pack light, bringing just enough to deal with the expected and unexpected. First, write down events you anticipate—golf outing, clambake, nature hike. Pull out clothes to fulfill these needs. Begin with a versatile piece of clothing. It might be a colorful jacket or a print dress. Use the predominant color as the basis for other items you choose. The simpler the style, the more ways you can wear it. Fabrics should be lightweight. Clothes that require the minimum of care are preferable: Linen wrinkles, cotton Lycra doesn't. Use accessories to vary mood. Try on everything. Nothing is worse than getting away and discovering that more than your horizons have expanded since last summer.

light

Floral patterns look especially good on summer dresses. In browns and beiges, the feminine design will look more sophisticated.

Summer accessories are often colorful and playful in pattern and design. A vintage cigarette case is a chic way to hold money and keys.

SATURDAY NIGHT

The ease of a long, bare summer dress allows you to wear it day or night.

SUNDAY

TRAVEL LIGHT. When you travel, what you wear getting there is as important as what you wear after you arrive. When en route, a jacket is key to pulling your look together. You will appear stylish and not overly casual. The jacket will continue to serve you throughout the weekend. With long shorts or pants to match, it dresses things up—rather like a casual summer day suit (also suitable for casual Fridays in the office). Draped over a strappy summer dress, it keeps you warm on breezy summer nights. A bathing suit is usually a must, but needs some sort of cover-up. Try wrapping a large cotton scarf around the waist to wear for a walk on the beach, or wear your swimsuit comfortably with drawstring pants and make a splash at a pool party. And, of course, shorts with a simple top is everyday weekend wear.

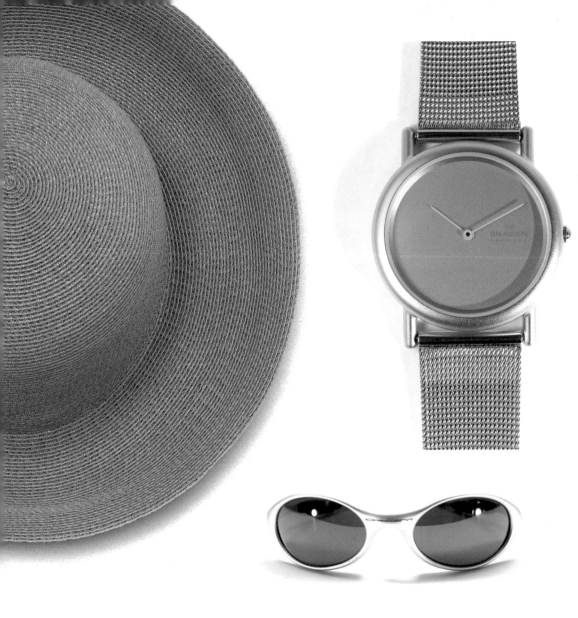

- ❏ **Inexpensive water-resistant watch**
- ❏ **Sun hat**
- ❏ **Funky-chunky jewelry**
- ❏ **Sandals**
- ❏ **Sandals for bathing-suit occasions**
- ❏ **Colorful ballet slippers or mules for casual parties**
- ❏ **Strappy sandals—high for night, low for day**
- ❏ **Leather pumps for more proper occasions**
- ❏ **Sunglasses**
- ❏ **Big plastic earrings**
- ❏ **Plastic, papier maché, glass beads**
- ❏ **Bold cuffs, collars, pendants**
- ❏ **Tote in canvas, straw, or nylon**
- ❏ **Small colorful handbag**
- ❏ **Decorative hair clips**
- ❏ **Sundress**
- ❏ **Great bathing suit with cover-up**
- ❏ **White pants and shorts**
- ❏ **Colorful tops**

One of the best parts about summer dress-up is not feeling forced to blow the budget on expensive accessories. And because the fun accessories move in and out of style as rapidly as afternoon thunderstorms move across the sky, it is best not to invest too heavily. Pick a sturdy straw bag that is neither too sporty nor too dressy and a colorfast tote bag that resists water and sand. Look for ethnic or bright beads in glass or plastic.

S U R V I V A L K I T

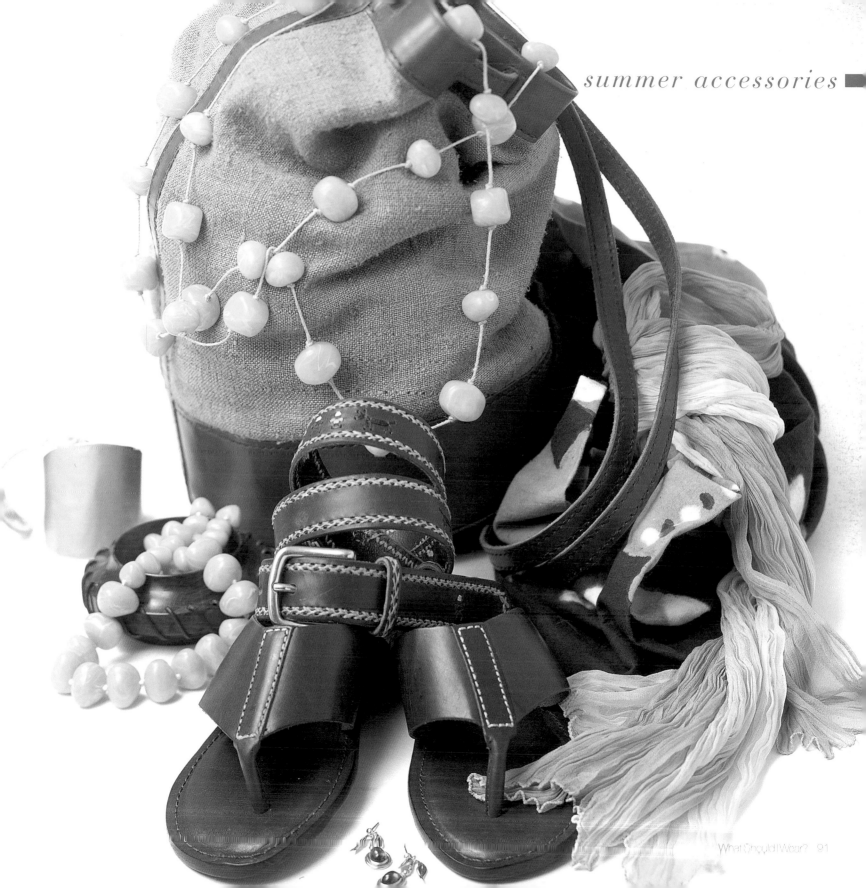

SPLISH SPLASH

To dress up for a pool party, wear a great pair of sandals or mules, fun earrings or plastic bangles, a dramatic sun hat and a colorful bag. Give yourself a manicure and pedicure, and although you may not wear full makup, a little lip color can look terrific.

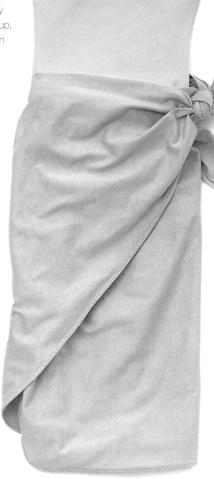

From the moment Dorothy Lamour kept house for Bob Hope and Bing Crosby on a South Sea island in the 1940 film *Road to Singapore* wearing a sarong, this sultry way of dressing was adopted by American women. Today it is seen at suburban poolsides or on city streets, yet it always makes one think of toes in the sand and palm trees.

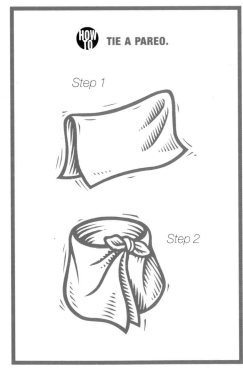

HOW TO TIE A PAREO.

Step 1

Step 2

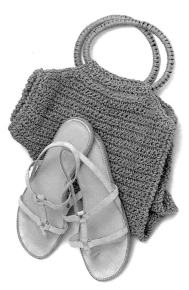

P O O L P A R T I E S

LIQUID DRESSING

Lounging around a pool in style requires more than wearing a great-looking bathing suit; it requires a great looking cover-up. Besides, most women feel more comfortable popping out of a pool and into a cover-up—tying on a pareo instead of donning a beach jacket. The pareo is a long rectangle of fabric that originated in Polynesia, where natives were encouraged by missionaries to cover their nakedness. Back then women tied pareos around their chests, letting them fall to their knees or below. Today we generally use pareos as skirts over swimsuits. Or toss on a sundress—much more charming than a muumuu.

C L A M B A K E S

SUN STROKE

Smoothing on sunblock should become a part of your everyday beauty routine, especially in summer. To save time, try one of the products that include color and function as both foundation and sunblock. Smooth lotion or cream away from the center of your face, upward on your forehead, outward on your cheeks, chin, and neck. And remember the backs of your hands, ultra-sunsensitive areas. Today it is possible, with chemical peels and cosmetic surgery, to remove blemishes, wrinkles, and age spots from the face, but a woman's age still shows in her hands.

B E A C H B I N G O

DINGHY TO ROOFTOP

WHITE PANTS

In each season one piece of clothing stands out as a shortcut to style. In summer, we choose white pants. Not super-model paint-ons that restrict movement or constrict our last meal, but easy-fitting pants in fabrics that range from crisp piqué to denim, silk shantung, or cotton with stretch. They may have elastic waists or

SIMPLE SOLUTIONS

neat bands, flat fronts or pleats, narrow or roomy legs. Only two things are for sure: They can take you nearly anywhere, and they will show dirt—both good reasons to have two pairs instead of only one.

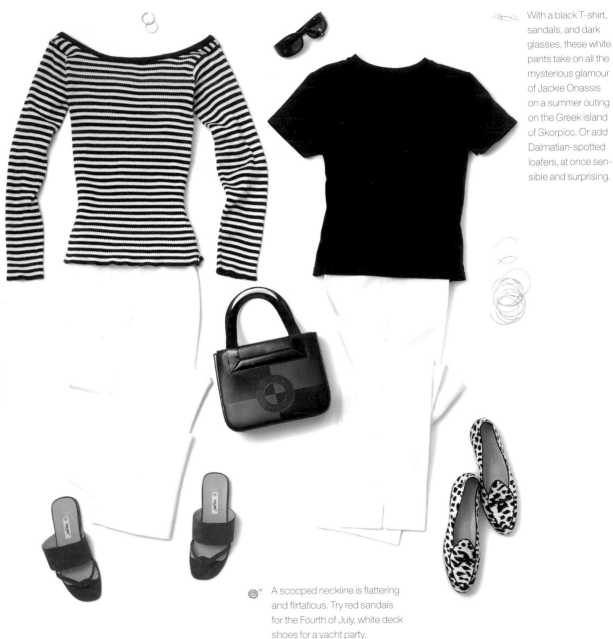

With a black T-shirt, sandals, and dark glasses, these white pants take on all the mysterious glamour of Jackie Onassis on a summer outing on the Greek island of Skorpios. Or add Dalmatian-spotted loafers, at once sensible and surprising.

A scooped neckline is flattering and flirtatious. Try red sandals for the Fourth of July, white deck shoes for a yacht party.

YACHT TO PENTHOUSE

A simple tank top is a little dressier when worked up in a metallic knit. More metallic accessories add festive detail.

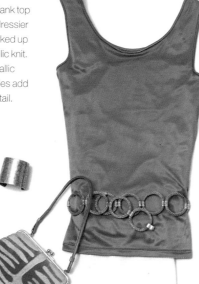

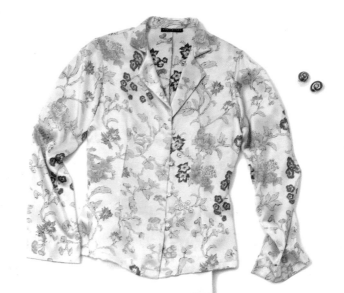

Summer is a time when what we wear can be a bit more playful, especially if it's party time. A decorative bag is an easy way to add some punch.

A floral silk blouse is an elegant summer favorite that can also be worn open as a jacket over a tank top.

SMOKIN'

The mood is relaxed and upbeat. Guests hope to kick off their shoes and listen to the sounds of Marvin Gaye while drinking a chilled margarita around the Weber grill. Even our fine china takes a break from the dining table unless it's part of a colorful, eclectic mix. And foods are succulent—often fresh from a local garden. And there's nothing like corn on the cob or wrestling with a steamed lobster to cut through any airs of formality. Entertaining Rule #1: Be relaxed. If you're not, then your guests won't be. Plan well, and prepare as much as possible in advance. If ever there was a time when people don't mind watching you cook, it's the summer, but keep it to a minimum—around the grill only. Otherwise it can get too hot. Rule #2: Keep it simple. This goes for food, clothing, and the table.

Nothing too elaborate, but everything attractive. Rule #3: Dress for a party. Part of entertaining is creating a fun atmosphere by looking more special than you do during the rest of your everyday life—especially your work life. Entertaining should not look or feel like work. If you're the host, feel free to dress a little extra special. After all, it is your job to set the mood. Whether it is a buffet birthday dinner indoors or a backyard barbecue, there are a few basics that will give your wardrobe the oomph that makes it festive. Tops: Halter, tank, off the shoulder. Pants: Capri, palazzo, bright colors, patterns, white jeans. Fabrics: Silk shantung, cotton with stretch, linen. Shoes: Mules, strappy sandals, color, pattern. Jewelry: Big hoop earrings, colorful beads and bangles, fun faux, bold. Dress: Long, florals. Wrap: A large scarf or a sweater over bare shoulders.

SOUNDTRACKS

- **Marvin Gaye—*What's Going On***
- **Astrud Gilberto— *Beach Samba***
- **Blossom Dearie—*Once Upon a Summertime***
- **Barry White—*Can't Get Enough***
- **Al Green—*Call Me***
- **Connie Francis— *Souvenirs***
- **The Drifters—*Rockin' & Driftin'***
- **Nina Simone—*I Put a Spell on You***
- **Various Artists— *1959–64 Ska's the Limit*, vol. 1**

The kettle-shaped charcoal-burning barbecue grill, first designed by George Stephen in 1951 as a result of his frustration with the inadequacies of conventional barbecue grills, soon became an American backyard icon. Since then, Weber-Stephen Products Co. has expanded its backyard calling to include gas grills, which prompts the sometimes heated debate among backyard chefs as to which means of grilling is preferable. Convenience or taste? Weber-Stephen remains committed to satisfying both.

> ❝ *Summer afternoon . . .*
> *the two most beautiful words in*
> *the English language.* ❞

HENRY JAMES

SOUP
Summer Borscht*

SALAD
Arugula Salad with Mango and Blue Cheese*

MAIN COURSE
Grilled Steak with Bourbon, Balsamic Vinegar, and Fresh Ginger Marinade*

- 3 tablespoons bourbon
- 2 tablespoons light brown sugar
- 3 tablespoons balsamic vinegar
- 2 tablespoons fresh gingerroot, finely chopped
- 1/2 teaspoon black pepper

1. Mix ingredients, add 2-pound steak, and refrigerate overnight.

Grilled Corn with Cayenne Butter*

- 1/4 pound unsalted butter
- 1-2 tablespoons cayenne pepper
- juice of 2 limes
- 8 ears corn, husked
- salt

1. Melt the butter over low heat in a small saucepan.
2. Add the cayenne and lime juice and mix well.
3. Brush the butter on the corn and place on grill.
4. Baste and turn occasionally until corn is cooked, about 12 minutes.
5. Salt to taste.

Roasted Mixed Vegetables*

- 1 large red onion, sliced, or 4 shallots
- 1 red bell pepper, sliced
- 1 yellow squash, sliced
- 1 zucchini sliced diagonally, if desired
- 2 cups cherry tomatoes
- 4-8 cloves garlic, unpeeled
- 1 teaspoon dried thyme, basil, or rosemary
- 1/4-1/2 teaspoon kosher salt
- 1/4 teaspoon black pepper
- 1 tablespoon olive oil
- 2 tablespoons balsamic vinegar

1. Preheat oven to 400° F.
2. Put all ingredients, except for the balsamic vinegar, together in a baking pan and bake for about 1 hour.
3. When finished cooking, remove vegetables from the oven and place in a serving dish. Sprinkle with balsamic vinegar.

DESSERT
Peach Blueberry Crunch*
Vanilla Ice Cream
Iced Coffee

SUMMER DRINKS
Margaritas, South Sides
Sangria
White Wine Spritzers

SPARKLING WINES
Prosecco
Bonnie Doone Vin Glacier

*RECIPE IN *CHIC SIMPLE: COOKING*

DANCING, ROMANCING

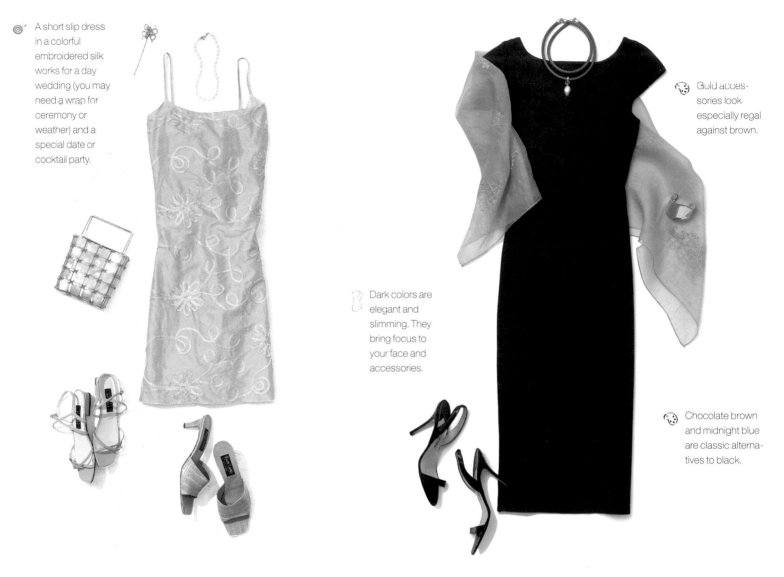

A short slip dress in a colorful embroidered silk works for a day wedding (you may need a wrap for ceremony or weather) and a special date or cocktail party.

Dark colors are elegant and slimming. They bring focus to your face and accessories.

Gold accessories look especially regal against brown.

Chocolate brown and midnight blue are classic alternatives to black.

Pick an embroidered slip dress and add touches of metallic accessories for cocktail parties, museum benefits, and festive birthday celebrations.

A longer dress looks sleek and elegant. Accessories shine against the dark tone, determining where this dress will go—dinner, a concert, or the ballet.

PALM SPRINGS, THE HAMPTONS

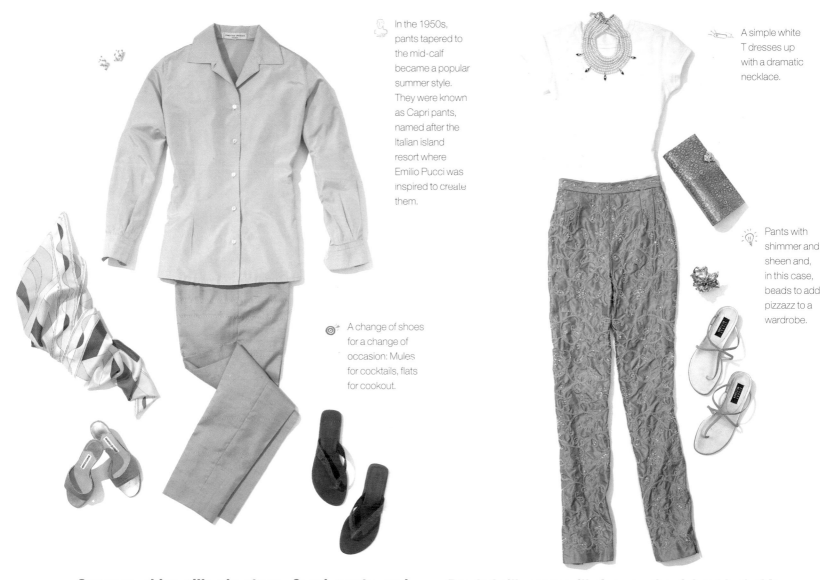

In the 1950s, pants tapered to the mid-calf became a popular summer style. They were known as Capri pants, named after the Italian island resort where Emilio Pucci was inspired to create them.

A simple white T dresses up with a dramatic necklace.

A change of shoes for a change of occasion: Mules for cocktails, flats for cookout.

Pants with shimmer and sheen and, in this case, beads to add pizzazz to a wardrobe.

Summer chic: silk shantung Capri pants and blouse untucked, all in blues brilliant in summer light perked up by a sunny patterned silk scarf.

Beaded silk pants will give you the richest look this side of an Eastern harem, even when accessorized with a cotton T-shirt and simple thong sandals.

If you cannot find a slip to match your skin tone, consider having one made, or try dyeing a white one. But with so many sheer dresses on the market, even petite and plus-size slips are now available in specialty clothing stores and catalogs.

S H E E R

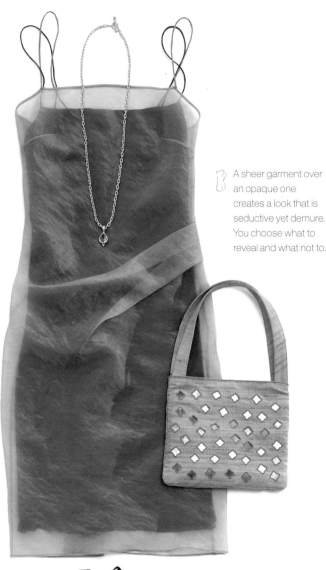

A sheer garment over an opaque one creates a look that is seductive yet demure. You choose what to reveal and what not to.

Alluring, shifting layers of seduction, will-o'-the-wisp teasing glimpses of being stark **NAKED! HELP!** What has happened to fashion that no matter our age or physique we are supposed to play the emperor's new clothes in a crowd of strangers? Though the magazines and runways seem to think nothing of making your tan lines the new fashion accessory, women since Salome have been utilizing the mystery and intrigue of sheerness. The challenge is to learn to handle sheerness discreetly. Proper undergarments are, of course, one way of doing that. A wispy bodysuit, an opaque chiffon slip, a lovely lace brassiere that is only glimpsed through a sheer blouse, not put boldly on view. There is an intriguing sexiness that is achieved with the use of nude "illusion" linings. Under lace, chiffon, organza, and devore velvet, little slips or camisoles of chiffon that closely match your skin, attached to the dress or loose, are the insurance you need to relax and enjoy the evening in a tantalizing outfit. Sometimes chiffon skirts are worn with longer jackets that cover well past the hips, in which case the woman must decide whether her legs are in shape to handle the sheerness. How sheer is too sheer? The rule of thumb is, the more formal the affair the more appropriate that the translucent become transparent. And if you do dress to have your high beams blazing, just don't be dismayed at all the dumb-struck bucks transfixed. Of course, that could be the intention.

Layering one diaphanous color over another creates a shimmering quality.

66 Maybe the naked truth is glorious,
but I like a bit of chiffon here and there. **99**

ELSIE JANIS

A wrap can
be flirtatious
as it moves
with your
every gesture.

W R A P P I N G

Fresh &

In summer, a time when we literally strip down for action, our makeup, fragrance, and grooming become integral accessories. Lipsticks, nail polishes, blushers, and eye shadows are part of our color schemes. When we wear white or black, our cosmetics may provide the only real color beyond our skin tones. And speaking of color: We must avoid coloring our hair if we spend lots of time in the sun or in chlorine. Wear a sun hat, and if you frequent a swimming pool, stock up on a chlorine-removing shampoo (a color-safe one if you color your hair) and conditioner.

HOW TO HAVE HAPPY FEET. In hot-weather months, there's no hiding your gams. Start the summer with a manicure and pedicure. When you choose a polish, buy a bottle for touch-ups. These months, when you are likely to be gardening and walking a lot, are hardest on your hands, feet, and nails. A pumice stone will remove calluses from your feet and heels, which sandals and mules show off. Defuzz legs and the crotch area by shaving, using a depilatory, or waxing. Apply moisturizer to combat the drying effects of summer heat, chlorine, and salt water. If your legs are very pale or not smooth in appearance, consider using a self-tanner. Before using it, exfoliate your skin. Wash hands immediately after using to keep your palms from absorbing stain.

HOW TO SMELL BETTER THAN BUG SPRAY. In summer, we seek lighter scents. Citrusy mandarin, lime, or grapefruit may be sprayed on strategically to mix with the earthy scent of freshly cut grass, moss, and ferns. These choice fragrances characterize what we like best about summer—the deliciously down-to-earth, carefree scents of nature. Spray colognes are fun to spritz on throughout the day, as they are less heavy than full-strength perfumes. Fragrance will not, however, cover a whiff of sweat, so now is the best time to check the efficiency of your deodorant or antiperspirant. And many of today's natural bug repellents have herbal and citrus fragrances of their own, so if you are planning on being outdoors in a buggy area, take time to seek out a repellent you enjoy smelling.

Clean

> **❝** The two basic items necessary to sustain life are sunshine and coconut milk. **❞**

DUSTIN HOFFMAN, *Midnight Cowboy*

HOW TO **FAKE IT.** When we were an agrarian society, having a tan was a sign of being a common laborer. During the Industrial Revolution, a tan betrayed membership in the leisure class. Now that we are in the information age, only those who lack knowledge still bake in the sun. But many of us still crave the sun and the glow it casts. Liquid tanners, cream bronzers, tinted moisturizers, bronzing sticks, and powders are just some of the ways you can fake it good.

Citrus perfume appeals to extroverts.

HOW TO **PAINT A SUMMER FACE.** First apply sunblock, even on cloudy days. Then lightly dust a bronzing powder all over your face with a large, soft brush. It is the easiest way to look sun-kissed because as powder it is light and can be applied over foundation if needed. When choosing the right color for your skin tone, stay with warm browns, not red-mahogany tones, and look for sheer textures. A little more can be used on the cheeks, nose, forehead, and chin— those areas where the sun usually tans or burns first. You may want to try a soft, shimmery brown shadow applied to lids. A little black mascara will give definition. In the summer, lips look great when they're coated with a generous topping of tinted gloss. Warm, pink-brown tones create a natural look.

66 October is the fallen
a wider horizon more

autu

— chapter five

The moment of change, after the languor of
those forgotten afternoons. The pace quick-
ens—there's a sense of being alive, as if the
generations before us who raced against the
end of autumn to get the harvest done are
still in each of us. Somewhere a voice inside
whispers: "Hurry, hurry, before the winter
comes," and we do, getting children ready
for school. And work steps into high gear,
and the air smells of smoke and excitement.

leaf, but is also clearly seen. **99**

HAL BORLAND

66 *Autumn...*
makes a double demand.
It asks that we prepare
for the future...
But it also asks that
we learn to let go—
to acknowledge
the beauty of spareness. **99**

BONARO W. OVERSTREET,
"Mists and Mellow Fruitfulness"

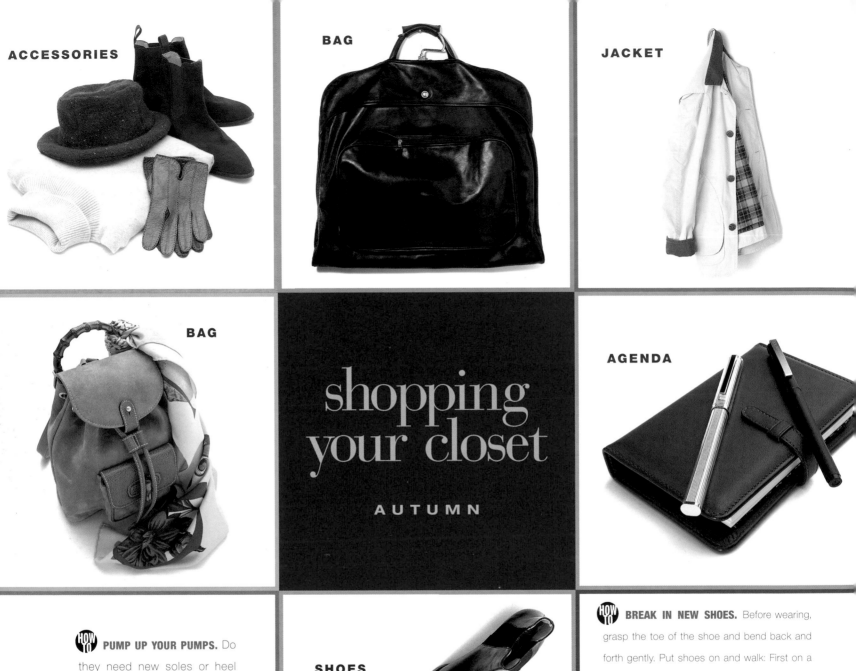

ACCESSORIES

BAG

JACKET

BAG

shopping your closet

AUTUMN

AGENDA

SHOES

HOW TO **PUMP UP YOUR PUMPS.** Do they need new soles or heel caps? Polishing? Do the edges of the soles need reblacking? If they are only scuffed or soiled or have stitching coming loose, perhaps your shoe repair shop can work wonders.

HOW TO **BREAK IN NEW SHOES.** Before wearing, grasp the toe of the shoe and bend back and forth gently. Put shoes on and walk: First on a rug, then on a harder surface. Always wear stockings or socks when breaking in shoes. If they still feel snug, ask your shoe repairman to stretch them. Or dip stockings or lightweight socks in a half-alcohol, half-water solution, squeeze them out, put them on, and wear the shoes until the socks are dry. This is harder on the lining of the shoes than a regular break-in but it's effective.

JEWELRY

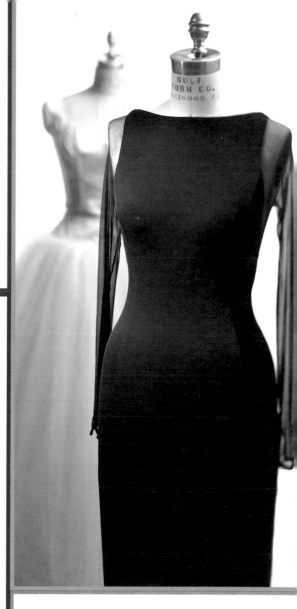

AUTUMN BASICS

- ❏ **long-sleeved T-shirts**
- ❏ **turtleneck**
- ❏ **sweaters**
- ❏ **wool slacks**
- ❏ **jacket**
- ❏ **leather bag**
- ❏ **leather boots**
- ❏ **wool suit**
- ❏ **cocktail dress**

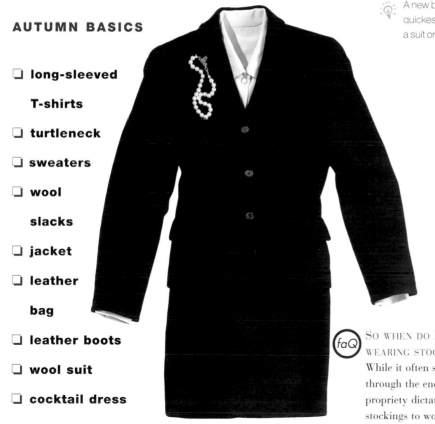

A new belt is one of the quickest ways to update a suit or pantsuit.

(faQ) SO WHEN DO I HAVE TO BEGIN WEARING STOCKINGS AGAIN? While it often stays warm through the end of October, propriety dictates that you wear stockings to work or for dressy events immediately after Labor Day—unless you are wearing strappy evening sandals. Weekends can be more casual,

AUTUMN OCCASIONS

Labor Day... Back to work... State fairs... Back to school... Tailgate parties... Harvest time... School meetings... Dining out... Art openings... Cocktail parties... Dinner parties... Business conferences... Halloween... Theater... Yom Kippur... Thanksgiving...

> **❝** I've never known anyone yet who doesn't suffer a certain restlessness when autumn rolls around...We're all eight years old again and anything is possible. **❞**

SUE GRAFTON, "Long Gone"

A U T U M N C O L O R

When the sun hangs lower in the sky and casts longer shadows, the rich colors of nature intensify. The bright summer melody of our wardrobe looks out of harmony with nature's new tune. And if we're not paying attention we won't be prepared for a sudden nip in the air, when we need to reach for our warmer coverings. But even in places that remain warm throughout the fall months, the sartorial code to pack away our summer fancies remains true. On cue, our eye is ready for a deeper color palette. We now reach for the earthy tones of wine reds, forest and moss greens, cadet blues,

pumpkin, rust, and aubergine. It's when the multicolor hues of tweeds echo nature itself. These are the colors of harvest time, of the foods and drinks we think of when days grow shorter and the sun turns afternoons into gold. Yet it is impossible not to be drawn back to neutrals in autumn: The versatility of black, brown, and gray will make it easier to dress for busy fall schedules and mean less drain on the pocketbook. But we can warm up these basics with blouses, sweaters, and jackets in earthy shades. Adding metallic bronze and copper—in fabrics, leather, or jewelry—will cast a rich glow for night, as metallics add light wherever they are used.

In cold weather, turtlenecks become a wardrobe must. In addition to warmth, they always provide a clean line when worn under an open-collared coat.

Originally created for sailors, the peacoat became everyday wear in the 1920s, thanks to Coco Chanel. Today it can be found in fabrics as luxurious as cashmere and in a variety of colors.

Simplify life by color-coordinating accessories. Brown is more casual than black.

autumn texture and fabric

L A Y E R S O F M E A N I N G

A classic black leather jacket has attitude without being intimidating.

> **"Toughness doesn't have to come in a pin-stripe suit."**

DIANNE FEINSTEIN

The great thing about suits is being able to wear the pieces in a variety of ways. Just remember to have pieces cleaned together or they'll age differently.

Pack away your straw tote and bring out the leather.

Fabrics are the most wonderful part of fall. After the heat of summer, when your body wants to reject all clothing, you look forward to putting on substantial garments again. There are lots more choices for dressing up, from the basics of smooth gabardines to nubby woolens and knits. The key is being smart about layering—learn to juxtapose texture—with smooth silks played against wiry wools or cashmere against leather. Start with wool blends and work your way to all-wool as the season cools down. Add silk blouses and sweaters until the thermometer dips below freezing, then pull out the wool, cashmere, angora, and mohair. What blended fabrics and knits do is help you pull off the transition from Indian summer to cold weather.

AS THE WORLD TURNS

There is a fickle period of time between the seasons during which we need our outfits to handle the sometimes tumultuous transitions of the weather. For those unprepared, the cool mornings of autumn followed by the hot afternoons of Indian summer will wilt what may otherwise seem like the perfect autumn wardrobe. Lightweight seasonless fabrics in dark colors are wardrobe staples you can (and will want to) wear year-round.

You may be surprised to learn that the very best seasonless fabric is wool. Super 100s—a tightly woven fine wool that bounces back from all kinds of routine abuse—is thin enough to wear on the hottest summer days, yet remains a favorite when temperatures drop. Similarly, Tasmanian wool, from an island in the Pacific Ocean south of Australia known for its devils—now-extinct little burrowing carnivorous marsupials—is also renowned for being fine and lightweight. If you think of wool as hot and itchy, you don't know these wools. They breathe, resist wrinkles, take dye beautifully, and retain their shape. You can sleep on a 10-hour flight in a pair of Tasmanian-wool trousers and walk into your hotel looking neat as a pin. Naturally, in the heat of September and early October, loosely tailored garments in these wools will be your best friends. There is a price for this amazing versatility, but it may be worth it for clothes that you never want to pack away.

Layering garments of silk, cotton, and wool, and mixing these with Lycra spandex and rayon, crepe-textured wool, or lightweight knits, will also get you through transitional times of year in unrumpled style.

> **66** *Fall is my favorite season in Los Angeles, watching the birds change color and fall from the trees...* **99**
>
> **DAVID LETTERMAN**

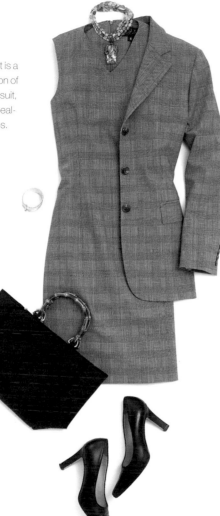

A dress with matching coat is a dressier version of the traditional suit, but offers appealing possibilities.

In conservative businesses, a pantsuit may be something women can wear only on casual Friday. It not only offers comfort but can also be professional-looking when well tailored in a fine men's suiting fabric, like this glen plaid wool gabardine.

faQ **WHAT TO WEAR IF WEATHER IS UNSEASONABLY HOT?**
Don't revert back to your sundresses and shorts. Rather, wear clothes in lighter fabrics that still adhere to fall colors, like a long black rayon skirt and a lightweight sweater set. Or consider layering a sleeveless top under a lightweight suit jacket.

faQ **I AM GOING ON A BUSINESS TRIP TO THE SOUTH. THE TEMPERATURE IS IN THE 80S. CAN I STILL WEAR MY SUMMER CLOTHES?**
Only if you want to look like a tourist. The well-traveled know how local residents change their wardrobe colors each season. Fabrics remain lightweight, but colors get darker and more autumnal. Summer whites and other distinctly summer garments like colorful floral sundresses and piqué suits are packed away.

CHEEKY AND BRIGHT EYE

After paring your summer makeup and hair-care routines to the minimum, it's often difficult to get up to speed when it comes time for more serious makeup in autumn. It helps if you gather the tools and products you need daily together in a tray or basket to review. And if you spend many evenings out, do the same with your evening cosmetics. Gently clean your brushes with shampoo and warm water. Rinse well and smooth hairs into place, then let air-dry. With the earthy and darker colors of fall clothing, you will probably want makeup in more subdued colors than you wore in summer. Lipsticks and blushes in burgundy, red, and brown shades coordinate well with shadows in the brown and gold families. If you have a tan, wait until it fades before adjusting the color of your foundation.

When the swimming season has ended, remember to make an appointment with your hairdresser to check the condition of your hair and have a shape-up cut. This is a good time to discuss ideas for hair color and to make sure your hairstyle is one you can manage on your own in the busy days ahead. Have your stylist show you some ways to dress up your hair for evening.

If the soft citrusy fragrances of summer feel too light, try some denser, richer, and exotic scents. They are heady, warm, and sophisticated, which complement the heavier clothing of the fall and winter seasons.

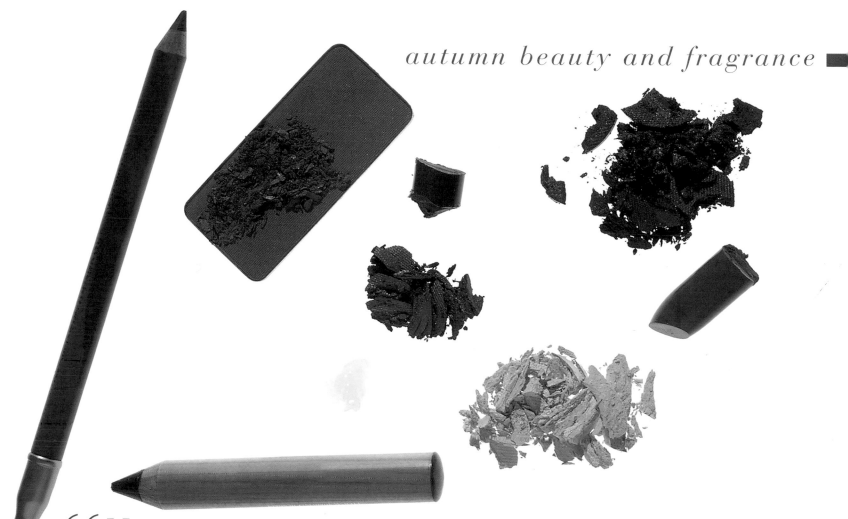

> 66 No spring, nor summer beauty hath such grace,
> As I have seen in one autumnal face. 99

JOHN DONNE, "The Autumnal"

FACE A.M. TO P.M. Fall is the time of year when we find ourselves running from one kind of event to another. Knowing how to freshen up and dress up your makeup for evenings on the run can be helpful. It may be handy to have smaller versions of your makeup and tools in a travel bag. 1. Wipe off surface powder and dull-looking makeup with a moist cotton pad. 2. Use a wide, flat foundation brush to apply foundation where needed. Blend lightly with a dry latex wedge. 3. Brush on loose powder all over. 4. Apply blush to the apples of your cheeks. 5. Use a latex wedge to clean up eye makeup, and press loose powder in the area around your eyes and nose. 6. Define the outer corners of the lid at the base of the lashes, using a soft lining pencil. Fade out edges and smudge the pencil line inward with your finger or a sponge-tip applicator. 7. Apply a neutral, shimmery shadow over the pencil. 8. Recurl lashes. 9. Add a coat of mascara. 10. Apply lip color and top with gloss for evening shine.

SEPTEMBER ... OCTOBER ...

Wearing a women's suit in a men's suiting fabric may seem like we are trying hard to dress like men. Yet pairing it with a matching dress is distinctly feminine.

The wrap dress was made famous by designer Diane Von Furstenberg 20 years ago, and was recently reintroduced to a new generation of admirers who delight in its colorful signature prints and flattering silhouette. The wrap helps to define the waist and bustline.

Accessorizing patterns is easy. Just pick a color and match it.

There is something about putting on a dress that makes a woman feel special. Whether she wears a dress to a luncheon, a shower, or a dinner, she often feels more feminine and sometimes even sexy. But by far the best thing about putting on a dress is that it's so easy. No jackets, blouses, or sweaters to coordinate. A solid-color dress or a quiet, simple pattern allows for more transformations with a change of accessories than a dress covered with a decorative pattern. Remember that large patterns will make you look larger—think floral Hindenburg—so approach with caution. Animal prints add a certain sly fun, and traditional men's suiting patterns can go to the office and other sober events. A dress captures a moment, so make it memorable.

... NOVEMBER ... DECEMBER

A coatdress is a tailored alternative to the suit for business. A white silk shirt feels good against the skin and frames the face. Remove the shirt and add a necklace to dress things up.

Boots are integral to a cool weather wardrobe. The higher the heels, the dressier.

A sumptuous tweed dress with a body-hugging cut combines luxury and sportiness and is all female. A good choice for a charity lunch.

66 A woman's dress should be like a barbed-wire fence: serving its purpose without obstructing the view. **99**

A LIFETIME OF OUTFITS

THE HEIRLOOM BAG
The Gucci bamboo-handled bag has endured as an emblem of chic for generations.

ROYALTY
It became a recognizable status symbol when photographed frequently on the arm of Princess Diana. A boxy bag with a short handle, it is often quilted and always dangles metallic letters that spell out the Dior name.

66 In fashion it's good not to have too many principles. 99

INÈS DE LA FRESSANGE

THE KELLY BAG
A cosmopolitan bag from Hermès, named for Grace Kelly. A detachable strap allows this truly elegant tote to do double-duty as a shoulder bag.

DESIGNER EMBLEM
The Vuitton bag, a direct descendant of luggage that was once carried only in first class, remains a touring status symbol.

ONE GREAT BAG

Relaxed. Functional. Carries work stuff and perhaps a change of clothes. Leather is heavier, but wears better than nylon.

What you wear with your dress clothes is as important as the actual clothing. Your choice of shoes and bag can determine overall style, while decoding a mission. (And no, your bag and shoes don't have to match in color, just in attitude.) Is your bag a hand-held jeweled minaudière that can compete with the best of jewelry? Or is it large and sturdy enough to transport your office essentials? Is it the finest of leather and a recognizable design, an investment that signals to sales clerks to be all the more solicitous? Or a throwaway trend meant only to last through one season? A bag can simply pull an outfit together, or destroy it. A carefully chosen tote, handbag, and evening purse can see you through a lifetime of outfits.

The yin and yang of a successful wardrobe. It's the fun of mixing opposing elements—a sober suit with a dazzling top. Day to night in a flash.

Light, dark, and medium gray come to life with silver, crystal, or diamond accessories.

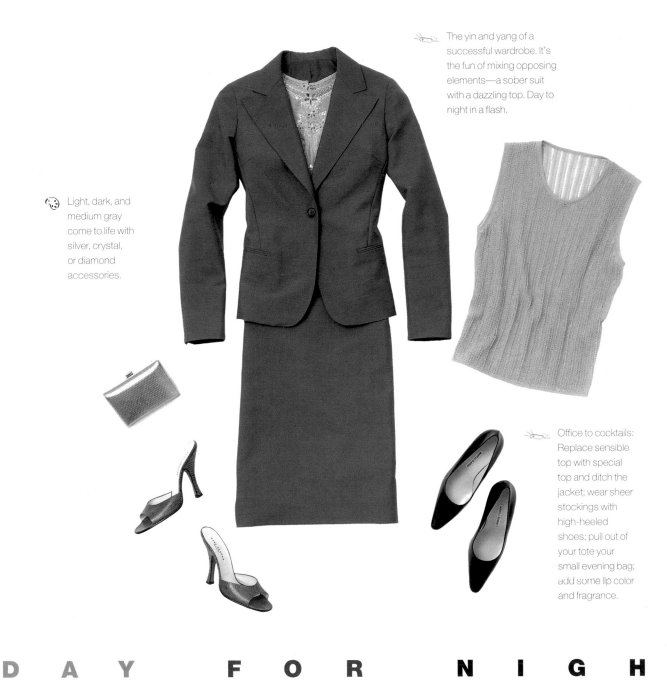

Office to cocktails: Replace sensible top with special top and ditch the jacket; wear sheer stockings with high-heeled shoes; pull out of your tote your small evening bag; add some lip color and fragrance.

DAY FOR NIGHT

A sweater set in a silk knit or cashmere can carry you through most day-to-evening functions looking feminine and pulled together.

American designer Bill Blass has perfected the art of American sportswear with evening ensembles that combine sweater sets with beaded skirts or full-blown taffeta ball skirts—winning combinations for cocktail and birthday parties, rehearsal dinners, and holiday celebrations.

In the autumn, perhaps more than any other time of year, a woman needs functional clothes to take her through work, meetings, presentations, and—without a trip home—on to cocktails, dinner, or the theater. Even women who do not work at a career outside the home are often busy organizing benefits, volunteering, or attending school or social functions that leave them too busy to change. It's smart to have clothes that work as hard as you do. Versatile clothing is the key. A suit, for example, takes to a glittering Lurex sweater top for an evening at the theater. Exchange pumps and daytime handbag for mules and an evening bag and—voilà! A charming sweater set can make the jump from pantsuit—perfect by day—to topping off a sequined skirt by night. Exchange flat shoes for pumps and add jeweled earrings. Let rich fabrics like silk, satin, or cashmere signal a special time. The way you pull it together is what personal style is all about.

Autumn is the most dangerous shoe season of all. Shoes made for fall's tweeds, good suits, velvets, and little black dresses are the shoes of dreams—dreams with high heels. Before you indulge, however, plan a shoe wardrobe for your special occasions. Every woman probably needs a pair of good black pumps, an evening shoe, and a pair or two of flat shoes—well-made loafers for day, velvet slippers for evenings at home. Remember, too, there is such a thing as an overly sexy shoe. Showing toe cleavage, unlike showing breast cleavage, is a matter of lowering a shoe's vamp—in essence, its neckline—only 1/16th of an inch. Showing toe cleavage in a conservative office or at a funeral is considered bad taste. No matter what your wardrobe color scheme, the black leather pump remains a wardrobe basic. Its advantage is that it looks businesslike as well as elegant. Heel shape determines longevity: It's the fashion element that can date a shoe. The color black serves as an understated note in whatever you choose to wear above. A simple pair is worth the extra cost. With the right care, your black leather pumps will walk you through a variety of occasions with a well-turned ankle, an elongated leg, and added inches.

A black fabric like satin or silk dresses up the classic stiletto.

A well-polished leather pump with a sensible heel can combine comfort with professionalism and style.

dressy shoes

GOOD BLACK PUMPS

You can tell a gentleman by his shoes, and you can tell a lady by her good black pumps. She can wear them night or day, rain or shine, for dress or everyday. They are her power shoes. If she didn't pay too much for them, she may not have paid enough. The best shoes are worth the price because you can wear them more. You are paying for quality materials and con-

SIMPLE SOLUTIONS

struction. They probably go with half the dresses and suits in your wardrobe. For that reason, consider investing in black crocodile or alligator pumps. They are made to last—and they are, simply put, something very special.

Velvet slippers are a great way to make your casual clothes appear more festive when entertaining at home.

> 66 *She came into the bar of the Ritz wearing a knee-length tweed skirt, a twinset, and moccasins—and in a time when everyone else was tarted up in Dior's New Look, she stopped traffic.* 99
>
> **BILL BLASS,**
> **describing C. Z. Guest**
> **in Paris in the '50s**

If your legs are thin, a stretch wool knit is not only comfortable but flattering.

A cashmere sweater in an animal print is the kick that every wardrobe needs.

Lux

A little luxury, to mis-paraphrase Diana Vreeland, is like paprika—it adds a sensual spice to your wardrobe. But luxury is very personal—a cashmere sweater, a perfectly fitted suit, a pair of buttery-soft leather pants, an afternoon nap, a Saturday to oneself—all of these can qualify. Luxury falls into different categories: a beautiful fountain pen, an Italian sports car, the appreciation of beautiful handiwork, a great painting, an over-the-top beaded dress. Whatever it is, luxury is highly subjective, since only you know your own sinful pleasures.

Savvy shoppers recognize the luxury of vintage clothing. Much vintage fashion is better made than the off-the-rack clothes available today. Often haute-couture clothes bought at auction are bargains compared to the original price. Look for jewel-trimmed sweaters, a satin evening coat, crocodile handbags, outrageous costume jewelry, decorative buttons, and extravagant evening dresses. Great finds are hand-embroidered and finely beaded tops. Avoid furs, which tend not to age well, and check for stains and moth holes. Caution: A little vintage goes a long way. Mix with your more contemporary clothes.

The beauty of vintage shops is discovering quality clothes that are unique for a fraction of the cost of a comparable new item. These pieces might not be basics, but they add enormous style to one's wardrobe.

u r y . . .

LUXURIOUS...

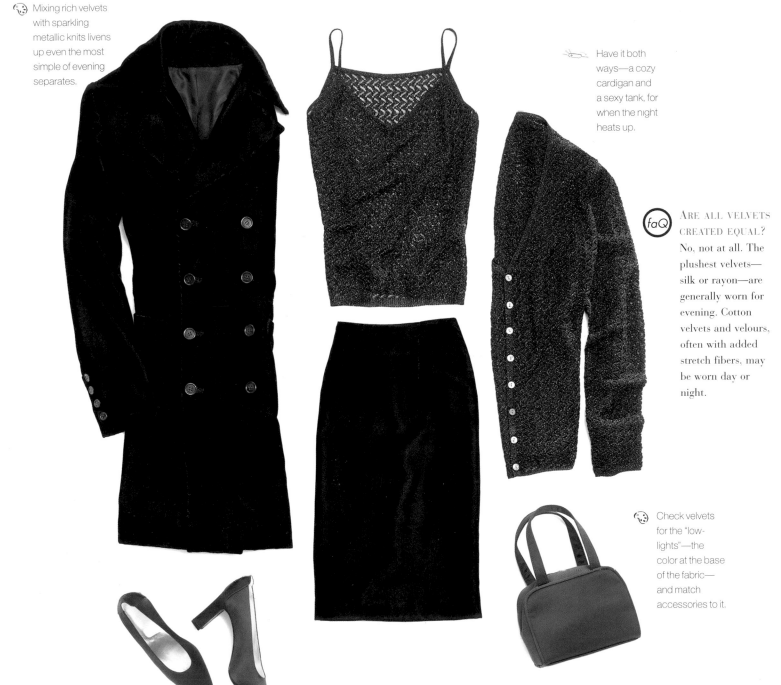

Mixing rich velvets with sparkling metallic knits livens up even the most simple of evening separates.

Have it both ways—a cozy cardigan and a sexy tank, for when the night heats up.

faQ ARE ALL VELVETS CREATED EQUAL? No, not at all. The plushest velvets— silk or rayon—are generally worn for evening. Cotton velvets and velours, often with added stretch fibers, may be worn day or night.

Check velvets for the "low-lights"—the color at the base of the fabric— and match accessories to it.

Luxury is a cashmere sweater.
Luxurious is a cashmere T-shirt.
Sinful is cashmere socks.

A luxurious indulgence doesn't negate the effort one puts into building a practical wardrobe. An evening suit or a classic hacking jacket in velvet or a sweater and pants of cashmere, another luxury fabric with a thick, soft pile, can be a valuable asset. The feel of these fabrics (and the cost) is a luxury but their wide spectrum of wearability helps make them worthwhile additions to your closet. Velvet and cashmere are equally at home paired with silk or denim.

The interesting deepness of its nap enables a velvet suit to take the strong colors of a print silk scarf or the softness of a white or ivory fringed silk scarf. For dressing down, velvet makes an elegant marriage with wool, cashmere, and gabardine. Play off the different-textured leathers of gloves, boots, and bag to add a more casual feel. Again the versatility—the ability to wear this outfit in myriad ways—makes it a worthwhile investment, and its sensual embrace will make you feel well dressed no matter where you are.

A velvet blazer can become a winter wardrobe essential looking great over casual knit pants, or a short satin slipdress.

Python is the skin of choice for garments with a fashion edge. It is supple and smooth, and has a sheen of elegance when worn over all black.

"The wilderness has a fashion code as rigid as the chicest neighborhood in New York."

CLAUDIA SHEAR,
Blown Sideways Through Life

Stripes can brighten up a wardrobe. For the very thin, thick knits and bold horizontals will give you more shape.

The safari jacket was worked in cotton for big-game hunters who needed a coat durable enough to survive the bush, but lightweight enough to endure the heat. In suede, it's a remake of a classic that can withstand the adventure of any week-end. With pants to match, it heightens the sense of occasion.

Suede has long been the choice for cool-weather jackets. It can be tough and rugged (ask any cowboy) or soft and sensual, adding a luxuriousness to casual dressing.

Leather pants are now as essential as jeans for many young women. The softness of leather makes the pants comfortable and versatile. Wearing them with a wool turtleneck and boots, you can trek urban streets in style. With a silk shirt and velvet slippers, these pants could be worn to Thanksgiving dinner.

Fall essentials: Leather boots. Don't get caught in the cold weather without them.

I n these politically correct times, what you wear can be considered sinful from a blatant sense of forbidden luxury or even morally reprehensible, depending on whom you are talking to or walking in front of. This is the fur debate, and the right or wrong of it is firmly within the province of "your call." But the appeal of warm shearling or the suppleness of soft leather is undebatably a sensual delight. What were once considered luxury items—suede, leather, and reptile skins—have become sportswear basics in many women's wardrobes. Crocodiles and alligators, once on the endangered species list, are now farm-raised. Fine crocodile belts, bags, or shoes can last a life-time, qualifying them as wardrobe investments. As with most classics, the simpler the lines, the more timeless the appeal.

BACK TO EARTH

The classic black blazer is a wardrobe anchor. Worn over khakis or a bare black dress, it has the range to work with most of the clothes in your wardrobe. Its shape gives the body definition, which makes it important to choose a cut that looks great on and is comfortable to move in. It's worth repeating that a style with simple lines will be more versatile. And because you will be reach-

SIMPLE SOLUTIONS

ing for this garment probably more than any other, make sure the quality is the best you can afford, which means good tailoring and a quality fabric. A nine-month-a-year fabric, like a wool crepe, will solve many wardrobe problems for years to come.

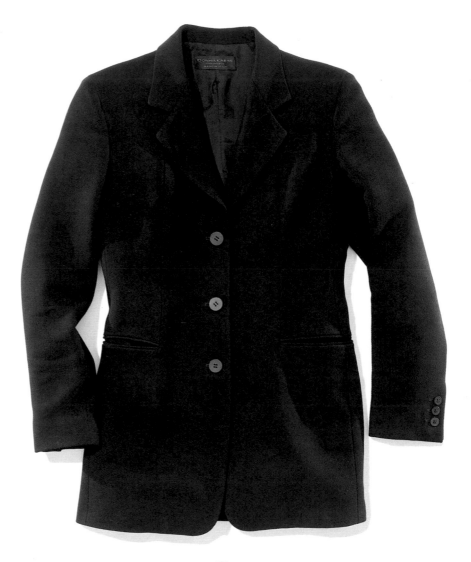

 WHY SHOULD A BLACK JACKET BE MY NUMBER ONE INVESTMENT, EVEN IF I DON'T LIKE BLACK? It goes with every other color in your wardrobe (yes, even navy and brown). It doesn't show dirt easily. It can be dressed up or dressed down. It's slimming (need we say more?). It's a classic—always in style.

THE BLACK JACKET

A lapel pin is a way to give the simplest of clothes your personal stamp.

A black jacket can have many personalities. The cut and the fabric are starting points. The rest depends on what you choose to wear with it.

A vest adds a layer of warmth and can add color and pattern to wardrobe basics.

501 jeans by Levi Strauss & Co. have been an American classic since the 1850s. Available in many colors, dark blue and black are considered dressiest.

FIRST CLASS

UPGRADED

LEAF CRUNCHING

WALKING BOOTS
Look for comfort, gripping soles, a rugged finish that will accommodate trekking both urban and rural trails.

BLACK TURTLENECK
An easy fit, whether hang gliding or wine tasting, and shows off your pearly whites.

GETAWAY TOTE
Look for an opening large enough for easy access, a wipe-clean, leak-proof liner, and outside pockets to stow maps, baguettes, or the paper.

DENIM JEANS
Our ode to Levi's 501s continues. American classics since 1853, the darker they are, the dressier.

For your fall weekend wardrobe, think simple, casual, and versatile (actually, think the same thing whatever the season). A hike through the foliage in the crisp cool air conjures up images of barn jackets, good flannel or wool shirts, and country inns. Unfortunately, many inns have strange wallpaper, suspect plumbing, drafty windows, and terrible coffee—but once you leave your lodging, your clothes can cheer you up. Throw your gear into a great tote. Don't forget a polarfleece or knit sweater, your trusty leather jacket, soft woolen trousers, and ankle boots. Add a turtleneck, your favorite pair of jeans, and a patterned scarf. You're now ready for college football tailgates, apple picking, or antiquing. Be sure to pack one nice sweater and wool pants for unforeseen discoveries like a charming restaurant or a surprise cancellation at Twin Farms in Vermont or the Ventanna Inn in Big Sur.

TO THE MANOR

The deep color, velvet collar, and quilting of the jacket add richness to this weekend essential.

Our friend the sweater set rescues us once again from the severity of well-tailored gray flannels, so we can feel feminine and comfortable at once.

66 Even if they've never been near a duck blind or gone beagling, Preppies are dressed for it. **99**

LISA BIRNBACH,
The Official Preppy Handbook

Pattern attracts attention, so be careful how you use it.

casual shoes

LOAFER

A classic first made popular by campus coeds in the 1950s, it has become an old friend with a new twist. Each season its color, fabric, and shape are varied, giving us more occasion to reach for it as a comfortable way to achieve low-key panache.

The better the shoe, the better the look. More than any other item, shoes define the degree of formality in what we wear. Shoes should blend with attire through color, texture, and shape. Brown shoes are inherently sporty and work very well with casual clothes. Black shoes are more sophisticated and elegant, or have attitude. Brightly colored shoes draw attention to the feet and have a festive and frivolous quality. The sturdier and more substantial the shoe, the more functional. Boots can range from dress-up stylish to practical four-wheel-drive trail-blazers. A thick crepe or Vibram sole signals a more country or surburban feel, but the key is to balance the shoe's message with your clothes and the occasion. The ramps of the Guggenheim and the elevated bridge of the San Francisco Art Museum don't require climbing soles, and squelching through wet leaves in ballet slippers is more Ugly Duckling than Swan Lake.

BALLET SLIPPER

A feminine party shoe. The more colorful, the more festive. Along with the sweater set, it dresses up jeans and khakis. It's a comfortable solution worn with short skirts and opaque pantyhose.

SPLIT-TOE OXFORD

Borrowed from menswear, this substantial shoe has an authoritative but comfortable attitude. Think khaki in summertime and gray flannel come winter.

JODHPUR BOOT

In brown suede, it's ideal with tweeds or jeans. In black calf, it's a boot that can be worn under a slim-legged pantsuit for a sophisticated look with a little attitude.

"For my fiftieth birthday, I had the bags removed from under my eyes and bought these black suede boots on 8th Street in the Village."

ILENE BECKERMAN,
Love, Loss, and What I Wore

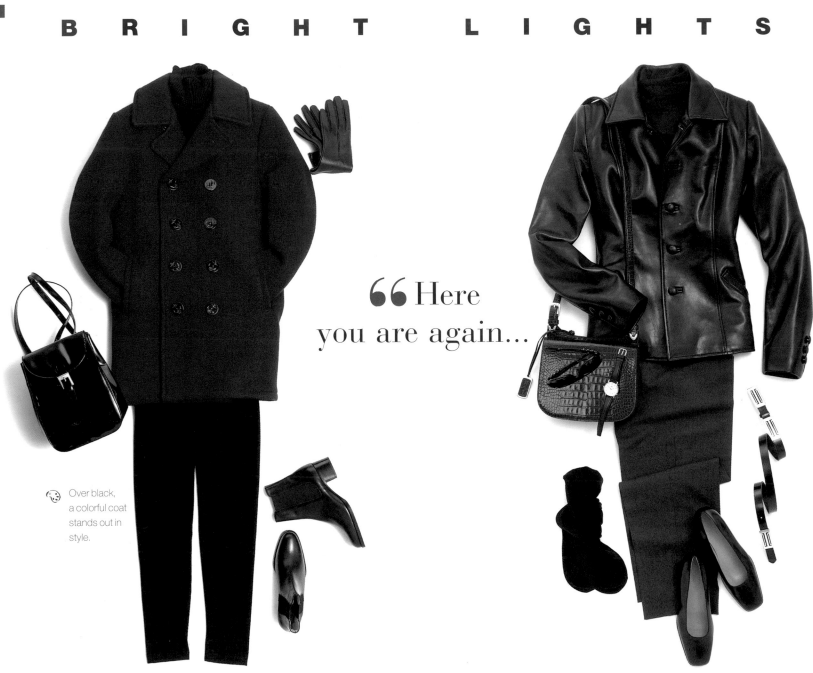

" Here
you are again...

Over black,
a colorful coat
stands out in
style.

SUNDAY IN NEW YORK—or Saturday in London or Milan or Paris or Tokyo. These destinations call for casual clothes that speak of a certain sophistication and

urban edge. Black leather is always perfect. A black cashmere turtleneck cleans up the act of your old khaki cargo pants (though what are you doing wearing those in Paris

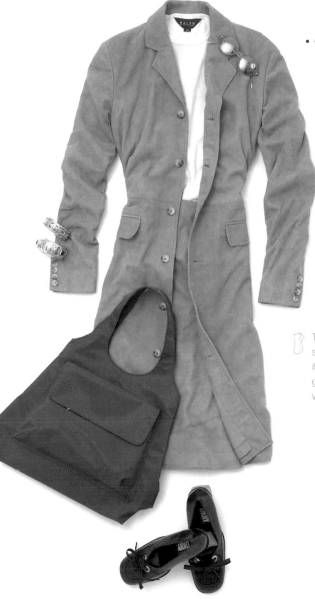

...all messed up and no place to go. 99

JAY MCINERNEY,
Bright Lights, Big City

The luxury of suede is not only its touch and its great look, but its warmth.

The soft drape of wool crepe pants flatters fuller bodies.

anyway?). A crisp white shirt goes to dinner with pencil-slim black pants or a longish black skirt. For the ultimate weekend-in-the-city challenge—nightclubbing, a gallery

opening, finding a cab in L.A.—try your black leather jacket with a simple black dress, earrings, and sandals (except in Milan—Italians feel that wearing all black is mournful).

You've heard it before, but like most wardrobe basics in black, they can easily be dressed up or dressed down and they are slimming. They tend to hide the dirt and wrinkles better than colors do, a bonus when traveling. In today's more casual world, they are as basic as the little black dress. The best wardrobe investment is probably a black pantsuit, so you

SIMPLE SOLUTIONS

have two pieces that work as well together as they do on their own. But if you find yourself always reaching for the pants, don't ruin the suit; invest in another pair of black slacks.

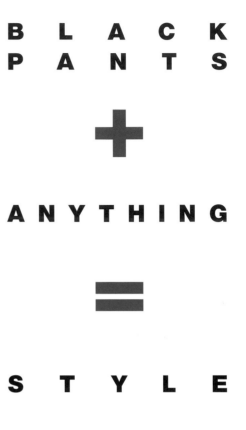

B L A C K
P A N T S
+
A N Y T H I N G
=
S T Y L E

If you wear the pants or jacket separately, be sure when you are having them dry-cleaned to send them in together to maintain color and tone.

Black pants can go to the office, out for dinner, and away for a relaxing weekend. Because of their amazing versatility, they are a favorite for seasoned travelers.

66 *Marlene Dietrich and Roy Rogers are the only two living humans who should be allowed to wear black leather pants.* 99

EDITH HEAD

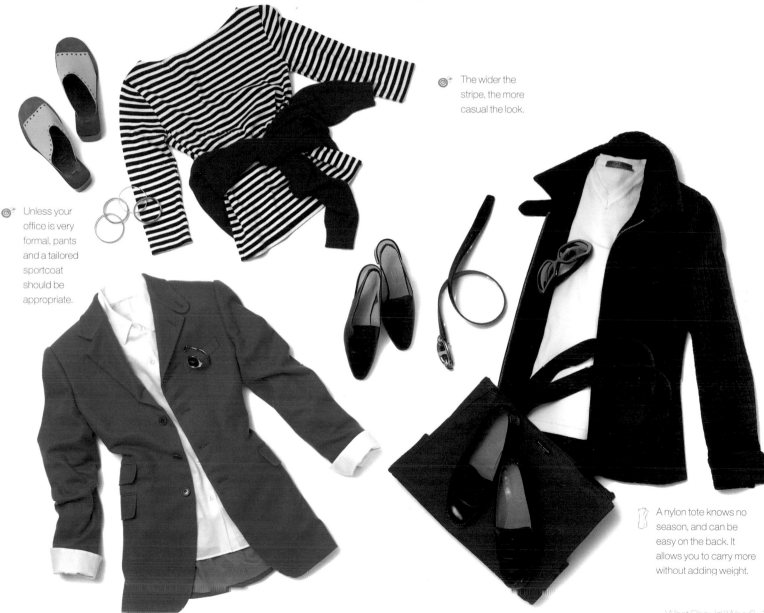

The wider the stripe, the more casual the look.

Unless your office is very formal, pants and a tailored sportcoat should be appropriate.

A nylon tote knows no season, and can be easy on the back. It allows you to carry more without adding weight.

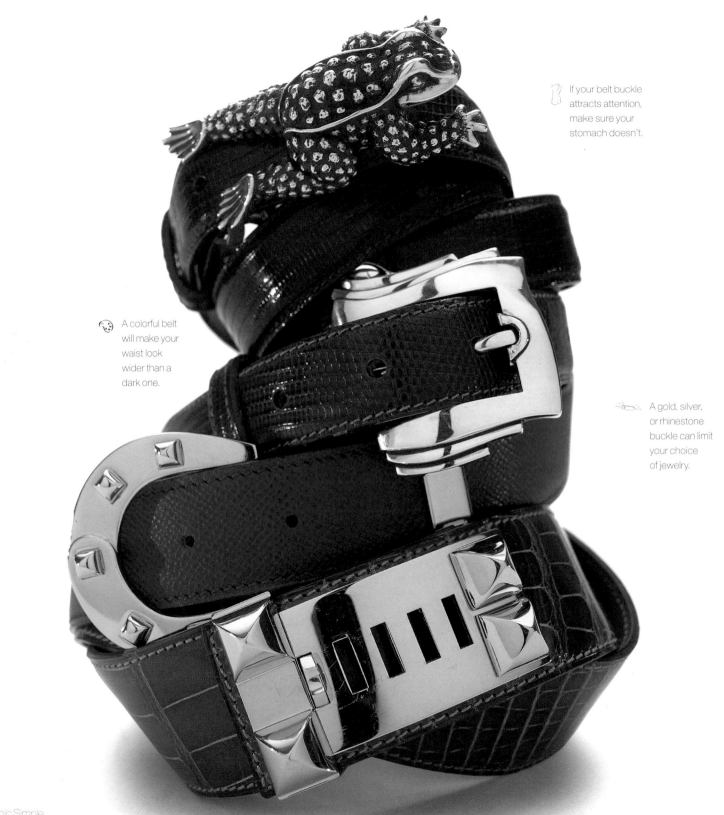

If your belt buckle attracts attention, make sure your stomach doesn't.

A colorful belt will make your waist look wider than a dark one.

A gold, silver, or rhinestone buckle can limit your choice of jewelry.

Much as a rodeo cowboy sports his championship belt buckle with his denims, today's classically dressed woman exhibits her style with the simplest of uniforms and her "investment" belt. One of the most basic of accessories, a belt often has the most impact. Because it usually cinches her waist, it is often the focal point of an ensemble. For that reason it is especially important to evaluate carefully any belt that comes with a garment. Is it of quality materials? Well made? Does it give the impression of the careful and stylishly dressed woman that you wish to convey? If not, replace it. A belt should be equal to or better than the rest of your ensemble. If it's not, it may drag down the rest of your outfit.

Belts can be discreet wardrobe basics (black or brown alligator or leather with little or no hardware) or the only jewelry one needs to wear. Today's designer belts have become objects of desire, guarded as closely as a woman guards her jewelry—and many cost as much. Perhaps the chicest outfit a woman can wear is all black with a simple gold or silver buckle on a supple leather belt.

it's a cinch

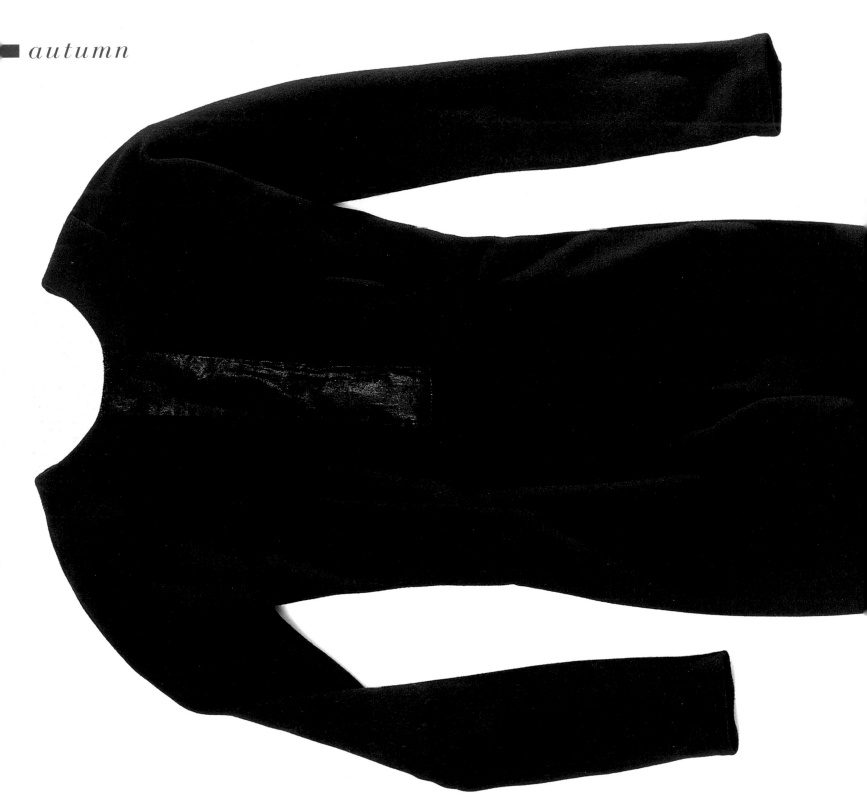

TRICK OR TREAT?

The jumpsuit, first worn by women early in the 20th century, had its origin as a man's uniform. When women began to pilot airplanes and "man" factories during wartime, they adopted the jumpsuit. It made a comeback as a fashion statement in the 1960s when it appeared on Diana Rigg playing Emma Peel in the British TV series *The Avengers.* It cycled through again in the 1990s with the inspiration of Michelle Pfeiffer playing Catwoman. Women's jumpsuits today are often sexy formal attire, usually with long sleeves and a zippered front or back. They come in fabrics ranging from jersey to wool and Lycra blends to silk (also leather, but usually found in stores with a specific clientele). In a solid color, the jumpsuit is the perfect foil for big necklaces and dramatic belts, and in gabardine, it's a fine traveling companion.

American designer Geoffrey Beene, the consummate master of the dress, is also the modern-day wizard of the jumpsuit. Beene grew up in Louisiana before moving to Paris to study design. He grew aware of the American woman's desire for comfortable clothing rather than staid French style. Beene's finely crafted designs led the way to almost weightless clothes that allow freedom of movement while defining women's bodies—designs that have earned him countless awards. His feminine renderings of jumpsuits feature gently curved waists and narrow legs pegged at the ankles.

WHAT IS THE DIFFERENCE BETWEEN A JUMPSUIT AND A CAT SUIT?
Basically, the difference lies in fit. A cat suit hugs the body like a second skin, with arms and legs that fit like a tight sweater-knit. Jumpsuits usually have more drape, and a shape inspired more by the designer's mind than by the wearer's body.

Invited to a Halloween party but you simply cannot deal with creating or renting a costume? Why not wear an all-black cat suit with a striking mask—or with a fantastic hat and gloves.

MARTINIS
AT EIGHT

> 66 A martini is like a woman's breast.
> One ain't enough and three is too many. 99

COCKTAIL WAITRESS,
The Parallax View

A martini is the cocktail equivalent of a zen koan: it is both the easiest and the hardest mixed drink to make. It was being mixed as early as 1887 and was referred to as a Martinez cocktail. Martinis are a religion, a private cult, an invitation to witticism and sophistication, and are as dangerous as a handsome man. Like all good things in life, from chocolate to miracle bras, they should be approached with caution and of course with no thought of operating heavy machinery. The debate is endless, but shaken wins with us every time.

As important as understanding day-into-evening wear and the how-tos of transforming the black office dress or suit into cocktail attire is focusing on what is an incorrect cocktail dress. All it takes is one slip of a neckline or a few thousand too many sequins or a skirt so short that your accessories clash with your panties—and an unfortunate message is delivered. Bright gold- or silver-sequined dresses: The cocktail hour is simply too early in the evening for this much glitter, unless it happens to be New Year's Eve. Suites of jewelry: Understatement is elegance. With a large necklace, wear small earrings. With larger earrings, wear a bracelet or brooch. On the other hand, here is a helpful list of delightful cocktail nuances that can shake or stir.

DÉCOLLETAGE: Plunging necklines were made for cocktail parties. How low? Depends on the mission you're on.

DIAMONDS: These jewels are truly a woman's best friend and never look better than with an understated cocktail dress.

STILETTOS: They're at their best during cocktail hour, on legs dangling from a bar stool, accessorizing a little black dress. For some, wearing a shoe that reveals the cleavage line between the large and second toe is stirring.

GAMS: Sheer black stockings add elegance. With seams—seduction. With fishnet—an audition opportunity for a cast part in *Cabaret*.

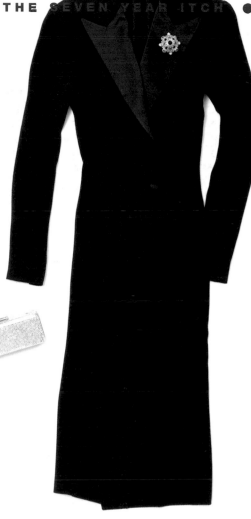

Marlene Dietrich, Judy Garland, Princess Diana, and Catherine Deneuve have all worn black tie to androgynous advantage. Details that women have borrowed from this masculine archetype include: wing-collared, pleated-front shirts; soft bow ties; cummerbund belts; patent leather flats with bow; and monogrammed velvet or suede slippers. Yves Saint Laurent has been the greatest proponent of black tie, or *le smoking*, for women. First introduced in 1966, his feminine dinner jackets remain an inspiration to designers today. They are worn with collarbones bared, over skirts or trousers.

HOW TO DRESS WITHOUT STRESS.

Accessories that you can confidently reach for when dressing for special evenings are valuable assets. Jet jewelry, diamonds, and pearls glow at night. Black silk or peau de soie evening shoes and bag play supporting roles to the dress of choice. Be sure you have unworn sheer stockings in black or nude always on hand. One of the most valuable tools a woman should employ before her grand night out is makeup. With the addition of only a brilliant red lipstick, she dresses up her face. Brushing on a pale matte powder and applying a smoky shadow and lash-lengthening mascara will ensure she won't fade into the night. Don't leave home before spritzing on your most heady fragrance.

THE BLACK COAT

It doesn't get more basic than this. Every woman should consider starting her coat wardrobe with a long black wool, cashmere, or alpaca chesterfield coat. Over a black dress or tuxedo ensemble,

it is the height of sophistication. Over gray flannel trousers worn with a cashmere sweater and pearls, it is the essence of relaxed chic—perfect for a casual dinner out wherever you are going.

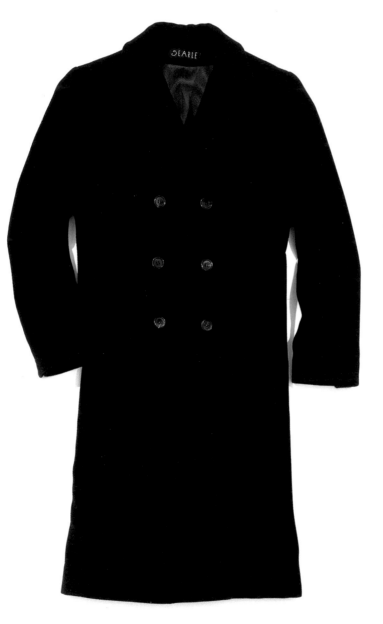

A coat is about more than staying warm. Consider it an introduction, and a remembrance. It can add glamour with a long sweep of fur, or give attitude by combining the unexpected—a leather biker jacket over a satin sheath. These style statements evolve, as a coat wardrobe is truly an investment that is built over time and should be enjoyed for many years. First start with the practical: raincoat, weekend jacket, and wool coat that can double for work and evening functions. Eventually you may desire something more luxurious that makes you feel fabulous every time you slip your arm into a sleeve. Possibly in a plush fabric like fur or pile. Velvet, brocade, matelassé, satin, and fur-lined silks are other sumptuous options. Maybe it's the color that seduces you, or a pattern that makes you feel daring. Even a dark cloth coat can be elevated to special evening status by virtue of a brightly colored satin lining, or by adding a beaded scarf or fur hat.

NIGHT FALLS ON THE CITY

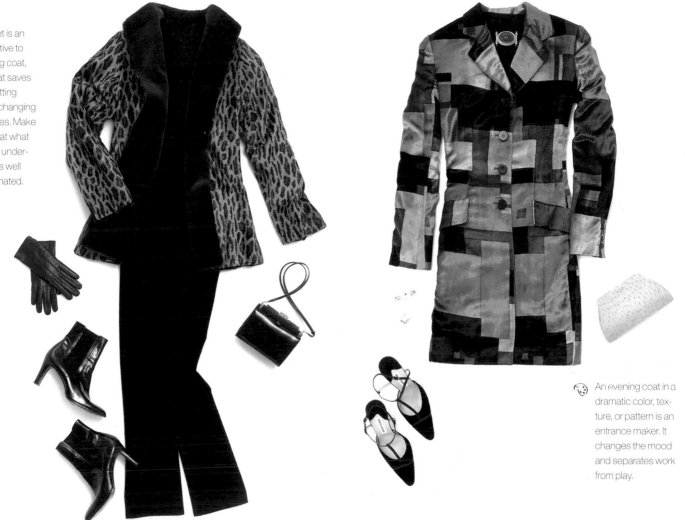

A jacket is an alternative to the long coat, one that saves you fretting about changing hemlines. Make sure that what shows underneath is well coordinated.

An evening coat in a dramatic color, texture, or pattern is an entrance maker. It changes the mood and separates work from play.

LEOPARD. Reversible coats can adapt to your whimsy or the occasion with little planning. Leopard print says "look at glamorous me." When reversed to sheared mink, a more elegant self emerges. Their versatility adds to their value, and the glimpse of lining adds mystery.

VELVET. Occasionally you're faced with a spectacular creation, one you fall for heart over pocketbook. It makes little sense, but does give you and your basic wardrobe a huge dose of style. Like all true fashion aficionados, if you don't have the occasion to wear it, you create one.

Win

chapter six

Winter is a time of clarity, of exploration, of travel, of holidays in white landscapes of snow and along the azure of faraway beaches. It also allows time to discover inside, with quiet weekends and restful retreats. It is the season of opportunity, of grand balls and intimate moments with a loved one over a glass of red wine in a sexy Valentine's Day rendezvous, enjoyed because February's gray holds within it the promise of the green rush of spring.

"*I am younger each year at the first snow. When I see it, suddenly, in the air, all little and white and moving; then I am in love again and very young and I believe everything.*"

ANNE SEXTON, *A Self-Portrait in Letters*

ter

RENEW & REINVEST
BEFORE

Check to see if any basics need replacing—sales begin during the holidays and continue through January. Make a list and keep checking it. You will be in the stores for holiday shopping and may save time by shopping for yourself as well.

WINTER BASICS

- ❑ silk blouse
- ❑ evening pants
- ❑ velvet scarf
- ❑ black coat
- ❑ two-ply cashmere sweater
- ❑ boots
- ❑ hat
- ❑ evening bag
- ❑ drop earrings

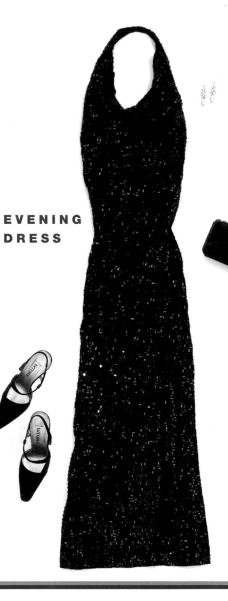

EVENING DRESS

HOLIDAY WEAR

shopping your closet

WINTER

BOOTS

WINTER OCCASIONS

Christmas... Chanukkah... Kwanzaa... Boxing Day... New Year's... Cocktail parties... Office parties... Caroling... Resorts... Ski trips... Valentine's Day...

PANTS

**DEJUNK &
RECYCLE**

RENEW & REINVEST
AFTER

After the beginning of the New Year, look in your closet for any spring items that no longer fit you or your special occasions. Resale shops usually begin adding spring clothing to their stocks in February.

"If I had a dress like that, I'd give it away too."

BONNIE HUNT,
in *Only You*

faQ NOW I WANT TO WEAR TIGHTS INSTEAD OF PANTYHOSE WHEN IT'S REALLY COLD. IS THAT OKAY? Thick tights that match your skirt or your shoes are okay. but they do lend a sporty air to your ensemble. Wear a long skirt or the thickest opaque stockings you can find with your short skirt.

**COLD
WEATHER
GEAR**

Always have at least one dressy at-home outfit—a beautiful matching sweater and slacks, and a pair of velvet slippers. Someone is sure to drop in un-announced during the holidays.

SURVEY & ASSESS

Try on your winter garments. Check for fit, spots, tears, missing buttons, and moth holes. Fabric and metallic evening shoes do not last as long as your good leather pumps, so inspect them carefully. Check your gloves to see there are two of each. If your leather or suede gloves are soiled, take them to your dry cleaner, who will send them on to a special leather cleaning facility.

HATS

JEWELRY

faQ SHOULD I WEAR LEATHER IN SNOW OR RAIN? Actually, the animal did. But then, its hide wasn't processed, dyed, smoothed, and stitched. You can wear your leather and suede in the rain or snow, but it may not emerge as soft or retain its colorfastness. Nappy suedes can be brushed when dry, but smooth leather should be dried with a cloth as soon as possible

More than bearing a designer's label, fabric is an important part of determining the price of a garment.

FEEL ME

Winter is fashion's big moment. Ask any designer. The opportunity to layer a mix of sumptuous fabrics is the thrill of their art. Not only can the visual richness of varying textures be seductive to the eye, but their sensuous touch can give us momentary pause. Yet beyond the dictates of fashion, fabrics need to thicken up in winter. We have to wear them—it's a matter of survival. It is also important to think of dressing in layers. In colder regions, an outer layer of shearlings, furs, and high-tech fibers promises warmth. In more moderate climates, micro-fibers, polarfleece, double-faced wools, cashmere, camel hair, leather, suede, and alpaca do the job. What we wear underneath can be aggressively bold in texture and dramatic in presence, not to mention easy to strip off when we're sitting beside a roaring fire and recounting our day's triumphs on the slope. It's the stuff that makes winter dressing exciting—nubby wool suitings, large-gauge mohair knits, and rugged suede vests. Last should be the most soothing layer, as it is worn against our skin. Light silks, satins, and cashmere help us to feel glorious.

Decadently
soft

TOUCH ME

While we may be hidden beneath layers of fabric, our choice of texture can make us stand out. Adding a garment with a satin sheen or a shiny thread woven throughout brightens up our heavy clothes. And there is one winter fabric so lush, so tempting, that you may look for ways to wear it day and night, or—regardless of traditional fashion rules—possibly all year long: Velvet. The pile is sumptuous, whether the fiber is cotton, rayon, or silk. Velvet makes us feel...well, luxurious. There are solid-colored, uncut pile velvets, devore velvets (in which the pile is literally burned away in production), cut velvets, and printed or painted velvets. And sometimes more than one of these elements appear in the same fabric—a printed cut velvet may be overpainted with touches of metallic gold. Other velvets include crushed, where a process produces an irregular, barklike surface, and panne, or mirror, velvet, where the pile is pressed in one or more directions to produce a surface sheen. We may wear velvet boldly, as a suit or evening cape, or subtlely—a velvet bag or shoes adds a richness to even the most casual of clothes.

(faQ) WHAT IS SHEARLING? The short-wooled skin of sheep or lamb is sheared before slaughter and tanned without removing the wool. It was once considered the "street fur" of European youth, but beautiful dyes and fashionable designs have elevated the status of this very warm leather.

Sparkling coppers, deep bronzes, and rich rusts are warm winter colors that are flattering to most.

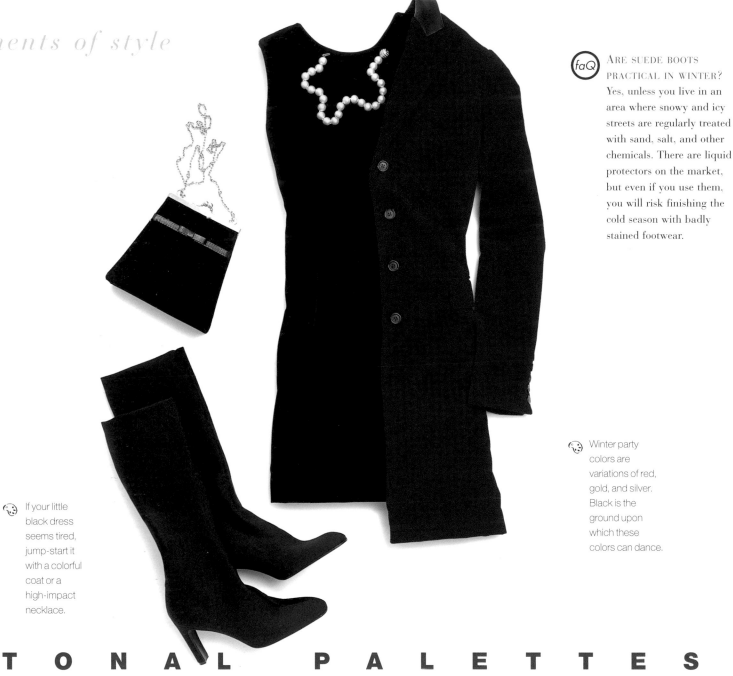

faQ ARE SUEDE BOOTS PRACTICAL IN WINTER? Yes, unless you live in an area where snowy and icy streets are regularly treated with sand, salt, and other chemicals. There are liquid protectors on the market, but even if you use them, you will risk finishing the cold season with badly stained footwear.

Winter party colors are variations of red, gold, and silver. Black is the ground upon which these colors can dance.

If your little black dress seems tired, jump-start it with a colorful coat or a high-impact necklace.

T O N A L P A L E T T E S

December is the month our social calendars can reach overload, and it is wise to plan for events, anticipated and spur-of-the-moment, in advance. How do you plan for the unknown? One way is to add colored velvets to your wardrobe. Bright-red, burgundy, forest-green, even luxurious black velvets signal the beginning of the holidays. A velvet jacket worn with dressy shoes and bag can be the perfect accompaniment to a simple black top and pants.

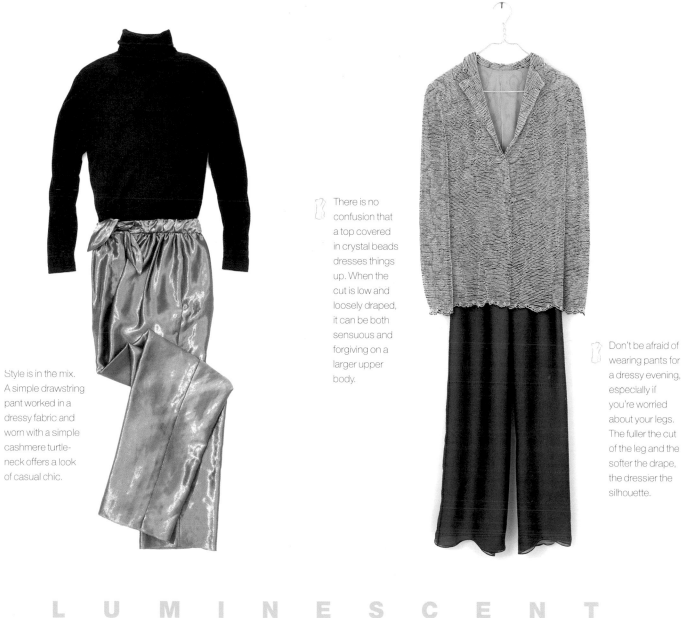

There is no confusion that a top covered in crystal beads dresses things up. When the cut is low and loosely draped, it can be both sensuous and forgiving on a larger upper body.

Style is in the mix. A simple drawstring pant worked in a dressy fabric and worn with a simple cashmere turtleneck offers a look of casual chic.

Don't be afraid of wearing pants for a dressy evening, especially if you're worried about your legs. The fuller the cut of the leg and the softer the drape, the dressier the silhouette.

L U M I N E S C E N T

A festive wardrobe is not limited to only dressing in holiday colors. Adding a few shimmering or sparkling pieces can give you just the right amount of sparkle whether you are going to a celebratory gala or just feeling special at home while dining with holiday company. When the warp or weft of your clothes is shot with metallic threads, your passage through a room becomes a moment of scintillating energy.

STILETTO

> **66** *High-heeled, thin-strapped sandals have been known to drive some men to frenzies, but they're often men who want to tie you up, so be careful.* **99**

CYNTHIA HEIMEL, *Sex Tips for Girls*

Contrary to popular belief and (men's) wishful thinking, not all women are in love with high heels. A stiletto heel can be harrowing, as it is narrow and often four inches in height. In the '50s, stilettos were banned from some marble and wood surfaces, as well as airplanes, where it was feared they would puncture the metal floor. High heels first became popular with American women when skirts began to rise in the 1920s, and if you have ever known a woman who was a true lover of high heels, you know the depth of her passion. In Houston, a power dresser of the 1980s accidentally fell into the orchestra pit of the Wortham Theater Center. Landing squarely on her stilettos, she broke every bone in her feet but was saved from other bodily injury by a tight brown leather suit. The minute she could walk again, she was back in high heels. A woman learns, almost instinctively, what high heels do for her posture and sexual allure, how they can drive a man crazy. The decision not to wear high heels may seem easy to make but is difficult to stick to in the presence of a meticulously crafted pair of crocodile pumps or a pair of spindly jewel-encrusted evening sandals. If you are not willing to compromise on comfort, there are sexy, dressy alternatives. Revealing toe cleavage or wearing the d'Orsay, a shorter pump cut low to reveal the arch, can be as seductive and infinitely easier on the feet. Start your evening collection with a pair in black peau de soie.

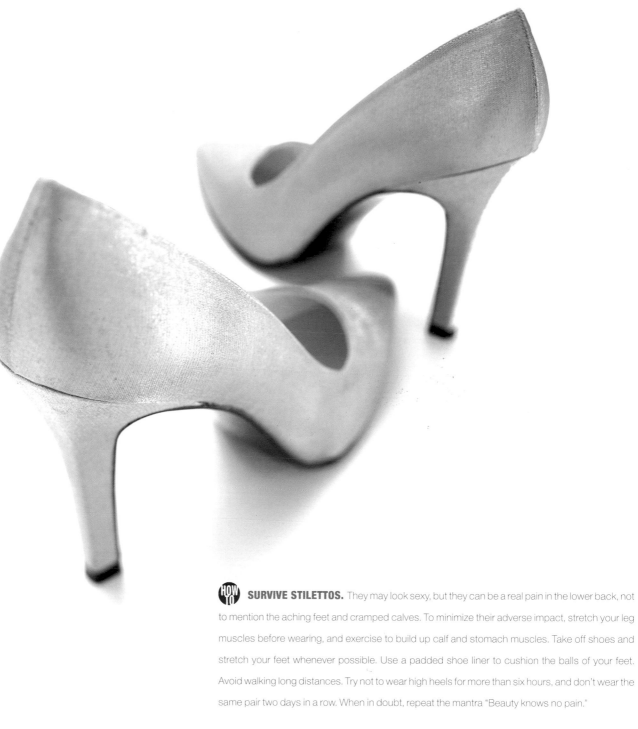

HOW TO SURVIVE STILETTOS. They may look sexy, but they can be a real pain in the lower back, not to mention the aching feet and cramped calves. To minimize their adverse impact, stretch your leg muscles before wearing, and exercise to build up calf and stomach muscles. Take off shoes and stretch your feet whenever possible. Use a padded shoe liner to cushion the balls of your feet. Avoid walking long distances. Try not to wear high heels for more than six hours, and don't wear the same pair two days in a row. When in doubt, repeat the mantra "Beauty knows no pain."

There comes a point in every woman's life— more often than not during the winter holidays— when it's time to pull out all the stops. Either you want to have the time of your life or the occasion calls for fancy dress. And fancy dress does not only mean long gown. Pantsuits, short suits, and cocktail dresses are now often as appropriate if they are worked in dazzling fabrics with decorative detail. Metallics, brocades, velvets, and lace can be cause for excitement.

NOT SHORT ON GLAM
A black velvet cocktail dress with feather trim is at once a young and a grown-up version of the little black dress. Although short, it is a viable option at most black-tie events because of its luxurious fabric and extravagant details.

EVENING SUIT
Silk taffeta, especially in gold and with jeweled buttons, transforms the everyday into nights only. Pants are acceptable at most black-tie events, especially in cutting-edge urban environments and the casual-dress atmospheres of Miami and Los Angeles.

show

WELL-SUITED
Although not necessarily black-tie formal, a short suit can be distinguished by a boldness in color made especially rich when worked in double-faced duchess satin. Such an ensemble would be the choice for a cocktail buffet in cities such as Houston, Dallas, Detroit, or Chicago.

LONG ON STYLE
The long dress, for those formal events when men are expected to wear white tie or black, represents a major investment for most women. Your first choice might be something black that can be transformed by accessories. After that, go for effect. A long, light-colored column of decorative fabric will stand out in a room of color. Long sleeves in a sheer fabric like lace is a great option for women who want to cover their arms yet still look feminine.

stoppers

TIME IS MONEY

Not since Cinderella has a dressy watch been as essential to a woman's special-occasion wardrobe as now. Today dressing up is usually for a charitable fundraiser, and the women who organize these events run them with the precision of a Swiss trainmaster.

> **66** Three o'clock is always too late or too early for anything you want to do. **99**
>
> **JEAN-PAUL SARTRE**

Notice some crossover between your everyday and special-occasion accessories. You can wear the black pumps or flats, the black purse, and the pearls to work, PTA functions, and for the theater. These versatile pieces become the foundation of a wardrobe. They are the simple solutions that you can depend on to stylishly get you through any event, planned and unplanned. But face it: It is for special occasions that you want something unusual. Most women are not satisfied with the few dress-up clothes or accessories that are on these basics lists, and therein lies the potential for making bad clothing and accessory investments. The point is to know what the basics are for you, then build from there. Therein lies the opportunity to begin acquiring over time special pieces that when worn repeatedly become your personal style markers, those pieces that set you apart from the crowd.

MIN-O'DYAIR

JUDITH LEIBER has been bedecking the glamorous and wealthy (Beverly Sills, Kim Basinger, and Ivana Trump, to name a few) with her jeweled, exotic designs since 1963. The craftsmanship involved, which she herself learned in an artisan's guild in Budapest, is unparalleled. Some of her minaudières are covered with 7,000 to 13,000 pavé rhinestones, each individually hand-set. One bag can take up to seven days to complete. They have become collector's items worthy of display.

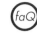 SHOULD I WEAR DIAMONDS DURING THE DAY? Mary Owen Greenwood, a Texas socialite, was once told that it was improper to wear diamonds during the day. "Honey," came Greenwood's retort, "that's exactly what I thought until I could afford them." Unless they are low-key, like studs, wearing diamonds during the day calls for an exercise in taste.

[ACTUAL SIZE]

Sometimes bigger isn't necessarily better, especially when it comes to evening bags. And few can match the beauty or status as collectible of the minaudière. One of these small sculptural bags, usually ornamented with pavé faux jewels, may be all the jewelry you need for any dressy occasion. When it has the day off, the minaudière can be displayed at home on a table or shelf, where it can function as a tiny objet d'art.

A perfectly managed Christmas correct in every detail is, like basted inside seams and letters answered by return, a sure sign of someone who hasn't enough to do.

KATHERINE WHITEHORN

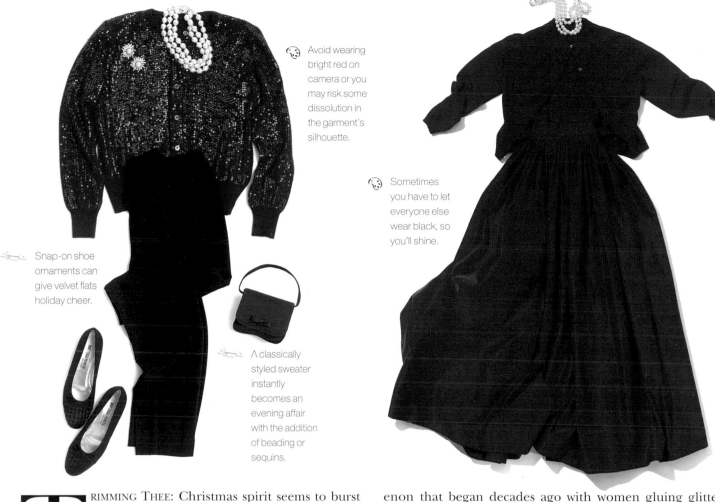

Avoid wearing bright red on camera or you may risk some dissolution in the garment's silhouette.

Sometimes you have to let everyone else wear black, so you'll shine.

Snap-on shoe ornaments can give velvet flats holiday cheer.

Λ classically styled sweater instantly becomes an evening affair with the addition of beading or sequins.

TRIMMING THEE: Christmas spirit seems to burst forth just as we finish saying Thanksgiving grace. No sooner is the table cleared than some invisible elf has trimmed every streetlight in town with boughs of holly. Throughout the United States, women are compelled to spread the holiday spirit by decorating themselves, just as they would their tree. Talk about the power of dress. Hence the Christmas sweater, a phenomenon that began decades ago with women gluing glitter designs onto sweatshirts. Today it has reached the proportions of holiday tradition, becoming one of the best-selling clothing items at this time of year. Choosing one can be similar to choosing a painting, in terms of considering quality, proportion, detail, and design. These sweaters are worn day and night, with jeans and velvet; try wearing them with black to make the design pop and your body recede.

SCARLET WOMAN: Perhaps the easiest way to spread Christmas cheer is by dressing in red. In the recent decades of power wardrobes, red has become a prerequisite, if not a neutral. It calls attention and can signal power. That red wool suit purchased for an important speaking engagement will be just right for the holidays. And what about the red twinset originally bought to brighten up your good black suit? Worn with a taffeta ball skirt, it can go from holiday dinner parties to nearly any formal occasion in the month of December.

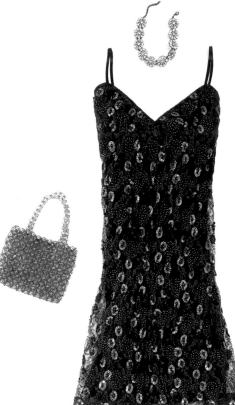

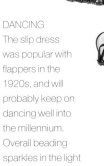

> ❝ May your only pain in life be champagne. ❞

Toast given by
DERRILL OSBORN

DANCING
The slip dress was popular with flappers in the 1920s, and will probably keep on dancing well into the millennium. Overall beading sparkles in the light of the disco ball.

COUCH POTATO
Times Square lights up your living room. The ball drops, followed by champagne toasts with loved ones. The moment calls for comfort clothes in luxury fabrics. A cashmere shaker-knit sweater, silk palazzo pants. Easy chic.

HOW TO **DRESS UP.** The one night of the year when every woman wants to dress for celebration is the last one—New Year's Eve—but she wants a look that will last into the wee hours of the next year. Whether you opt for low-key glamour or highbrow elegance, think festive, think fabulous, and think com-fort—you'll be partying for hours. Sexy sleeveless tops help to ensure sweat-free dancing. Highlights of beading, sequins, and metallics add fireworks to cashmere and velvet. Make sure your shoes wear you out. And don't forget what you put on to go outdoors—it's not just the getting there, it's the journey.

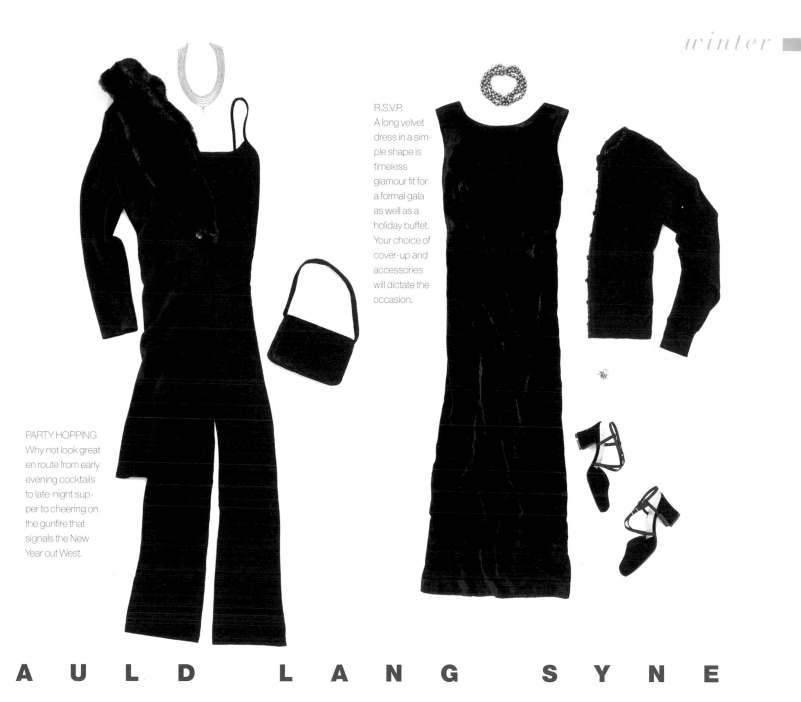

PARTY HOPPING
Why not look great en route from early evening cocktails to late-night supper to cheering on the gunfire that signals the New Year out West.

R.S.V.P.
A long velvet dress in a simple shape is timeless glamour fit for a formal gala as well as a holiday buffet. Your choice of cover-up and accessories will dictate the occasion.

A U L D L A N G S Y N E

NEW YEAR'S RESOLUTIONS: *I will...Stop smoking...Drink no more than fourteen alcohol units a week... Reduce circumference of thighs by 3 inches (i.e., 1½ inches each) using anticellulite diet...Purge flat of all extraneous matter...Give all clothes which have not worn for two years or more to homeless...Go to gym three times a week not merely to buy sandwich...Form functional relationship with responsible adult...Learn to program video...*

HELEN FIELDING, *Bridget Jones's Diary*

SWOOOOOSH

If you ski, the idea of an upcoming ski trip is one of excitement, with memories of the smell of pine trees, the sun burning your face as it reflects off the crisp white slopes, the whooshing noise as you carve out sweeping turns in fresh morning snow, and the sensuous tiredness of muscles as you later relax outside in the hot tub under the stars as falling snow gives you a turban of white—you know most of this. If you don't ski or if it's your first time, your feelings are probably best summed up by Erma Bombeck's adage "I do not participate in any sport with ambulances at the bottom of the hill"—in which case, the following will be helpful.

The key to enjoying skiing is staying warm and comfortable whether on or off the slopes, and that is always best accomplished by wearing layers of clothing. Think lean and multiple layers instead of bulky. Opt for lightweight outerwear in techno fabrics that combine function and style, keeping you warm and dry. Layering stretches your wardrobe and helps you adapt to the many temperature changes you can experience indoors and out, when relaxing and when exercising. Wear comfortable knits for travel, cashmere tops and pants for après-ski. A dressy top, luxurious cashmere sweater, or fur-collared cardigan to wear with a long skirt or pants will take care of evenings out. And best of all, they're versatile enough to enhance your entire wardrobe when you get back home. Color adds pizzazz and will help to locate you on the slope, but don't forget basics in black; they make those colors pop.

Small walkie-talkies help keep everyone in touch on the slopes.

Mittens keep hands warmer than gloves.

Beaver-collared high fashion meets techno performance-wear. The one-piece ski suit has long been a European favorite.

This watch shows temperature and altitude, plus it tracks vertical feet skied, for bragging rights at the end of the day. It has five daily alarms and comes in an array of cool colors.

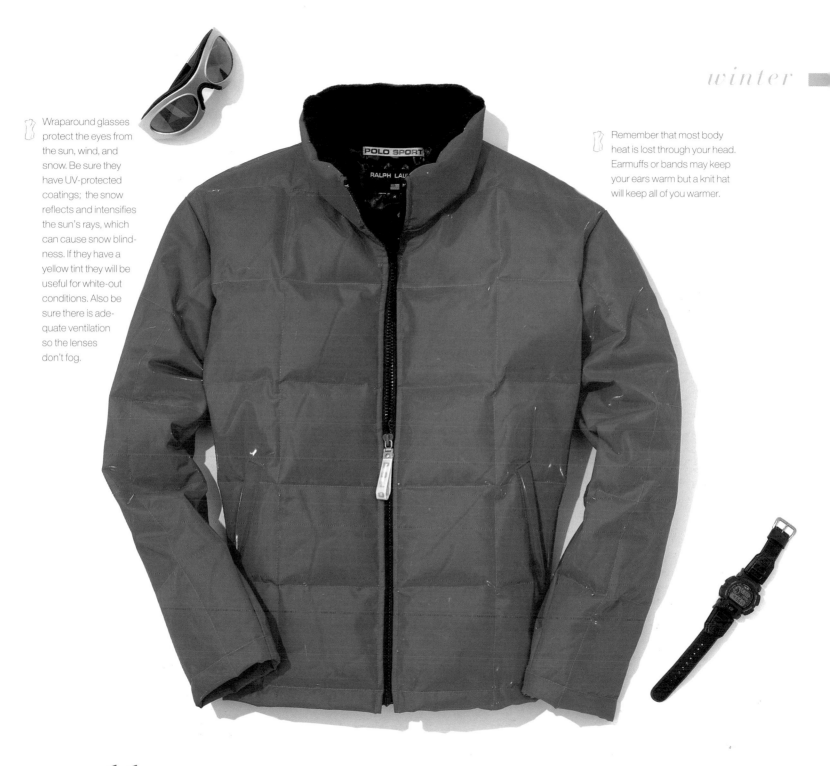

Wraparound glasses protect the eyes from the sun, wind, and snow. Be sure they have UV-protected coatings; the snow reflects and intensifies the sun's rays, which can cause snow blindness. If they have a yellow tint they will be useful for white-out conditions. Also be sure there is adequate ventilation so the lenses don't fog.

Remember that most body heat is lost through your head. Earmuffs or bands may keep your ears warm but a knit hat will keep all of you warmer.

POLO SPORT
RALPH LAU

66 It was so cold, I almost got married. 99

SHELLEY WINTERS

APRÈS-SKI DAY

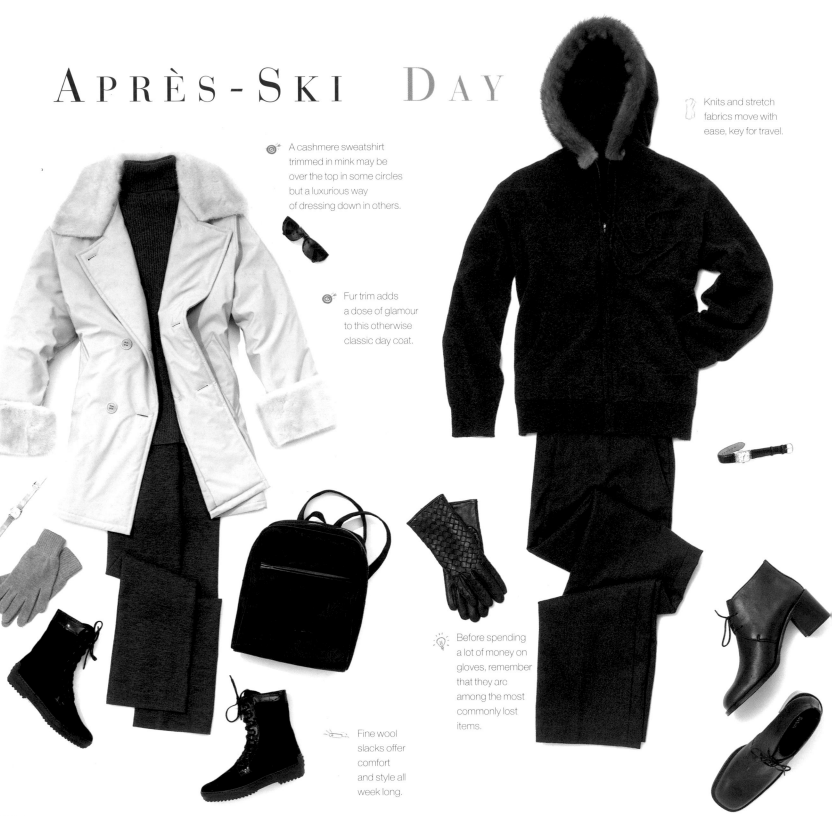

A cashmere sweatshirt trimmed in mink may be over the top in some circles but a luxurious way of dressing down in others.

Knits and stretch fabrics move with ease, key for travel.

Fur trim adds a dose of glamour to this otherwise classic day coat.

Before spending a lot of money on gloves, remember that they are among the most commonly lost items.

Fine wool slacks offer comfort and style all week long.

SKI TRIP LIST

- ❏ **jacket**
- ❏ **polar vest**
- ❏ **ski pants**
- ❏ **fleece/knit tops**
- ❏ **gloves/mittens**
- ❏ **ski hat**
- ❏ **ski socks**
- ❏ **neck gaiter**
- ❏ **headband**
- ❏ **sunglasses**
- ❏ **sunblock**
- ❏ **lip gloss**
- ❏ **goggles**
- ❏ **thinsulate or silk undies**
- ❏ **après-ski boots**
- ❏ **boot bag**
- ❏ **gear bag**
- ❏ **sweaters**
- ❏ **ski boots**
- ❏ **poles**
- ❏ **skis**
- ❏ **first-aid kit**
- ❏ **altimeter watch/ serious ski gear**
- ❏ **knit separates**
- ❏ **jeans**
- ❏ **swimsuit**
- ❏ **tights**
- ❏ **athletic shoes**
- ❏ **dinner clothes**

& NIGHT

A dressy shirt paired with slacks may be all you need to dress up for dinners out.

An unexpected invitation and nothing to wear? A pleated slip dress takes up no room and could come in handy. Another option: Dress it down by wearing it under a sweater with boots.

An evening sweater provides warmth and style when worked in cashmere with fur trim.

HOW TO GO SKIING. Pack a durable, lightweight bag that can accommodate ski boots in a separate compartment. Dress in lightweight layers to cut down on bulkiness (silk undies, Polartec pile for insulation, shells and wind pants in nylon). Cross-country skiing is hot—and it offers a great workout. The look varies from knickers to one-piece Lycra suits. Ventilation is key. Downhill skiers endure cold rides up the slope before racing back down. They need up-to-date fabrics for warmth and comfort.

APRÈS-SKI. Bring festive yet relaxed clothing and don't be afraid to mix them with skiwear. Most resorts have exercise rooms and indoor pools, so pack workout clothes and a bathing suit.

S U N [PF14] R E S O R T

◎ Bathing suit cover-ups are key when traveling. Think about the walk from the hotel room to the pool for starters. And during the winter months, balmy breezes can get gusty.

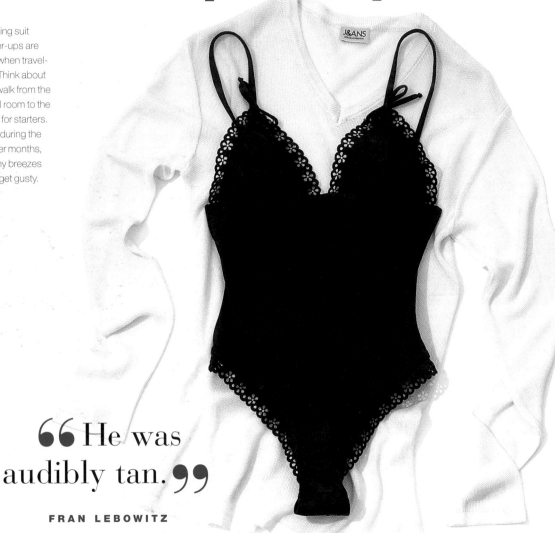

66 He was
audibly tan. 99

FRAN LEBOWITZ

There comes a time every winter when the avalanche of days with snow, ice, rain, sleet, and the blah look of gray leafless trees sends us spiraling into cabin fever. Resort time! Or as Adeline said in *I Wouldn't Have Missed It for the World,* "A trip is what you take when you can't take anymore of what you've been taking." But playing beach bum doesn't mean you have to look like one. Retailers call this line of clothes "resort wear," to distinguish it from summer items relegated to the sales rack. But that is a confusing and dated-sounding name, and a depressing label if you're not going anywhere. But conceptually, resort wear is made up of lightweight fabrics that pack well and can be worn in spring and early fall, like matte jersey. The colors are brighter, but not necessarily

COOL HEAT

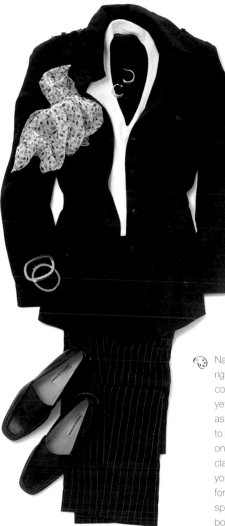

Dress up a jumpsuit with strappy heels, an evening purse, and some jewelry. Downplay it with flat sandals, hoop earrings, and a sweater draped around the neck.

Navy adds the right dose of color—deep, rich, yet not somber, as no one wants to look somber on holiday. It's a classic, whether you're striving for elegant or for sporty, and has a bonus: Navy looks great on everyone.

A navy peacoat is nearly seasonless when worked in silk. In winter months, silk jackets look best at night.

pastels which can look terrible against pale winter skin. The wardrobe base color tends toward navy, perhaps because of its nautical heritage. Travel with a classic-cut jacket coupled with cooling cotton shirts, tailored trousers, and a few well-chosen accessories—an all-purpose getaway ensemble. Tank tops, pants, and perhaps a trench jacket—for unexpected showers or chilly evenings—take you through the day

Add a necklace, a jeweled belt, or a tiny purse for evening. For the beach or pool, a swimsuit will need a cover-up. Why not a pointelle sweater that works over the swimsuit or over pants for dinners out. And bring a white or black cotton crewneck sweater to tie around your neck for breezy nights, plus a large, elegant scarf. The tendency is to over-pack, so be ruthless—it's your holiday, not your closet's.

makin'

Add radiance to your face with a gold necklace. A locket pulls attention downward, toward the bustline.

Avoid going overboard on holiday themes. Yes to Christmas sweaters; hold back on Valentine's and Halloween clothing—except for costume parties. A well-dressed woman never wants to become a walking greeting card.

VALENTINE'S DAY

As winter roars into the new year, the reds in your wardrobe become even greater assets. Not only do they brighten up the dark days of winter, but they set the tone for Valentine's Day. For most women, red is a flattering color—rich, warm, the color of love. But if you happen to find the color overpowering, try wearing something white around your face. A choker of pearls or pearl earrings can add a softening touch, as can a white shirt or a blouse, or even an ivory sweater. And remember, on Valentine's Day be sure to dress first for yourself. Wearing something soft against your skin, like cashmere or silk, becomes a personal luxury. If you *feel* pretty and romantic, you *are* pretty and romantic. Other people will feel it too.

whoopee

Wearing a halter is an opportunity to show off your great shoulders. Try pinning up your hair.

> **❝** *I love the idea of there being two sexes, don't you?* **❞**
>
> **JAMES THURBER**

D R E S S I N G S E X Y

There are times when you want to feel sexy but think you haven't got the stuff—the legs or the cleavage—to strut. But sexiness has never been a body prerogative; it's a mental state, an aura of self-comfort and awareness. When you want to radiate vitality, your lusciousness and sensuality will come easily—it's a feeling that communicates well. Often what we put on will trigger a mood—sheer fabrics strategically placed: arms, shoulders • off the shoulder neckline • drop back • sexy undergarments • stilettos • toe cleavage • mules • hair, loosely pinned up or long and unpinned • shimmery fabric • slit skirt • pants that sway • a fitted top, bottom, or waist • colors: white = purity, red = danger, black = mystery • bare shoulders • a man's white oxford-cloth shirt • a glimpse of lace • the feel of leather or satin against our skin • red lips • heady perfume • clear eyes • a sexy mind.

66 Luxury need not have a price.
Comfort itself is a luxury. **99**

GEOFFREY BEENE

YOUR OWN SPECIAL OCCASION

The rarest and best occasion of all is time for yourself. Make a date with yourself one day a week; it can be a lunch, a museum wandering, whatever, but set aside that time and hire baby-sitters for the kids if necessary. Take the idea even further and find time for yourself at home on a weekly basis. Whether it's just an hour that's sacrosanct, or an afternoon, or maybe every season a full day—go for it. One thing is for certain: What we wear can help transform our mood. Comfort clothes break through the routine of the everyday, whether it's the symbolic wearing of an old sweater or T-shirt or the self-indulgence of a luxurious silky slip. The only criterion for comfort clothes is that they suit your inner style so well that you are drawn to them again and again and again. The idea is to feel unencumbered and gloriously self-centered for that brief amount of time. You deserve it, and not only you but the people around you will benefit.

HOW TO **POWER BATH. FOR MUSCLE RELIEF.** Place a half cup of bay leaves in a pint of boiled water and let steep for twenty minutes. Remove leaves, pour the liquid into warm bath. Sit in tub for 15 minutes.

FOR MENTAL RELIEF. Take a teaspoon each of rosemary, basil, dill, mint, thyme, sage, and chamomile, tie them up in a cheesecloth bag, and suspend the bag under the bathtub tap while the water is running.

FOR HEADACHE RELIEF. Put 5–10 drops of clove oil into bath water. In the bath, quarter a lemon and rub the juicy side under each armpit. Follow up by eating 10 strawberries and drink a cup of ginger tea. Go figure.

WINTER CARE: Winter skin is about extremes. We leave parched, overheated rooms to battle the frigid cold, and our skin pays the price. It becomes raw, chapped, blotchy, red, itchy, and tight. In a word, it gets angry. The rules of winter: Protect and soothe. Avoid products with alcohol. Consider a more gentle cleansing routine, like using a mild milk cleanser with lukewarm water and a moisturizing mask to replenish and nourish irritated skin. Try specially formulated oils and lotions made from natural substances like lavender and rose water to calm and heal. A heavier, non-water-based moisturizer can lock in moisture and protect against wind and cold. The delicate skin on your lips and eyes needs special attention. Use a lip balm and an eye cream day and night. Other tips? When outdoors, wrap a scarf around your face to protect sensitive capillaries from breaking. Wear sunglasses to protect your eyes and keep you from squinting (another cause of wrinkles). Fight dry indoor heat with humidifiers. Gently exfoliate dead cells to allow the skin to breathe and regenerate. And just because it's 20 below, don't forget to put on a sunscreen: Snow and ice reflect harmful UV rays. Winter color? Most women's skin is paler than usual in the winter. You might need a lighter-colored foundation until the sun makes its return. Reduce paleness with rosy blush hues. Add depth around the eyes with deeper shadows, and find a good moisturizing lipstick.

wear what,

chapter seven

While the dress code in the United States has become more relaxed, invitations have become more confusing. Creative black tie, Western weddings, and a night at the opera are just some of the occasions you'll find explained in the following pages. Our most important piece of advice? Wear what feels good on you.

" HIP WEDDING ON MOUNT TAM

She wondered if she ought to call her friend Carol and ask what to wear. Martha had said 'dress down,' but that could mean anything from Marie Antoinette milkmaid from The Electric Poppy *to bias-cut denims from* Moody Blues... *Now the problem was Harvey, who absolutely refused to go to Mount Tam weddings in the French jeans Kate had bought him for his birthday. She knew he'd wear his Pierre Cardin suit, which was fine two years ago but which was now establishment...* **"**

CYRA MCFADDEN,
***The Serial* (1977)**

where?

"If I thought my epitaph would read HOSTESS I'd refuse to die."

BARBARA HOWAR

faQ IS IT OKAY TO WEAR WHITE TO WEDDINGS? Traditionally white has been reserved solely for the bride, and in many parts of the country older people would consider it rude to wear white to a wedding without first consulting the bride. It's her day, so do as she wishes.

faQ IS IT OKAY TO WEAR BLACK TO WEDDINGS? Yes, but in some parts of the deep South it might still be frowned upon. If you take special care not to look funereal, black can be a chic and sophisticated choice, especially if sparked with pearl jewelry and a beautiful frilly hat.

HOW TO READ AN INVITATION

Chances are you can spot a what-to-wear problem as it emerges from your mailbox. You know the drill: A thick vellum envelope arrives with your name and address in swirls of calligraphy. Or a bright postcard jumps out at you with a commanding message to "save the date." Uh-oh, you think. What will I wear? Relax. If you know how to read an invitation, you have valuable clues in your hand before you even open the envelope or read a word. Thick, ecru-colored paper normally denotes not only that the occasion will be a dressy one, but that your host and hostess know the finer points of enter-

taining. Generally, the later the hour, the more formal the invitation, the more formal the dress.

FORMAL INVITATIONS
Formal wedding invitations are usually engraved on heavy ecru-colored paper. The same holds for invitations to formal anniversary celebrations or presentation balls. A more casual wedding invitation is often printed on white or pale pastel paper.

INFORMAL INVITATIONS
Colored envelopes indicate less formal occasions, such as a barbecue or a costume party. A postcard is usually sent only for the most casual of get-

togethers or for "save the date" notifications. If a hostess plans a dinner party or get-together on short notice, she might call guests to extend invitations, then follow up with a formal "to remind" note that details the date, time, and possibly the dress. Receiving an invitation by phone is the perfect opportunity to ask your hostess, "What are we wearing?"

HANDWRITTEN INVITATIONS
For handwritten invitations, the size of the envelope gives you a clue to the nature of the event to come. The larger the envelope, the more costly the invitation and postage. Thus you may assume that your host has spared no expense for the

planned event. Translation: You are expected to dress up. The problem comes in knowing how far is up. When in doubt, telephone your hostess for advice.

RSVP

When an invitation says RSVP, it means you should let the host know if you will be attending the event. It stands for the French phrase *Répondez s'il vous plaît,* meaning "Please respond." Avoid sending invitations reading "RSVP: regrets only." It's fine for a host to follow up with a phone call, as people are so busy nowadays that sometimes an invitation is unintentionally overlooked. Sometimes people put off opening their mail or an invitation gets lost. If you invite someone over the phone, you may consider following up with a *pour mémoire,* the French phrase for a reminder note.

A WORD TO THE WISE

Do not toss the envelope that contains the invitation. Wedding gifts and thank you notes should always be sent to the return address on the back flap of the envelope.

SINGLES ONLY?

Unless the host is matchmaking and it's agreed upon in advance, singles should have the option of inviting a date or escort to an event, especially if there is to be dancing. Some hosts argue that when it's an intimate occasion they don't want strangers present (black-tie wedding or birthday) or, worse, don't want to spend the extra money on someone they don't know.

When unaccompanied, singles often feel uncomfortable. They may also feel that not having the option to invite a date is disrespectful of their status. Alternately, if you are single, don't feel that it is necessary to have a date. It may be more fun to work the room than baby-sit someone who knows no one at the event. Another option is to ask your host if many other singles are invited.

DECIPHERING THE DRESS CODE

Creative black tie—
This is probably on of the most annoying requests to ask of your guests. If there is a theme (luau, '50s, *Titanic*), state it. Otherwise, call your host for an explanation. Or, if it's around Halloween, wear a long dress and a mask.
Black tie—Long or short dressy dress.
Black tie optional—Short dressy dress or great evening pants.
Formal—Like black tie, long dress or ultra-dressy pants or very dressy cocktail dress.

faQ **IF I'M INVITED AS A DATE TO A WEDDING AND DON'T KNOW THE WEDDING COUPLE, SHOULD I BRING A GIFT?**
No. Your date will bring the gift, although he is not required to include your name on the card. You may want to follow up with a personal note if you enjoyed yourself and became friendly with the couple.

Usually refers to an evening event, so sequins are fine.
Informal—Depends on where you live. In the suburbs it usually means pants and a nice sweater or blouse, dressier at night than day. During summer months, dressier means bolder jewelry or dressier fabrics (silk shantung, velvet, cashmere).
Cocktails—Short dress, cocktail suit, or dressy pants, often in black. Today, when many cocktail parties are scheduled immediately after work, women may want to change only their shoes or accessories, and open their jackets to reveal a dressy camisole top.
Cocktail casual—Slacks or skirt with a nice sweater or blouse, or knit separates in nice fabrics. Festive jewelry, shoes, scarf, or belt.
Urban chic—Basically, wear what you wear to drop in at someone's home on Friday night. The term denotes a host's desire that you show up dressed comfortably: not too dressy, but not sloppy, and not in work clothes. All black is a safe bet.
Dressy casual—Means you need to gussy up. Wear simple, comfortable clothes but in more luxurious fabrics or fun patterns and colors. It is the perfect time for a great white shirt and black silk pants or a twinset with trousers and pearls.
Pool attire—Women might wear long caftans, patio pajamas, Capri pants, and sundresses. Do not wear swimsuits unless your hostess specifically commands it, and then be sure to take a cover-up. Accessories can be bold, colorful, and cheap.

> " *So that on a morning when she awoke, in high spirits she would raze the clothes closets, empty the trunks, tear apart the attics, and wage a war of separation against the piles of clothing that had been seen too often, the hats she had never worn because there had been no occasion to wear them while they were still in fashion…She would say: 'Someone should invent something to do with things you cannot use anymore but that you still cannot throw out.'* "

GABRIEL GARCÍA MÁRQUEZ, *Love in the Time of Cholera*

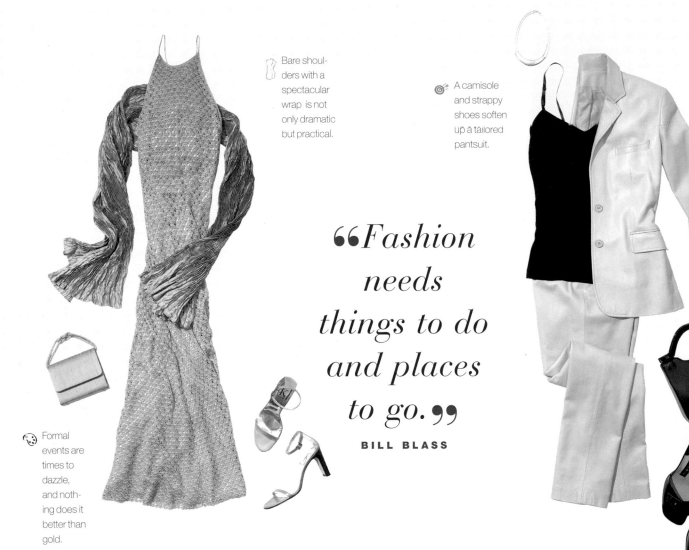

Bare shoulders with a spectacular wrap is not only dramatic but practical.

A camisole and strappy shoes soften up a tailored pantsuit.

Even an outfit in the most conservative of cuts develops attitude when it's made in supple lambskin.

Formal events are times to dazzle, and nothing does it better than gold.

> *"Fashion needs things to do and places to go."*
>
> **BILL BLASS**

Part of the fun is that the scene has evolved into a fashion show of *the* most glamorous evening attire. Stylists to the stars scout designer showrooms and jewelers to find the perfect outfit and accessories so they can score high fashion marks with the press and fans. If you are one of the lucky attendees, be sure you wear clothes that express the real you, as opposed to what somebody else is saying. And practice walking in those high heels and slinky dress to be sure you can make your entrance in a relaxed manner.

Artists are creative and often determine their own fashion code, so you can feel less anxious about your own fashion choice. These events are usually held after work, so suits are popular, although it's a great opportunity to wear something more cutting edge. If you want to dress your suit up, change into a camisole, ditch the big bag for a smaller whimsical one, and trade your sensible shoes for less sensible ones (yet bear in mind that you may be standing for hours).

Tailgate Party

Garden Party

Sometimes the dress code doesn't require dressing up, but you may still want to look a little special. A silk scarf and quality accessories may be all you need to add to your weekend clothes.

A white dress can look demure or dramatic, depending on how you accessorize.

Elaborate traditions are often in evidence at equestrian events or at homecoming football games, where sumptuous picnics are not uncommon. There may be tablecloths, candelabras, and fabulous food. In fact, at some events, prizes are awarded for presentation. Clothes are often stylish, yet casual. Women might wear tailored slacks with sweater sets, and fine accessories. Shoes should be sturdy for dirt or mud. Don't wear riding gear unless you are riding.

Silk, linen, or fine cotton sundresses long or short and slightly bare look wonderful. White and pastel prints also look great in a garden. Hats are optional, though they are functional and stylish outdoors. Avoid spiky heels or you'll sink into the ground. Consider wearing a citrus fragrance from the neck up (you want to stand out from the scent of the surrounding garden), and OFF! from the neck down. Don't forget your sunglasses, especially as the sun begins to set.

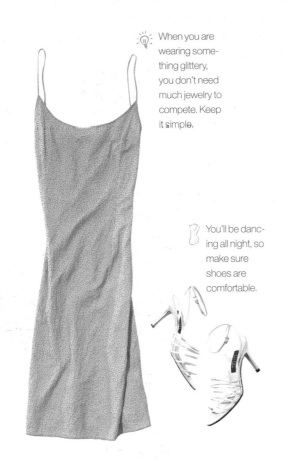

When you are wearing something glittery, you don't need much jewelry to compete. Keep it simple.

You'll be dancing all night, so make sure shoes are comfortable.

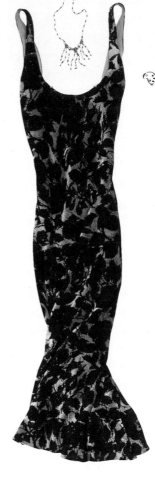

Wearing all red is sexy and will definitely attract attention, unless everyone else has the same idea.

If a dress is intrinsically dramatic, you don't *need* a necklace. Then again, why not?

Debutantes are required to wear long white dresses with long white gloves. Guests should not. If you are the mother, long is appropriate, yet ballgowns are matronly. Friends can wear short, dressy dresses, although long is fine. Choose a strappy or strapless dress, or a bias-cut sheath—simple yet elegantly adorned with beading or jewelry. Long silky chiffons and florals look good in summer; velvet and silk sheaths look great in winter. If you're not the deb, don't wear white.

Charity balls are glamorous fundraisers. They are also one of the few events where one can get really dressed up anymore. Women who attend these regularly need a wardrobe of evening dresses, and often have the money to wear ones that are memorable. The more practical woman, or the one who has less need for them, may choose to wear a simple long black sheath that can be transformed by accessories and hair. If you have the jewelry, this is the time to wear it.

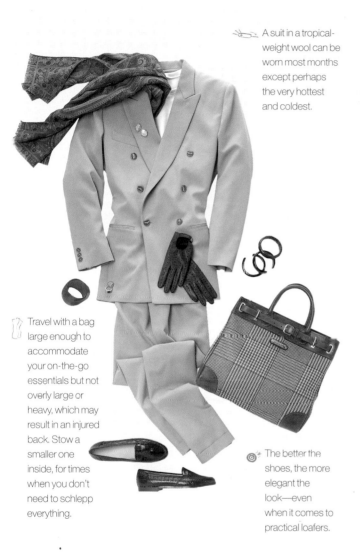

A suit in a tropical-weight wool can be worn most months except perhaps the very hottest and coldest.

Travel with a bag large enough to accommodate your on-the-go essentials but not overly large or heavy, which may result in an injured back. Stow a smaller one inside, for times when you don't need to schlepp everything.

The better the shoes, the more elegant the look—even when it comes to practical loafers.

A pantsuit has the formality of a man's suit, but in a relaxed cut and a soft fabric with a decorative pattern it becomes less severe.

Sexy stiletto slides give a surprising twist to conservative wear.

Women who travel from city to city on business need to develop an expertise in packing. Dallas chic and New York chic are not necessarily the same thing. To ensure your business attire is taken seriously, invest in one exquisite suit. Its superb tailoring, seasonless fabric (which doesn't wrinkle without a fight), and neutral color will be your uniform. Depending on the city and the event, you can change the shoes, the bag, or the shirt—or even go bare underneath.

Everyone is generally casual about theater dress, especially if the performance is a matinee. Pants are typically paired with a jacket or a good sweater or blouse for a weekend performance, unless you will be going on to a more formal dinner afterward. For weeknight theater dates, most people wear the suit they wore to work. On opening night expect to dress up—even formally if you are going on to a cast party or if it's linked to a benefit gala afterward. In this case you could wear your good pantsuit, dressed up with a beaded top and your very best accessories.

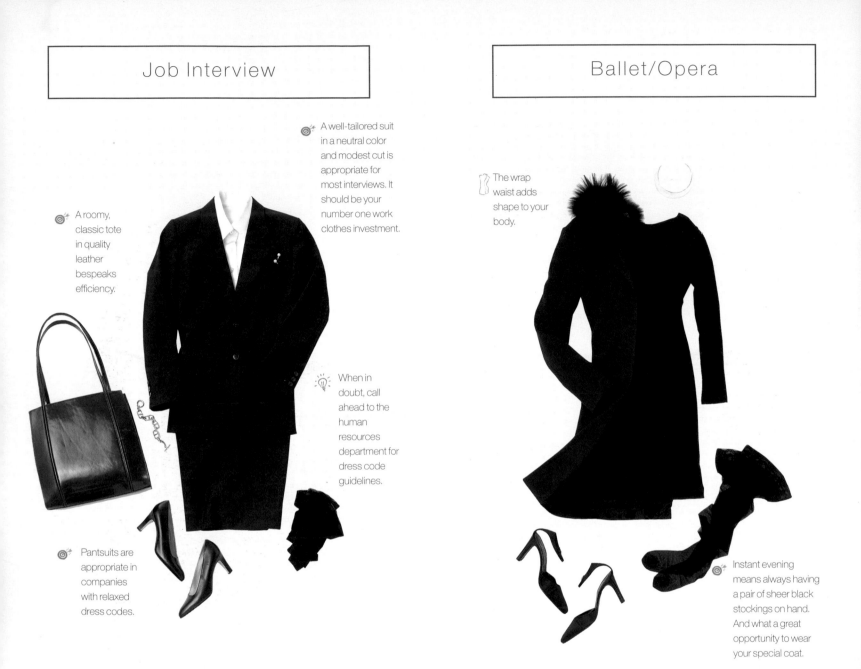

A well-tailored suit in a neutral color and modest cut is appropriate for most interviews. It should be your number one work clothes investment.

A roomy, classic tote in quality leather bespeaks efficiency.

When in doubt, call ahead to the human resources department for dress code guidelines.

Pantsuits are appropriate in companies with relaxed dress codes.

The wrap waist adds shape to your body.

Instant evening means always having a pair of sheer black stockings on hand. And what a great opportunity to wear your special coat.

Always wear a suit in a neutral tone like gray, navy, black, or beige. Stick with wrinkle-free fabrics and knee-length skirts. Keep accessories to a minimum and stay away from high or clunky shoes. Hair and makeup should be neat and subdued. Keep a pair of hosiery in your bag—just in case. Try to fit your style to the place where you're interviewing, but don't wear something you would never normally wear—your discomfort will show. Err on the conservative side.

Usually people come right from work wearing a suit. The ballet or opera may be dressier on opening night or on weekends (date night). A pretty dress or evening suit will do. If it's a fundraiser, it may call for big-time black tie. Don't wear noisy jewelry, and turn off your watch alarm. No big hats, high hair, or intense perfume. The dress code in Europe is dressier than in the United States. In Sante Fe, performances are held outdoors and the dress code is casual.

Auction

Velvet is a rich winter fabric that can be worn day or night, but it demands upkeep: Clean at the end of the season—too much dry cleaning is bad for any garment. Store on padded hangers. Steaming will help revive crushed pile.

Entertaining at Home

A shirt worn open over a camisole is an alternative to a summer cover-up.

Parties are times when you can wear the bold patterns and bright colors that are inappropriate to wear to the office.

Summer party shoes can be flat, strappy, and colorful—comfort is key.

An auction at one of the finer houses such as Christie's or Sotheby's can be a glamorous evening event where there is as much interest in the fashions in the audience as in the goods on the auction block. Think of the Jackie O estate or the Princess of Wales dress sales. Also, dressing up may convince your bidding opponent that you are willing to go all the way and that you have the money to back up your bid. For a less glamorous auction, wear a day suit or even a pantsuit.

It's party time, even if it's a low-key potluck dinner. And what you wear sets the mood, so dress things up—at least a little bit. It signals that getting together with friends is a special and joyous moment in our busy lives. Consider adapting at least one of the following elements: evening pants, mules, bold jewelry, an off-the-shoulder sweater with your casual clothes. Things get dressier when there are written invitations, and even dressier when invitations are engraved.

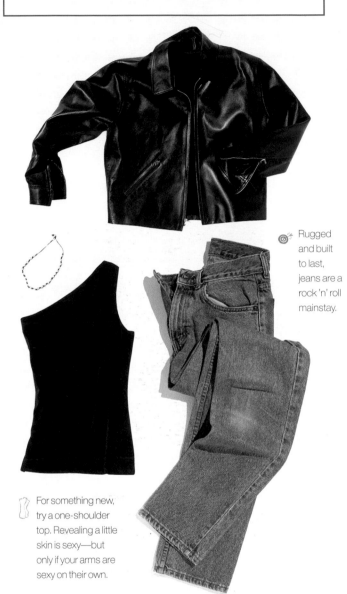

◎ Rugged and built to last, jeans are a rock 'n' roll mainstay.

For something new, try a one-shoulder top. Revealing a little skin is sexy—but only if your arms are sexy on their own.

◎ Short, lightweight dresses are perfect for a night out on the town.

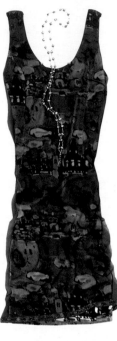

◎ An evening bag should be small: Some people think all you need to carry is a $100 bill, a lipstick, and your keys.

Never skimp on shoes: If your feet are unhappy, the rest of you follows—especially if you're supposed to be out club hopping.

Jeans are the uniform of choice at rock concerts, although leather jackets or pants have a more sophisticated attitude. You'll feel right in something as basic as a T-shirt or something strappy and sexy on top. If the concert is outdoors during the day, remember water, sunscreen, shades, and a hat. If indoors, it might get hot, so wear something under your jacket.

This is the time to look sexy or feminine—in other words, wear a dress. Whether you're swinging to a hot Latin beat or flirting in a smoke-filled room, it should be somewhat bare—the more fun you have, the hotter and sweatier you'll get (bring your compact). Shoes should be comfortable, perhaps with an ankle strap and shorter heel.

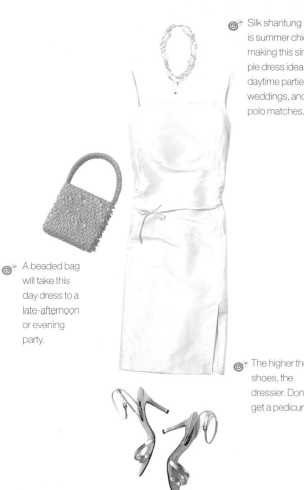

Silk shantung is summer chic, making this simple dress ideal for daytime parties, weddings, and polo matches.

A beaded bag will take this day dress to a late-afternoon or evening party.

The higher the shoes, the dressier. Don't forget a pedicure.

Keep makeup and accessories sensible and low-key.

A classic double-breasted skirt suit translates well in the legal world.

66 Here I am, a woman attorney being told I can't practice law in slacks by a judge dressed in drag. 99

FLORYNCE KENNEDY,
Sappho Was a Right-on Woman

Besides sightseeing clothes, evening clothes are required. Though cruises in general are getting more casual, the better the ship, the dressier. Caribbean cruises are less formal than European. There are usually two or three dressy nights on a seven-day cruise, where long or short cocktail dresses are required. Other evenings a pants outfit or a simple dress is perfect. Usually the first and last nights are the least formal.

Unless you're Ally McBeal, your clothing and accessories should be conservative. A suit in gray, navy, dark brown, or black is appropriate. Avoid flashy fabrics, brilliant colors, and loud jewelry. Wear your sensible leather pumps, not your sandals or sneakers. Aim to look intelligent and responsible, and appear to hold the court in respect.

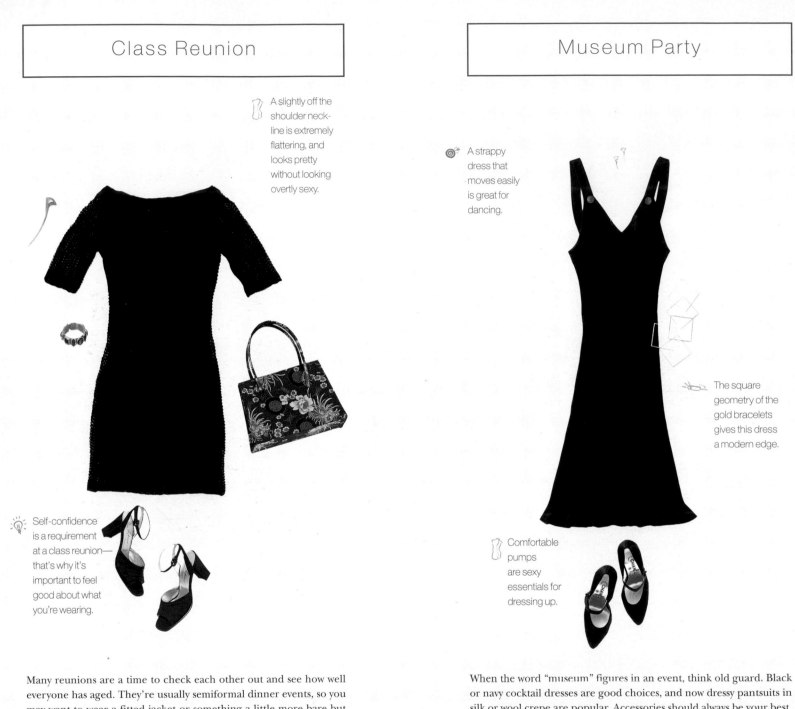

Class Reunion

A slightly off the shoulder neckline is extremely flattering, and looks pretty without looking overtly sexy.

Self-confidence is a requirement at a class reunion—that's why it's important to feel good about what you're wearing.

Museum Party

A strappy dress that moves easily is great for dancing.

The square geometry of the gold bracelets gives this dress a modern edge.

Comfortable pumps are sexy essentials for dressing up.

Many reunions are a time to check each other out and see how well everyone has aged. They're usually semiformal dinner events, so you may want to wear a fitted jacket or something a little more bare but not too revealing. Black or midnight blue is sophisticated and slimming, especially good if you're worried about those few extra pounds. Wear some great accessories, but don't overdo it. Get a good sleep the night before.

When the word "museum" figures in an event, think old guard. Black or navy cocktail dresses are good choices, and now dressy pantsuits in silk or wool crepe are popular. Accessories should always be your best. If you are invited to a gala ball at the Costume Institute of the Metropolitan Museum of Art, you'll notice women very dressed up, wearing the latest designer statement or something of their own creation. As long as it's glamorous, anything goes.

A modest coat-dress in navy pinstripes is elegant and reflects the solemnity of the occasion.

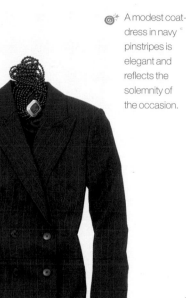

A new classic—the sailor's peacoat is transformed into glamorous day wear when luxuriously cut in a fine knit and alluring color.

Black pumps really do work well with navy blue. Otherwise it's too hard to find another navy that matches.

A knit dress and pearls are comfortable wardrobe basics that you can slip on for a variety of events that require dressier clothes than slacks, yet less dressy than your splashy party clothes.

> **66** Does fashion matter? Always— though not quite as much after death. **99**
>
> **JOAN RIVERS**

Unless you are a member of the bereaved family, black is not required. Subdued colors like navy or gray are appropriate. The spirit of the occasion is solemn, so avoid flamboyant jewelry, short dresses, or overly dressy or attention-getting fashion. Traditional attire includes skirt suits, coatdresses, and day dresses, although as the country is getting more casual, some opt for pants, especially if the ceremony is at the graveside and the weather is inclement. Consider wearing your old, yet polished, good shoes in case the ground is muddy. If you wear mascara, wear waterproof and tuck a few extra handkerchiefs in your bag.

For these events, the family usually gathers with relatives and close friends, particularly those chosen to be the godparents. Christenings are held at a church and are usually followed by a buffet lunch at the home of the parents or godparents. A good dress or suit is the proper choice— something you would wear to church. The bris is the ritual of circumcision for male babies and signifies the bond between Jewish males and God. For girls, there may be a baby naming in which she is blessed with her Hebrew name. These take place in the home or synagogue and are followed by a buffet meal. At home, wear a dress or skirt; in a synagogue, wear a suit or dress that would be appropriate for religious services.

Black is elegant, yet a little extra sparkle will be dazzling on the receiving line and the dance floor.

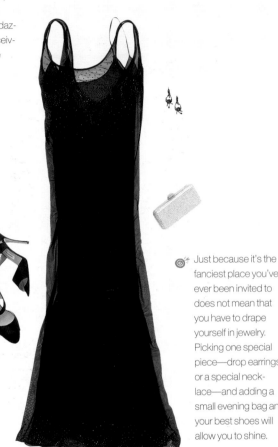

Just because it's the fanciest place you've ever been invited to does not mean that you have to drape yourself in jewelry. Picking one special piece—drop earrings or a special necklace—and adding a small evening bag and your best shoes will allow you to shine.

Wear a jacket with shape, especially when on television, or your body will look ill-defined.

Red takes you to centerstage, but beware— too bright a red may vibrate in the camera's eye.

If you're invited, congratulations! We wish we were too. All in all, Washington, D.C., is more conservative in dress than New York and Los Angeles. Color is welcome, ballgowns are not uncommon—but avoid revealing clothes and avant-garde fashion statements. Then again, check out who is dressing the First Lady and who is being honored. Our invitee wore a long black-and-white silk check skirt with a black silk T-shirt and black velvet jacket. If in doubt, inquire when you RSVP.

Appear at ease (wearing clothes you feel comfortable and confident in will help). Wearing something colorful will set yourself apart from your audience, and from other speakers. A bright color like red attracts attention and signals self-assurance. Muted vertical stripes can elongate your body. If you're going to be on TV, remember that skin gets shiny and patterns tend to vibrate, so cover arms and legs and wear solid colors.

Bar/Bat Mitzvah

Communion and Confirmation

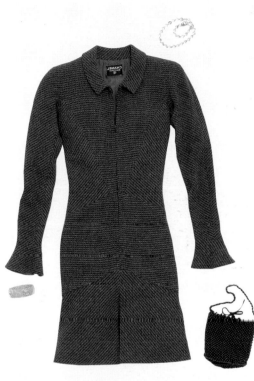

A sweater set is a relaxed, feminine alternative to a tailored jacket.

Celebrations don't mean you have to bare all—especially in a place of worship. A long-sleeved frock in a lush fabric can be beautifully stylish—just don't skimp on the accessories.

Colorful ballet slippers offer a relief from heels and look great with a variety of summer outfits.

These ceremonies mark the time when a Jewish child becomes an adult after years of studying Hebrew and Torah. In the Jewish faith this is cause for celebration, and festivities continue after the service with prayers over wine and bread, and often a buffet. The party might include a lunch or an evening affair. To a morning service, wear a good day suit or dress, making sure your shoulders are covered. At night, a big party calls for a party dress or pants (glitter is fine). Gifts are expected: Family and adults traditionally give money, savings bonds, or jewelry. Classmates might give gift certificates to music, clothing, or fitness stores.

These are ceremonies in which Christian boys and girls take their place among the members of the church congregation, and guests should wear the same dress they would for conservative religious services. A long skirt, a pretty dress, or a pantsuit is appropriate; head coverings are no longer required. After the church services, family and close friends are usually invited to the parents' home or to a private club for lunch. Some families celebrate with gala affairs—remember *Godfather II*—although these are unusual. Because most of these ceremonies are in late spring, light spring clothes are in order.

The bride herself may be wearing a short dress or pantsuit nowadays, so guests have more options. Although white and black are acceptable in most areas of the country, guests in more traditional places like the South wear color. Shoulders should be covered during the ceremony in a Jewish sanctuary, but the cover-up can be removed during the reception. Cocktail dresses are often worn for evening weddings, although long dresses and dressy pants are also acceptable. Suits or dresses are popular for day weddings, but save the glitter and beading and sheen for evening weddings. Often the dress for a rehearsal dinner is less subdued than for an afternoon wedding. Long evening skirts, palazzo pants, and cocktail dresses are appropriate.

◎ An elegant dark dress with glimmering accessories is festive, not mournful.

◎ Ingredients for a dressy pantsuit: shape, sheen, and fine button details. In a metallic lamé or taffeta, there is no confusion as to whether pants are appropriate for an evening wedding or rehearsal dinner.

" My boyfriend and I broke up. He wanted to get married, and I didn't want him to. "

RITA RUDNER

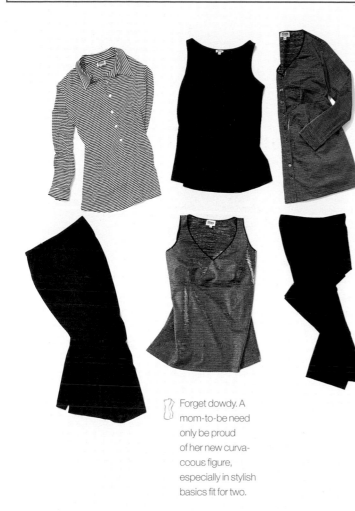

Forget dowdy. A mom-to-be need only be proud of her new curvaceous figure, especially in stylish basics fit for two.

Turtlenecks provide no-fuss style—in black cashmere they're considered comfort clothes.

Check treads on your athletic shoes before your departure. With regular use, sneakers should be replaced every 200–300 miles.

First the waist goes, and then it doesn't stop. Your breasts get fuller and your clothes no longer fit. When accumulating maternity clothes, use basic wardrobe principles: Build around a neutral color; pieces should be interchangeable; darker colors are slimming and work with a variety of brighter colors and patterns. A dark skirt and leggings will get you through both dressy and more casual occasions. The tops are what make the difference. Now there are more clothes available for pregnant women who demand style. Though tradition calls for covering up with loose clothes, those with great bodies (Jada Pinkett Smith, Elle MacPherson) choose to celebrate their good fortune by wearing stretch dresses that hug the body. Why not? But if you like a more private celebration, still consider showing off your good points. If it's your legs, wear your skirt shorter. Or consider baring your shoulders or newly enhanced décolletage. Jewelry can be bolder, drawing eyes to your radiant face.

The goal is physical and spiritual rejuvenation through exercise, meditation, and a healthy low-cal diet. It's not about fashion, hair, and makeup, yet that doesn't mean you don't want to feel you are looking your best at all times—that's why you're there. Basically, you need comfortable clothes for the various physical activities: leotard, tights, athletic shoes topped by layers for early-morning treks—T-shirt, turtleneck, polarfleece vest, sweatpants. Bring along a backpack to hold the layers of clothes you peel off as the rising sun burns off the early morning chill and you burn off calories hiking uphill. Dinner may mean jeans worn with a cotton shirt, cashmere sweater, and comfortable loafers. You also may need a light jacket or fleece sweater.

regional guidelines

GENERAL GUIDELINES

Geography isn't nearly as important as it once was in determining how we dress. We're all exposed to more and more of the same influences, and inevitably our tastes have become more global, less local. Formal dress is where geographical distinctions still apply—not so much in what we choose to wear as in when and how we wear it. In order not to look like a tourist when traveling to another region for business, a special occasion, or even a holiday, it may be helpful to understand characteristics of different parts of the United States and the world. A savvy dresser will be able to remix her existing wardrobe to suit her destination.

Unless you're traveling overseas for business (in which case basic business attire is almost always called for), you are traveling to see and experience other cultures when going abroad. "Respect" is the operative word. Some general notes:
• Most countries—especially developing countries—are more conservative in dress than the U.S. Longer skirts, no shorts, no low-cut blouses, no tight clothing, some kind of head covering, shoes on your feet—these are the basic rules. Read a guidebook before you go to find out the specific customs of the place you are visiting. You will feel more comfortable, and so will your hosts. • Generally, women should dress more conservatively when traveling alone. Sometimes wearing a wedding band can discourage unwanted attention. • Style in cities is often less conservative than it is in rural areas. • Be prepared for very specific rules regarding dress whenever you are visiting a religious site. The usual code involves covering your head, arms, legs, and feet—or some combination thereof. Slip-on shoes can be very useful for visiting shrines and mosques, as you will be expected to wear slippers or socks inside. A scarf can be an instant hat, convenient for respecting local customs. • Steer clear of native dress unless you learn otherwise. It can look patronizing and silly. • Bring at least one bathing suit that has some coverage, until you're sure about how much skin is too much on the beach. • Bring something nice for the evening. It doesn't have to be fancy, but in most places outside the U.S. people change clothes for dinner. In some countries you may be eating on a floor or mat; it's important that you dress appropriately and comfortably so that you will be able to bend your legs to the side without being too revealing.

And just because you are a tourist does not mean you have to look like one. When traveling to any urban area, do not wear shorts (unless they are long and nicely tailored), T-shirts emblazoned with logos, or athletic clothes, except for sneakers.

REGIONAL

MIDWEST (CHICAGO AND DETROIT)
Fundraisers
Cities like Chicago and Detroit are more cosmopolitan than other parts of the Midwest. Black-tie fundraising events take place quite often in these cities, especially on weekends. Women wear cocktail dresses or pantsuits to black-tie events in dressy fabrics like velvet and satin. Accessories are dressy and unique. Velvet scarves, stoles, wraps, cashmere shawls, velvet gloves, velvet and beaded evening bags are popular. The popular colors for formal dress for both men and women in the Midwest are black, deep browns, midnight navies, and dark purples.

Entertaining at Home
Because of the increasing casualness of the workplace (which is widely accepted in regional parts of the Midwest, including Minneapolis), people are entertaining more frequently at home and like to dress festively, whether it's a casual buffet or more formal setting. Dresses or an evening suit are the preferred clothes. In Chicago, for example, there is very little seated dining. Even in the most lavish of apartments, buffets with lap eating are the norm. Cocktails are at 7, dinner at 8, home by 11. While there are no toasts and little drinking, martinis and cigars are popular. People do sit-down dinners at restaurants and use place cards

Work
Work clothes in the Midwest differ between the cities and the regional areas. In Chicago and Detroit, women dress up for work in suits. In Minneapolis and other regional cities, women are comfortable with the workday casual look, wearing khakis and sweater sets. There are a lot of day-to-evening looks.

Weddings
Weddings are very festive here—an excuse for an elaborate party. Brides usually wear long white dresses, even if it's their fifth wedding. Vera Wang is most popular. Receptions are at the Four Seasons, Ritz Carlton, a private club, or a weekend house or farm. Business associates are included. Guests wear a lot of Escada, long or short, Carolina Herrera, Chanel—cocktail dresses with jackets, taken off for dancing. Guests do wear black, often Donna Karan or Richard Tyler. The clothing line is very sleek, very Armani or Ralph Lauren. Zegna is also very big. Bridal pearls, even in the hair, are very popular and there is always someone at the hair salon who does hair exclusively for weddings.

Graduation
Guests wear day suits, most typically by Richard Tyler, Carolina Herrera, Armani, or Ralph Lauren.

Miscellaneous
People wear exercise clothes to run errands in Chicago. Evening bags are not that important. Social life revolves around the Chicago Bulls and a lot of entertaining is corporate. In Lake Forest, people are still entertaining with seated dinners and place cards at home.

NORTHEAST (BOSTON)

Fashionwise, there is a division between suburban and urban women. The suburban woman is slightly more conservative and wears brighter colors and lower hemlines. The city woman prefers trendier fashions, in more subdued colors and with higher hemlines. For evening wear and charity functions, most women will wear a little black evening dress but personalize it with an evening jacket—say, a lace bolero. It is an intellectual city, which gives rise to individualism and trend setting. The younger set wears black-tie formal attire when going clubbing. Because of the cobblestone streets and the periodically inclement weather, women most often wear low heels.

NORTHEAST (NEW YORK)

Women are fashion-conscious yet iconoclastic. New York City is considered the fashion hub of the country, and many trends start there. The city has international and cosmopolitan influences, which allow for the development and acceptance of an individual's personal style. For evening functions, what women wear depends on the crowd they're with: For most formal parties, long dresses with quality accessories will do nicely; the old-money society set dresses simply and elegantly for black-tie charity functions; for glitterati-literati openings and events, women dress dramatically, and not necessarily in a traditionally formal manner. The newest, cutting-edge designs are popular and usually photographed on women by the fashion reporters. Many New York women own a little black dress, which can be worn to a variety of events simply by adding or subtracting accessories. Many people are label-conscious. They often mix separates, which contributes to enormous personal style, a hallmark of New York dressing. Colors are urban standard: black, charcoal, chocolate, beige, and white. Grooming is as important in New York as what you wear. Pedicures, manicures, haircuts and color, and groomed eyebrows are essentials. Suburban New Yorkers are much more relaxed and colorful.

NORTHEAST (WASHINGTON, D.C.)

The suit is key in D.C. and women wear color. The quilted Chanel-like bag is popular and the no-nonsense suit is worn after dark, dressed up with a scarf or pin. A lot of women buy clothing through catalogs. Women in D.C. also avoid

making fashion statements and frown upon seductive dressing, since they want their political views, power, and influence to make their statement. Washington entertaining is often in the home. Politics is the talk—read the newspapers, magazines, and listen to the news on TV and radio to keep up. Mixing Democrats and Republicans can liven things up. People's political standings may change, but as Sally Quinn, a Washington journalist and hostess, says, "You should never count anyone out in Washington, because they always come back." For more of Quinn's words of wisdom, we recommend her book, *The Party! A Guide to Adventurous Entertaining*.

PACIFIC NORTHWEST (SEATTLE)

Women are more concerned with being comfortable than with being on the cutting edge of fashion. Precious high heels and suede shoes don't last long in a city where it rains constantly. Many women wear sneakers on the street to preserve their dress shoes. As in other cities, fitter women wear barer fashions and shorter hemlines. Many women live up to the West Coast stereotype of being slim and health-conscious: They may even race-walk or go to the gym during their lunch hour. However, because of the notoriously bad weather, there's an equal number of women who avoid the outdoors and sports altogether and tend to be overweight. For formal evening occasions, women tend to wear a classic dress (narrow cut, hem to just above the knee; not a cocktail suit) in black or jewel tones. Leather backpacks and soft Coach and Dooney & Burke shoulder bags are popular. Structured handbags are considered overly formal. Accessories are where women indulge in being fashionable: This season's choker or branded belt buckle will be the way a woman updates her look.

THE ROCKIES (DENVER)

Because the West is oriented toward outdoor athletics, women like showing off their good figures with short hemlines and form-fitting clothing. In the eighties, many Texans moved to the area, imparting some of their characteristic fashion flashiness to the social scene. There are more charity functions per capita in Denver than in any other city in the country, providing many occasions for formal dress. Women's evening wear is understated and elegant. The little black cocktail dress predomi-

nates, but women will wear ankle-length gowns for very grand events.

Westerns

Many events in Denver call for "creative Western elegance." Men often sport Western tuxedos that feature a yoke cut, satin lapels, and silver conch buttons. They also wear cowboy classics such as frock and cavalry coats harking back to the 1850s. Women typically wear broomstick skirts and matching Western jackets with nickel or silver conch buttons to events that call for Western elegance. Other women might wear an expensive animal-print gown with a suede fringe Western jacket. Such Western clothing has become an art form in cities like Denver and can be very expensive indeed.

Weddings

Western-style weddings are popular. Oftentimes the bride will wear a cowboy hat with a veil attached. These weddings can take place at country-Western bars or on top of Lookout Mountain (the burial spot of Buffalo Bill), and often feature authentic Navajo music bands.

Entertaining at Home

Home entertaining often takes place at people's ranches and mountain homes. In general, men and women dress casually when entertaining at home.

SOUTHEAST (ATLANTA)

All in all, Atlanta is a casual city, aflood with khakis and loafers. It is not unusual to see people sporting khakis and polo shirts at nightclubs and bars. Black is not as popular a color in Atlanta as it is in New York. On the contrary, teal, gold, and red are prevalent colors among women. Society women wear khakis, the "great white shirt," and expensive loafers, belts, and bags when they shop and lunch. Traditional taboos are respected: After Memorial Day and before Labor Day is the only period of the year to wear black patent leather shoes or white shoes.

Some of the strict Southern fashion rules seem to be fading in Atlanta. This is probably because of the city's booming business sector, which has relocated people from around the world. Taffeta and hoop skirts have been replaced by clothing that can be worn both to the office and to the symphony.

Southern Weddings

A big wedding in Nashville is always at the Belle Mead Country Club, just as in Atlanta it is at the Driving Club. Even if you have a huge house with a big garden you would never have the wedding at home. In the Delta, however, you would most likely have a big wedding at your house and only occasionally at a country club. Weddings are always at night, at 8 p.m., probably because it's so hot during the day. The invitation says "Cocktail-supper" and dinner is not seated. There are massive amounts of food—most important, homemade rolls and tenderloin. In Nashville, Charlie Cates is the big caterer and the food is passed on platters, but there is also a spread on a long buffet table. At Belle Mead, finger sandwiches such as watercress or cucumber are passed around as late as 9 o'clock. Later, smoked salmon, tenderloin, a raw bar, and caviar are served. Vera Wang is very big for wedding dresses, which are always long and traditional. A wedding is always very formal—black or white tie. The wedding party is in white tie and the guests wear black tie. A lot of people wear long dresses to weddings, although a cocktail dress is acceptable. The bride's mother might be in a cream or pale-yellow dress. It is perfectly acceptable for guests to wear black or navy to weddings in Nashville and the Delta.

Rehearsal Dinner

Most rehearsal dinners are black tie, and most weddings, particularly if they're big and include a lot of people from out of town, last three to four days.

Weekend Wedding Events

Thursday: Informal cocktail party or barbecue.
Friday: Very formal rehearsal dinner, black tie and dancing; women wear cocktail dresses or very dressy Armani pants.
Saturday: The day of the wedding there is a big lunch, perhaps at the country club where the rehearsal dinner took place. At the lunch before the wedding the bride probably wears a sleeveless summer dress with strappy sandals. After the wedding party is over, when the bride and groom leave, at about 2 a.m., the bride always wears her "leaving suit"—Armani or Calvin Klein—even if she's not going anywhere. Some people just drive around the block and then go home.
Sunday: There is often a party the day after the

wedding—very casual, something like a catfish fry at which you wear jeans. The bride and groom often stay for it.

Christenings

In the Delta these can be quite formal, with the children dressed in lacy dresses and carrying bouquets of flowers. There is usually a big social buffet lunch at the parents' or grandparents' house, not seated.

Openings and Balls

In Nashville, the big opening is not a movie or a museum but the Antique and Garden Show, which goes from 5:30 to 10:30. Women wear long to mid-calf Armani dresses. Clothes are sleek, and a designer like Pamela Dennis is very popular for her cream and butterscotch-colored fabrics. Alfred Fiandaca, another very popular designer in Nashville, does a lot of organza outfits. Gowns by both Dennis and Fiandaca are worn to grand events like the Hunt Ball and the Swan Ball in Nashville. In Nashville the women wear a lot of jewelry—big important brooches, necklaces, earrings. In the Delta area, dressing is more risqué and less jewelry is worn.

Entertaining at Home

Dressy silk or chiffon pants are worn by the hostess, and the guests come in either cocktail dresses or silk pants. You have either a seated dinner or a "buffet supper." In Nashville, at one kind of dinner you are given a tray by a butler. A big Christmas party at home would always be a "cocktail supper."

Tailgate Parties

These are still very big in the South, and the most ritualized event takes place at "The Grove" in Oxford, Mississippi, before the Ole Miss game. You have a very elaborate picnic on the spot where your grandmother had her picnic (families have their own sites). There are silver candelabras and white tablecloths, and women wear "tailored casuals"—khakis with blouses, flats, and cashmere sweaters but no jeans.

Steeplechase

The steeplechase in Nashville is a big event. Women get extremely dressed up in floral, pastel, or cream dresses and suits with high heels. They often walk around in the mud and grass in these.

Clubs

At some establishments like the Belle Mead Country Club or the Driving Club, women are expected to wear very traditional clothes, either a silk dress or a good suit.

Debutante Balls

They are still very big in the South. During the summer before the winter when the young women "come out," there is a very formal tea. All the debutante balls are black tie, and most women wear long gowns. After the ball itself, there is a "cocktail supper" at the house of the debutante, where hot seafood and crabmeat morné on toast are served. Many of the women guests get dressed up in chiffon and accessorize with a lot of jewelry.

Miscellaneous

Holly's Harp cut velvet and printed chiffon are worn by both old and young. For a dinner party in New Orleans or in Nashville, very narrow gabardine pants and a Fortuny-type shirt of chiffon, often printed with flowers, is a kind of set look that works in these towns. Women are practical but not prissy. Style is always ladylike, which is the most important dressing guideline for women. Tailored feminine elegance is admired more than trendy extremes.

Charity Balls

Charity-ball season is between November and January. Women who attend these events shop for new formal wear almost every season so as not to wear the same dress over and over again. Huge ballgowns are considered excessive. Dresses, not pants, are worn for evening.

SOUTHWEST (HOUSTON)

Texas women have a well-deserved reputation for being the most dressed, if not the best dressed, in the nation. It is not unusual for women in Houston or Dallas to change clothes three times a day. They begin the morning in upscale exercise clothes, which they also wear to run errands; change into a chic suit or pantsuit for lunch and shopping; then into a cocktail suit, dress, or formal wear for evening. And if a woman has good jewelry—stones one might refer to as "jewels" rather than jewelry—she wants clothes that show these off. Destination dressing is the rule rather than the exception in

the Southwest. Heat, humidity, bitter cold, and the chill of air conditioning have a lot to do with this, but even career women tend to change clothes for the evening. With the revitalization of downtown areas, however, young people and urbanites of every age are finding that cocktails, tapas bars, and clubbing immediately after leaving the office are making them rethink their wardrobe choices. Still, black leather and Prada bags have not replaced the cachet of Chanel and Armani labels.

Dinner at Home
Entertaining with dinner at home is on the upswing in the Southwest, although lots of entertaining is still done at fine restaurants and at private clubs. At home, women almost always wear short dresses or pantsuits. In Houston, the March of Dimes, perhaps the most socially elite charity, has ditched its annual ball in favor of 10 dinners for 50 guests in private homes, and people are most anxious to attend—at any price. Black-tie dinners in private homes are rare but growing in popularity and tend to be for very special occasions.

Entertaining Out
Most people who choose to entertain outside their homes in Houston select a private club or nice restaurant, the most prestigious being Tony's and Café Annie. The latter is nice for out-of-town guests who may not have tried Southwestern cuisine. In Dallas, dinner at the Mansion on Turtle Creek is the meal of choice.

Weddings
In Houston the best weddings are almost always held at a large church, even for the second or third time around. The same is true in Dallas, although some weddings and receptions are held at the Mansion on Turtle Creek. Others might be at the staid Dallas Country Club or the Tower or Petroleum clubs. In Houston, a big wedding reception is usually held at one of the private country clubs—River Oaks, Houston, or the Bayou Club. The latter, by the way, is pronounced Buy-oh Club. Anyone who says Bay-oo is immediately branded a Yankee.

The designer of choice in both cities is Vera Wang, although in Houston women love the couture designs of Lisette Lux, whose creations run from beaded extravaganzas to Texas wild-flowers sensitively embroidered on Swiss cotton.

Guests at weddings dress to the teeth. In fact, daytime weddings may be the only occasions when women still wear dressy hats anymore, although they are by no means standard dress. Daytime wedding dress runs to dressy suits and pantsuits and dresses with jackets. Evening weddings tend to be black tie, even when the reception is a cocktail buffet. The most lavish weddings always include seated dinners afterward.

Polo
Polo is an important and growing sport in the Southwest, no matter the horrors of the climate. In Dallas, women tend to dress up more than in Houston, where it's not unusual to see shorts, sandals, and even jeans—sometimes jeans without designer labels. Stockings are usually not worn at the Houston polo grounds unless the weather turns nippy.

Cattle Barons' Balls
Both Houston and Dallas charities host these galas, day into-evening events held at local ranches. Because they tend to be held in warm-weather months, dress is always a problem. It is difficult to find Western or Santa Fe wear that is cool without making the wearer look as if she only recently stepped out of a dance hall. Suede and leather—often teamed with denim—reign supreme, but make sure they are lightweight. And for these events, it is always appropriate to wear your denim with diamonds.

Ranch
Usually on fall weekends, these social events generally involve shooting, primarily birds. Wear a pantsuit, fancy jeans with a great top, and resort ranchwear but certainly not dude ranch. On weekends Texans invite friends who own neighboring ranches to parties. Many people fly into their own ranches or to small airports nearby, where they keep any number of sport vehicles.

Weekends on the Water
A lot of Houston entertaining actually occurs at beach houses in Galveston, especially in the upscale Pirate's Cove subdivison. Dress is akin to resort wear, common fabrics being linens, cottons, and silks. Do not show up in beachy tank tops or cut-offs. The women are always coiffed and accessorized, no matter how hot it is. (The beach houses are all air-conditioned, as is every other indoor venue in Texas. If the chill bothers you, take a sweater or a wrap.)

To Bare or Not to Bare?
This is one of the biggest controversies in the South and Southwest, but women here, in spite of the heat and discomfort, continue to wear stockings—usually pantyhose—for weddings, church, luncheons, and most evening events. The only time women here may remove their stockings is when they are wearing extremely casual clothes with flat shoes or if they are "fashion forward."

TROPICAL (MIAMI)
Pastels are not as popular as they once were in this region. Busines wear has been influenced by the influx of South and Central Americans conducting business who tend toward darker, more urban colors. In South Beach, evening attire is the barest of bare: Minis, cropped tops, bathing-suit tops, hip-hugger pants, and open-toed strappy sandals reign.

Entertaining at Home
Many people host a cocktail hour in their home before going out for the evening.

Charity Events
There are many charity events, including the annual Ocean Drive Party, the Make A Wish Foundation fundraiser, and the White Party (to benefit AIDS research).

Dining Out
Four-star restaurants are also upscale scenes. Women are generally dressed up for such events in Miami, wearing little black cocktail dresses and long, tight gowns. They enjoy accessorizing with minimal bracelets, necklaces, and handbags. Sunglasses are an essential status accessory.

Religious Services
Women wear mid-thigh skirt suits with boxy jackets to religious services. Coats and hats are never seen.

Sporting Events
Sporting events are popular in Miami. One big event is the The Lipton, a tennis tournament that takes place in March in Key Biscayne. The

weather is usually gorgeous and people tend toward a dressy-casual look, including expensive shoes and jewelry.

TROPICAL (PALM BEACH)

Though they're geographically close, Miami and Palm Beach are worlds apart. Palm Beach sports an old-school, old-money look.

Charity Events

Black-tie charity events are held often. Women dress in shifts and dressy cocktail dresses with shoes and bags to match. Hats and patterned, bright coats are popular. Jewelry is typically large and obvious.

Weddings

Weddings here are either at the Everglades Club, the Palm Beach Club, or at home with a big tent. The model is a royal wedding, and since most weddings take place in the afternoon, there are a lot of big hats with flowers, and knee-length pastel suits. A wedding will take place over 2 or 3 days with a party and a lunch the day before so that the people coming in from all over the world have enough to do. Dyed fabric shoes or light calf shoes are standard. Lots of jewelry.

Entertaining at Home

It's an early town, and dinner will always be seated and served. Drinks at 7, dinner at 8. Women wear chiffon, cocktail dresses, or evening pants from Armani or Ungaro, but Chanel and Valentino are also very big; Charles Jourdan strappy sandals in lots of colors and beaded tops and jackets are standard. Also popular are the Judith Leiber jeweled minaudières in the shape of an animal—women actually place them on the table as an extension of the table setting. Barry Kieselstein-Cord bags are also popular.

Polo Match

There is usually lunch in the clubhouse, where the women wear big straw hats, silk suits, or dressy pants in white or navy, or riding pants from Ralph Lauren with a white shirt and a cashmere sweater.

WEST COAST (LOS ANGELES)

An important thing to remember about L.A. is that few people are from there. For this reason, style and customs are diversified. Most women are extremely casual, yet responsive to each season's new trends. Some say the most important accessory a person can own in L.A. is a car. The weather is predominantly warm, but wealthier women will buy furs for travel. L.A. occasions range from beauty pageants to proms, Latino Sweet 15 ceremonies, bar/bat mitzvahs, Latin American weddings, AIDS benefits, and fashion shows.

The Beach

The beach is a major hangout, day or night, which means skimpier, more revealing clothing. Long skirts are rare. In L.A. black tie for women can mean a clingy dress of assorted colors, a sexy cocktail skirt suit, or a trendy slip dress.

Weddings

A favorite spot is the Bel-Air Hotel. People tend to wear sleeveless white dresses, either long or short, though Angelica Huston got married in a Richard Tyler pantsuit.

Gallery Opening, Book Party, Ballet/Theater/Symphony

None of these would require dressing up. One might wear pants and a jacket or just a top to most of them unless it were an opening night, and then a pantsuit in silk or linen. Book parties are usually held at bookstores, but even when they're not, people dress very casually.

Museum Party

Black or navy cocktail dresses, and more pantsuits in silk or linen.

Movie Opening

The stars wear short dresses or pantsuits, always designer wear, but everyone else comes from work and is very casual because the movies all start at 7:30. The stars are often in silk and sequins.

Polo Match

White or beige pants with a T-shirt or cotton shirt and a sweater around the shoulders.

Business Functions

The younger generation wears Helmut Lang or Jil Sander, and the older generation wears Armani.

Wardrobe for All Occasions

There are a lot of people walking around in ski parkas who look as though they've just been on the slopes; they're in North Face jackets, with surfing, snowboard, or skateboard wear mixed in. There is a great fetish for athletic gear, warm-up suits, etc., and Nike and Adidas shoes.

Bags

People tend to wear tote or shoulder bags; Gucci is very popular for day, and vintage 1920s bags or beaded bags are carried in the evening.

Shoes

People in offices wear Clergerie, Manolo Blahnik, or Christian Louboutin. J.P. Tod's informal day shoes are popular.

Suits

People do distinguish between summer and winter and they do wear wool in L.A., and not necessarily pastels; navy blue is very popular, and some people even wear boots.

Entertaining at Home

People eat dinner at 7:30 or 8 at the very latest; the hostess often wears pants, and at the moment, for guests, long or short Chinese dresses or Chinese pajamas with gold slippers are popular.

Entertaining Out of the Home

A black Dolce & Gabbana dress with a black cashmere cardigan by Lucien Pelletfinet.

Jewelry

Kathy Waterman makes a lot of the jewelry the stars buy, and at openings little strands of diamonds or somewhat larger strands of pearls from Harry Winston are popular.

WEST COAST (SAN FRANCISCO)

Women are sophisticated, formal, and European in style. • Weather is variable (long springs, cool summers; September and October are the warmest months) and demands a seasonless wardrobe. Light wool crepes and seasonless silks are favored; there is little need for heavy winter overcoats or clothing for steamy climates. • Women here enjoy forward-looking style and structured clothing—they're not scared of corsets. • Day-to-evening looks are popular because so many people go to an early dinner straight from work. • Sweater sets work well because the temperature drops at night. •

People look pulled together and would rather overdress than dress too casually.

INTERNATIONAL DRESS CODES

AFRICA

Generally, in rural areas skirts should be below the knee. Arms, underarms, and shoulders should be covered. Jeans and shorts are usually appropriate in cities, and formal wear is only rarely required. • Dressing neatly and cleanly is a sign of respect. It is important to wear well-pressed clothing, particularly when visiting a private home or a business office. • Throughout the Ivory Coast, the residents dress primarily in French style and are very fashion-conscious. Loose pants and dresses are both stylish and comfortable. • In Zimbabwe, dress is quite Westernized. Loose-fitting pants or skirts that are not revealing are appropriate. • Tennis shoes and sandals are often not appropriate for restaurants, which may have a dress code. • In Uganda, unlike in many other African countries, it is appreciated when Westerners wear the national dress on special occasions. This long cotton gown with a sash is called a *busuti*. At other times, a dress or skirt is appropriate, especially in villages. • It is crucial not to wear camouflage or military dress. In some countries this dress may be perceived as that of a mercenary, while in others it is actually illegal. • For viewing game, wear jeans and a parka or windbreaker. • There are some topless beaches in Senegal and South Africa. However, be sure to check ahead of time about how conservative the dress on a particular beach should be. In Uganda, Nigeria, Kenya, and Ghana, for example, going topless would be considered offensive or shocking.

ASIA

Many Asian countries can be very hot and humid, so you will want to pack clothing made of natural, not synthetic, fibers. Because they breathe, fabrics made of natural fibers are much more comfortable. Cotton, linen, and silk are best. • Hosiery may not be necessary in countries where it is extremely hot. • In China, pantsuits are particularly appropriate, since Chinese women often wear pants. • High heels, expensive purses, and flashy designer clothes are viewed as extravagant and unnecessary. • Wear as little makeup and jewelry as possible. • In China, rubber-soled shoes are a must for visiting factories

and communes, which may be muddy. • White should not be worn to a traditional Chinese wedding, since this is the color associated with death. • Wearing saris is acceptable in India, but they can be difficult to put on. • In Malaysia, yellow is the color of royalty and should not be worn to formal functions or when visiting the palace. • Wearing the native dress is welcomed in Pakistan. This consists of a long blouse, called a *kameez*, worn over pants, called *salwar*. Jeans are also perfectly acceptable on the street. • Black should not be worn in Thailand, where it is considered funereal unless strongly accented with color.

AUSTRALIA

The women of Brisbane wear similar styles as the women of Houston or Dallas. They usually dress in casual and simple lightweight clothing, especially dresses, and accessorize with gold jewelry and bright makeup. In summer months, women prefer lighter colors and navy. In Sydney, women are very aware of labels. They are among the most "fashion forward" of all Australians. During the day, conservative work clothes are the norm, while outdoor dress is very L.A. in style, with shorter skirts and lots of exposed flesh. Women living in the Melbourne region are very sophisticated and fashion-literate, yet carry themselves with conservative style and color. The look on the weekends is natural and relaxed.

ENGLAND

The climate is a little cool and often rainy. Be prepared. The dress is conservative in general, although there is a lot of exciting cutting-edge fashion coming out of London.

FRANCE

French women are known for their quiet, discreet elegance. They know to buy less, but better quality. Feminine appeal, accessories, and solid basics are what make French women among the best dressed in the world.

ITALY

Italians are very chic and enjoy wearing rich colors and textures. They consider all black too serene and mournful. Glamorous Italian women are bare-legged in the summer and usually wear gold jewelry.

JAPAN

In general, women are stylishly dressed. • For business, all neutral colors are appropriate, except black, which is viewed as funereal. Red is considered flashy and inappropriately sexy. • Overcoats are considered unclean, so it is important to remove them in the hallway and carry them, rather than wearing them into an office for a business meeting. • In private homes or restaurants, you may be seated on tatami mats during dinner. You will be expected to remove your shoes at the entrance. Wear good hosiery and a loose skirt, and sit with your knees bent and to one side. • Shorts should never be worn except at a resort. Going topless at the beach is against the law. • You may be lent a kimono while staying at an inn or private home. Be sure not to fold the right side of the kimono over the left side, since this is a traditional symbol of death. • Japanese are extremely fashion- and designer-conscious. Conservative, quality accessories (scarves, handbags, shoes) are respected status symbols. The Japanese enjoy wearing international fashion brands from Prada to Levi's. • For traveling outside Tokyo, comfortable shoes, slacks, sweaters, blouses, and jackets are appropriate for a pulled-together yet relaxed look.

LATIN AMERICA

Any dress that is not revealing or provocative is acceptable. Casual wear means a shirt or blouse with fashionable pants or a skirt. • Throughout Latin America, shorts should be worn only at the beach. Appearing nude or topless on beaches is extremely offensive, particularly in Costa Rica. • In Argentina, bathing suits should be conservative; in Brazil they can be more revealing. • Native clothing should not be worn in Bolivia or Peru. • Be sure not to wear green and yellow clothes together in Brazil, since these are the colors of the Brazilian flag. • In Colombian and Guatemalan villages, only dresses and skirts should be worn.

MIDDLE EAST

Throughout the Arab world, shoulders should be covered, with sleeves at least three-quarter length and skirts to mid-calf or longer. • Should a formal occasion arise, a cocktail dress with sleeves is appropriate. • A shawl should be a part of daily wear in Arab countries, folded and draped over one shoulder and used to cover the

shoulders and head when visiting a mosque. Long sleeves are also customary. • Women may want to wear sunglasses to avoid eye contact with men, a Middle Eastern taboo. When sitting, women should cover their legs completely. • Arabs will be offended if you point the soles of your shoes or feet toward them. This action traditionally signifies contempt. • Visitors should wear modest dresses that cover the knees. • Jackets are excellent business wear because they look professional and are not too revealing. • Israelis tend to be very casual. Jeans and shorts are appropriate, except when visiting a religious site. But dresses and skirts should fall below the knee, and shoulders should be covered. • Formal dress is rarely required. • Sandals are appropriate everyday footwear in Israel.

SWITZERLAND
Ski

February is the height of the ski season in Gstaad, Switzerland. It's much less dressy than it used to be, although it's somewhat sport-dressy. Most women do ski in one-piece suits, either Head or Bogner. For walking around immediately afterward, they might wear fur hats and suede boots—moon boots are out.

Aprés-Ski

Black velvet or black silk pants with a big silk white shirt or dressy sweater and velvet jacket are popular for dinner. Burgundy and claret colors are also worn. Everybody wears their outdoor suede boots to the house and then changes into their dress shoes, which they carry in a little bag, once they get there. A Russian/Gypsy fantasy look is also popular—a long skirt with boots or over-the-knee boots. One fashionable hostess favors Chanel's multicolor tweed jacket-sweater, which comes almost to the knee, with a black catsuit under it for some evenings. For staying at home, leggings seem to be popular. A lot of people give theme parties, like rock 'n' roll, or Carmen-style parties, where you have to wear gold. Another is a circus theme for which you have to come as a circus entertainer. During the day, women wear jeans with cashmere sweaters, and generally jackets with fur trim rather than full fur coats or jackets.

BUSINESS DRESS
Work

When grooming for work, keep in mind:
1. Cleanliness (hair, nails, clothes).
2. Neatness (clothes should not look as though they've been crumpled on the floor for three weeks).
3. Respectable hygiene (deodorant, mouthwash).
4. Perfume should be subtle.
5. Avoid overly dressy clothes.
6. Avoid too much hair, makeup, and jewelry.
7. Avoid overly bright colors (fluorescents).

If your office has a casual dress code and allows for bare legs in the summer, keep them free of hair, and consider applying self-tanning makeup for an even tone. Underarm hair should never be exposed on the job. Fingernails should always be clean and well kept; nail polish is not necessary. Decals or other expressive designs should be saved for Halloween. If your toes show, they too should be clean and well kept. A pedicure at the beginning of the summer will get them into good shape, making maintenance a lot easier. Makeup: Not everyone has that smooth, evenly pigmented, glowing skin. You should wear light foundation, concealer or powder, mascara for eye definition, and perhaps some glossy or sheer lipstick. Fragrance: Wear deodorant (like, we had to tell you that) and keep the perfume light. Too much perfume is just as offensive as bad body odor.

Meetings

For meetings held in restaurants, follow the office-dressing guidelines. Out-of-town conferences usually call for clothes that are more casual than everyday business wear. Sweater sets and gray flannel trousers work well. Avoid short shorts, no matter where the conference is being held. Inquire ahead of time about what evening clothes are needed.

Office Parties

For office parties held in the workplace, consider something slightly more dressy than everyday clothes, like a dress or jacket. Use texture to dress things up (e.g., satin shoes or a velvet scarf). You can also add simple accessories to what you're already wearing. The main guideline is to not overdress.

Basic Corporate Dress-Down Don'ts

Short shorts
Exercise clothing
Sweatpants or sweatshirts
Tank tops
Jeans that are too tight or have holes in them
Spaghetti straps
Anything low-cut
Bare midriffs
Anything see-through
Thongs, backless shoes without a strap, casual sandals
Baseball caps
Skirts shorter than three inches above the knee

Creative Fields

Journalism, publishing, multimedia, advertising, graphic design, art galleries: Your own style is more important here. You are being hired for your creative talents, so show them off in a subtle way, by dressing with personal flair. While on the job, journalists in particular should learn to match their wardrobe to their assignments.

Service-Oriented Jobs

Retail, restaurants: These jobs are all about looking presentable. Try and get a sense of what the company's style is before you go in for your interview. Then adapt your own look.

Getting the Message Across

Don't fidget—even small movements are noticeable, especially on television. Watch your posture. It can affect everything from how your suit looks to the strength of your voice. Choreograph your gestures to correspond to what you are saying. Maintain eye contact with the interviewer, not the camera. Shift your focus from one of the interviewer's eyes to the other. (This adds sparkle to your face.) Remain calm enough to remember what others are saying. Don't recite scripted phrases—you will sound insincere and robotic. Make sure your voice has a round, resonant sound. Drop your voice slightly at the ends of your sentences, so that they have the air of statements, not questions. Practice talking into a tape recorder to work on articulation. (Experts consulted: Kathleen Ardleigh, senior vice president, Ailes Communications, New York, and Dorothy Sarnoff, chair, Dorothy Sarnoff Speech Dynamics, New York.)

dressing for your body

Hollywood designers have long known the importance of showing an actress off to her best advantage. Travis Bantant, a Paramount designer in the 1920s, invented Claudette Colbert's trademark collar. His successor, Edith Head, engineered wider waistbands on the front of Barbara Stanwyck's gowns while slightly narrowing them in the back, which disguised her low-slung behind. Understanding a few basic principles will help you to accentuate the positive while diminishing the negative.

LOOKING YOUR BEST

Dark colors are slimming. From head to toe, monochromatic outfits create the illusion of height and deemphasize individual flaws or lack of proportion. Separates in different colors break up the body and highlight each area. Horizontal stripes emphasize the horizontal, making one look broader. Vertical stripes emphasize the vertical, visually elongating the body. Be sure to keep it simple in your problem area, wherever it may be; elaborate attempts to camouflage a body part will often call more attention to it.

BATHING SUITS

When bathing-suit season strikes again, you'd better act quickly or you'll be stuck wearing last year's number. If you enjoyed it then, it's likely to be a bit faded or stretched now—in other words, not guaranteed to look good for another summer. It's a cruel truth that the item we most hate to shop for is one that needs frequent replacing. But now for the good news: Though we can all point to the flaws in our figures, somewhere lies the perfect suit, designed to help us look our most beautiful. Fabrics like Lycra firm and lift; sheer panels reveal as they conceal; colors and pattern direct the eye toward one's best features and away from the worst. So relax—there's hope!

HOW TO SHOP FOR A BATHING SUIT

Wear underwear that won't get in the way of bathing-suit lines. • Allow time to try on lots of styles. • Don't let suit sizes scare you—they're often made a size larger than your dress size. • Bend, stretch, sit—does it move comfortably? Is the lining sufficient? • And think lifestyle: Are you buying a suit for soaking in a hot tub (constant heat ruins fabrics, so don't spend too much) or soaking up the rays (a bandeau top minimizes tan lines), swimming laps (a tank is best), or sheer glamour (try velvets, sheens, and sheer panels)?

HOW TO LOOK YOUR BEST IN A BATHING SUIT

Minimize the negative and accentuate the positive. • No waist? Try a belted suit or a high-waisted two-piece. • Small bust? Look for fabrics with body (velvet, crochet), details across the bust (ruffles), tops that push up and pad. • Big bust? Wide straps and high necklines offer support. • Heavy thighs? Avoid a high-cut leg; emphasize shoulders, bust, waist. • Big bottom? Try a bottom with an inverted-triangle design, so the sides ease slightly up and out. • Thick middle? Look for a princess bustline. • Pear shape? Go for bright colors on top, dark on bottom.

TIPS FOR EVERYONE

What do most women want from a bathing suit? They want comfort. Comfort in the way it moves, what it reveals, and what it hides. If we fall out of our bathing suit when reaching, it doesn't work. If it rides up when walking, we're aggravated. • Next, women want a bathing suit to help their bodies look their best. Elongate the leg with a high cut, emphasize the back with something low and daring, or strut in a bikini if it shows a body off at its best. • The best thing you can wear with a bathing suit is sunglasses, sunblock, and a smile. • Sometimes we are called to dress up, even when bathing suits are required. Cover-ups can add elegance, accessories add flair, and swimsuits in unusual fabrics or attention-getting patterns add just the right amount of gaiety.

Bottom-heavy

Your best suit has a darker bottom than top, or a high neckline that broadens the shoulders, thereby balancing the figure. A bottom that is cut wider than about 2 inches at the side seam is a flattering proportion. For a big butt, the back of the suit should look like an inverted triangle, which will cup the curve of your entire rear by grabbing it at the center and letting go of it gradually as it extends to the sides.

No Waist

Look for belted suits, high-waisted two-pieces, and color-blocked full pieces with darker midriffs.

Top-heavy

Try suits with built-in bras, wide straps, or high necklines. All offer substantial support.

Round

Go for a suit in a darker color with princess seams or vertical stripes. Also look for high-tech fabrics like microfiber to hold you in! A bikini that supports your bust with a hint of cleavage, paired with a bottom that hugs the hips and sits below the belly button, is a way to make your curves work for you.

Too Thin

Whites and pastel colors add weight; boy-leg silhouettes, horizontal stripes, and prints are also flattering. Look for suits with padded bras or a bust-enhancement feature. You want a feminine style that doesn't convey "cute."

Big Bust

Support from above and below will flatter a large bustline. Wide shoulders, thick straps, and empire waists with darts or shirring beneath the bust are ideal features. Some suits have "hidden" inner support like floating underwires or shelf bras. A deep V-neck with a slightly higher-cut armhole is another option for supporting and complimenting a large bustline.

Small Bust

Fabrics with built-in body like velvet, textured lace, and crochet add oomph. Prints, subtle details, and seaming across the bust all make the most of a small bustline.

Thick Middle

Curvy cut-outs and asymmetrical silhouettes are a sexy way to show your shape. Princess seams that trace the curve of the bust and waist minimize a thick middle. For a two-piece, try a bikini that has a bottom with a scoop-shaped front.

Pot Belly

A brief that rests just below your belly button lands a subtle curve that accentuates the body rather

Halter Top with Boy Shorts Bottom

This is generally a younger look, and is great for active water sports. The halter top shows off shoulders and downplays the bust. The shorts cover the tummy. Be sure it doesn't pinch at the waist.

Bandeau Bikini

A bandeau offers a clean tan line. Bottom dips below belly button, drawing attention to the tummy.

String Bikini

A sexy bikini adds oomph to boyish lines. The triangle top embellishes a flatter chest.

One-Shoulder Asymmetrical

Geometric lines are dramatic, but the exposure requires a firm tummy and good arms and shoulders.

Glamour Suit

Overall shirring builds up a small bust, hides a skinny body, and softens big busts, hips, or tummies.

Waist Enhancer

Contrasting vertical panels elongate the silhouette and flatter round bodies.

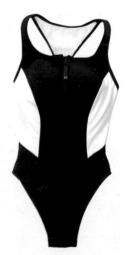

than cutting it in half at the waist (look at the way lingerie briefs are cut by European manufacturers).

Pear Shape

Accentuate your shoulders with something asymmetrical or strapless. A cropped top with a boat neck will accentuate your collarbone. Pair this with a bikini cut so the legline reaches just below your hip bone. Avoid a high-cut suit.

GENEROUSLY SIZED BODIES

There's nothing like an impeccable outfit, a flattering haircut, and good personal grooming to refute the uninformed perception that generously sized women are undisciplined. Designers and media are finally responding to the needs of generously proportioned women with clothes that are flattering in luxury fabrics, and that are well-made.

Bags

Avoid bulky shoulder bags that rest around the middle part of your torso; they only add bulk and call attention to that part of your body. Instead, carry flat bags, briefcases, or totes that draw the eye away from this area.

Belts

For hourglass figures, a belt can define the thinnest point.

Fabric

Loose, long, flowing layers of lightweight fabric are flattering. Make sure that the fabric is tightly woven, however, because it will hold its shape better. Avoid large patterns. Keep in mind that dark colors are slimming. If you want to add a bright color, do so in a long, slightly fitted blazer, oblong scarf, or vest.

Jewelry

Long necklaces, pendants, and dangling earrings can elongate the face; a pin at the shoulder can distract from a thick waist. If your neck is thick, avoid jewelry that calls attention to it, like chokers. Wear one bold piece, not a battery of pieces. Rather than camouflaging a body part, jewelry calls more attention to it. (However, it is alleged that Coco Chanel draped herself in jewelry to detract attention from her body.)

Pants

Avoid pants with straight-cut legs; wear pants only if full-cut, and in a fabric with drape so it moves gracefully. Consider topping with soft layers of vest and blouse, or a big soft sweater. A blazer that covers your hips and derrière also can create a good line.

Skirts

Unless your legs are fit, avoid short skirts and look for long, narrow skirts with elastic waists, or loose, flowing skirts. Avoid flouncy skirts; the added fabric only enlarges the silhouette.

Tops

Cover buttocks with a loose top, jacket, vest, or sweater. Don't tuck in shirttails.

Underwear

Proper-fitting, structured undergarments can streamline a silhouette.

COLOR

Use it to your advantage. Darks are slimming as are monochromatic looks. Wearing a brightly colored jacket, like a magenta, over an all dark ensemble can be very chic. Add bright colors or jewelry to draw attention to your face.

RESOLVING PROBLEM AREAS

ABOVE THE WAIST

Double Chin; Short or Thick Neck

Hair. If you have a narrow face and a short neck, short hair or wearing your hair up will give the appearance of a longer neck.

Jewelry. Wear long necklaces and small earrings. Avoid chokers and dangling earrings, which draw the eye to the neck.

Scarves. Wear oblong scarves, loose or knotted far below the collarbone. Avoid scarves tied around the neck—they will diminish neck length and attract attention to the chin.

Tops. Anything that shows more neck will visually elongate: V-necks, scoops, open shirts over a camisole, or strapless tops. Avoid mock turtlenecks, although high turtlenecks will help hide a double chin.

Long Neck

A long neck is generally considered an asset, but if you feel you have too much of a good thing for your proportions, consider the following:

Hair. Don't wear it super short; if you want to shorten the appearance of the neck, wear hair that covers the neck.

Tops. Look for high-necked clothing: cowls, ascots, Nehru collars, and turtlenecks, all of which minimize the length of the neck. Avoid off-the-shoulder necklines and V-necks. Also consider wearing a scarf at the neck.

Broad Shoulders

Some women feel the need to detract attention from their broad shoulders. It should be said, however, that the look of broad shoulders is admired and preferred by many fashion experts.

Coats. Unstructured dolman or raglan sleeves look good. Avoid any style that calls attention to the shoulders: trench, safari, coachman, or Sherlock Holmes.

> 66 *She works me out—upper and lower body—for an hour, then condemns me to twenty minutes on the bike at level one and twelve more minutes at level two. I leave exhausted, and I can't tell if my legs are coming with me.* 99
>
> **DODIE KAZANJIAN,**
> *Icon: The Absolutes of Style*

Proportion. If you're slender, loose clothes below the belt will balance out the upper body.

Tops. Break up the width of your shoulders with V-necks or deep scoop necks; wear fabrics that drape easily. If you wear straps (camisoles, spaghetti straps), choose ones that hang near the neck and draw the eye in from the shoulders. Avoid halter tops; they emphasize shoulder width. Don't wear anything that emphasizes shoulders, such as shoulder pads (which are always removable), stiff fabrics, horizontal lines, wide scoop necks, square necks, strapless styles, western yokes, or epaulets.

Narrow or Sloping Shoulders

Try to build shoulders up while still looking natural. Your proportions will be thrown off if you overbuild your shoulders.

Coats. Look for coats that have a defined shoulder, such as coachman, Sherlock Holmes, trench, or safari.

Tops. Wear shoulder pads, but be sure they rest comfortably on the shoulders—if they are too large or move around, they will look sloppy and overwhelming. Also effective are oversized tops, boatnecks, cap sleeves, epaulets, off-the-shoulder styles, and halters. Avoid drawing attention to the center of the body by staying away from neckties, long necklaces, oblong scarves, and tight tops; these call attention to the fact that the hips are wider than the shoulders. Soft-shouldered designs like kimonos, or raglan or dolman sleeves, do not help equalize the silhouette.

Large Bust

Belts. Don't wear wide belts and other styles that shorten the upper body and therefore call more attention to it.

Bottoms. If you are slender below the waist, wear pants or skirts in brighter or lighter colors than the top, or patterns. This will deemphasize the top and make the bottom part of your body appear larger.

Dresses. Avoid empire bodices.

Tops. Draw the focus away from the upper body with V-necks, open collars, scoop necklines, or large but unfussy designs. Unlined, unstructured, flowing tops or jackets in gently fitted styles are flattering. Make sure there's enough room to move freely. Avoid tight blouses or bodysuits, boxy jackets, flap or patch pockets over the chest, buttons over the chest, and off-

the-shoulder, strapless, and halter tops.

Underwear. Wear a supportive underwire or minimizer bra with wide shoulder straps.

Jewelry. Use jewelry to distract from your chest: wear bracelets and earrings. Don't wear pins, necklaces, or pendants that hang low.

Small Bust

Tops. Tops should be of brighter or lighter colors than bottoms. Wear anything that accentuates the upper half of the body, such as loose tops with ornate detailing, layers, pockets, off-the-shoulder styles, and tight tops.

Underwear. Wear pushup, padded, and underwire bras to accentuate the bustline.

Heavy Arms

Tops. Loose, long sleeves are best, or try bell or angel sleeves. Avoid anything that reveals the upper arm.

Small Waist

Belts. Wear wide or plain belts that call attention to this feature, but beware of nipping in too much at the waist, as this can draw too much attention to the hips.

Thick Waist

Belts. Avoid belts altogether if you can; if necessary, narrow or medium-width belts in dark colors are less attention-getting. Avoid brightly colored or contrasting belts.

> **❝** *I've got a stomach now as well as a behind. And I mean—well, you can't pull it in both ways, can you?... I've made it a rule to pull in my stomach and let my behind look after itself.* **❞**

**AGATHA CHRISTIE,
"The Dressmaker's Doll"**

Coats. Emphasize the shoulders to detract from the waist. Try straight, unfitted coats, or yoked or Sherlock Holmes styles.

Dresses. Drop waists, empire bodices, and A-line or sheath dresses are recommended.

Pants. Try sewn-in waistbands or elastic waists.

Scarves. Oblong scarves that drape over the body will distract attention from the waist.

Skirts. Long and full skirts, or short ones, will help draw attention to the legs and away from the waist.

Tops. Emphasize shoulders and neckline: oversized, blousy, loose-waisted tops are all good, as are tunics or wrapped styles, and shoulder pads. Avoid tanks, tube tops, cropped tops, and fitted blouses.

Underwear. Control undergarments that cinch the waist are effective.

Vests. Below-the-waist vests can be extremely flattering.

Long-Waisted Figure

Belts. To visually shorten the upper body, wear plain belts the same color as pants or skirt.

Pants. Wear high-waisted, fitted, or full-leg pants—pants that cover the foot's instep visually extend the leg. Avoid hip-huggers, low-slung men's jeans, or pants with cuffs.

Tops. Tops should emphasize shoulders and arms. Off-the-shoulder, strapless, halter, or cropped styles are ideal, as are short-sleeved knits. Avoid anything frilly down the middle, anything long and fitted, belted tunics, and short vests, unless they're worn over an untucked loose blouse.

Short-Waisted Figure

Belts. To elongate the line of the upper body, wear a belt the same color as the top. If hips are narrow, wear belts low, below the natural waistline. Avoid flashy buckles or wide, colorful belts.

Pants and Skirts. Hip-huggers or "low-rise" pants, no-waistband pants, or low-slung skirts look good. Avoid high-waisted pants and skirts and those with wide waistbands.

Tops. Wear jackets, vests, tops, and tunics that hang below the waist to elongate the line of the body. Deep scoops, belted tunics, and surplice tops also look good. Avoid tucking in clothing severely; let it blouse a little.

BELOW THE WAIST

Short Legs

Coats. Short coats elongate the leg.

Skirts. If the legs are in shape, short skirts are a good way to create the illusion of length.

Pants. Leggings, stirrups, Capris, and pedal pushers and cigarette-leg, narrow, or cropped pants all enhance the line of the body. Avoid wide-leg pants, pleats, and cuffs.

Tops. Short tops give the illusion of a longer leg.

Long, Thin Legs

Pants. If you want to minimize their proportion, try wide-leg, pajama-style, bell-bottomed, palazzo, boot cut, or harem pants. Overalls and pleated or cropped pants are also flattering, as are those with baggy pockets, patterns, stripes, or cuffs.

Skirts. Short skirts show off great legs. If you feel your legs are too thin to appear sexy, a long skirt with a slit or with buttons up the front can create allure.

Wide Lower Body

Dresses. Unless you have a small waist, choose dresses that are beltless, with straight lines. Tailored, structured dresses that drape from the shoulder, empire bodices, an A-line dress with a fitted top and a flowing skirt, and dresses with long, slightly fitted jackets are also effective.

Pants. Don't wear tight pants.

Tops. Wear shoulder pads, loose, long vests, or blousy tops loosely gathered at the hips over leggings or a slim skirt. Avoid tight tops and short jackets. Don't tuck in clothes tightly at the waist.

Jackets. A dark jacket with shoulder pads makes the waist and hips look narrower.

Big Thighs

Pants. Look for soft, minimally detailed, wide-leg pants; jodhpurs with the exaggerated upper leg (because it looks like the style of clothing, not you) or heavy fabric in a wide, straight-leg style. Avoid tapered pants that emphasize the difference between calves and thighs, and pants that are pleated or side-pocketed. Dark colors are slimming.

Skirts. Wear loose skirts with a drape or soft pleats. Avoid Lycra-blend narrow skirts unless your top covers your thighs.

Tops. Wear loose and off-the-shoulder tops. Fitted jackets that flare over the thighs and long jackets can also work well. Bright, light colors

"I can't believe I gave my panties to a geek."

MOLLY RINGWALD,

Sixteen Candles

and horizontal stripes draw attention away from your bottom half.

Underwear. Try slimming-thigh undergarments.

Tummy Bulge

Pants. Narrow-leg pants under hip-length tops are flattering. Side and back zippers look better than button flies and front zippers. Avoid front pockets and anything tight.

Skirts. Try soft A-lines that drape nicely. Avoid clinging, tight waistlines, as well as anything with lots of pleats, and sarongs.

Tops. Wear jackets, vests, and tops in roomy, boxy shapes that cover the stomach. It might be worth hemming a T-shirt so it falls just to where your stomach starts to swell. Otherwise your shirt will tend to hug this area and emphasize its fullness.

Saddlebags

Pants. Try baggy, waist-widening pants—if the waist appears wider, the hips will not seem so wide. Avoid slim, narrow-legged pants. Dark colors are slimming; avoid patterns.

Skirts. Pleats should start below the hips.

Tops. Vests, untucked or long shirts with straight, narrow skirts and pants, scoop necks, décolletage, and off-the-shoulder necklines all call attention to your upper half; kimonos, dolman sleeves, epaulets, and blouses in puffed, peasant, or Gibson styles are all effective. Avoid anything that ends just at the hipline.

Large Buttocks

Some say large buttocks are a sign of youth. Remember this before you try concealing your better half.

Coats. Long coats, capes, or swagger-backed styles are best.

Pants. Wear wide-leg trousers that minimize the difference between thighs and rear. Avoid back pockets or anything tight. Dark colors are slimming.

Skirts. Skirts are more flattering than pants, especially when loose and draped, and when paired with a jacket or vest that covers the rear. Avoid Lycra fabrics and bias-cut skirts.

Tops. Wear vests and blazers that cover the rear. Avoid cropped tops.

Flat Buttocks

Coats. Belted coats impart shape.

Pants. Seek out styles with pockets and pleats if hips are narrow. Avoid fitted styles, patterns, and back pockets (they just call more attention to the buttocks).

Skirts. Experiment with Lycra fabrics or anything tight; try bias-cut skirts.

Tops. Peplums are effective, as is anything waist-emphasizing (if the waist is a strong feature). Pair vests that cover the rear with straight and narrow skirts and pants. Avoid anything cropped above the rear.

Underwear. Butt-boosting underwear gives buttocks a lift.

Thick Ankles

Hosiery. Dark is best.

Pants. Avoid cropped and body-hugging pants.

Shoes. Solid-colored, unadorned. Low vamps elongate the foot; shaped medium heels make legs look longer. Avoid straps and detailing around the ankle, chunky heels, or stiletto or very high heels, because their narrowness sharply contrasts with the width of the ankle. Boots can have a magical effect.

Skirts. Long and loose, worn with above-the-ankle boots. Avoid flouncy skirts with borders that call attention to the calves and ankles; eschew miniskirts.

HOW TO BUY THE RIGHT BLACK PANTS

Just as every woman needs a good black dress, every woman needs the perfect pair of black pants. Unfortunately, one woman's perfect pants are another woman's nightmare. Pants hug the figure more than dresses or skirts. They can highlight waists, hips, thighs, even calves and ankles,

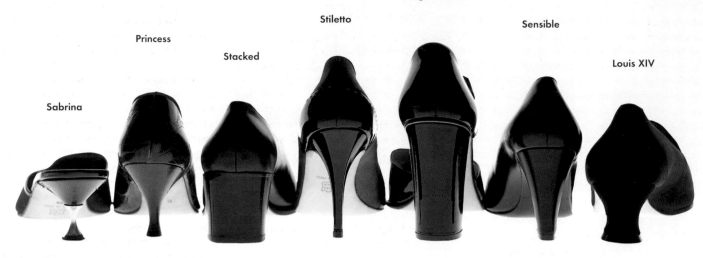

High Stacked

Stiletto

Sensible

Princess

Stacked

Louis XIV

Sabrina

light waists, hips, thighs, even calves and ankles, but there are pants for nearly every figure type. It just may take a lot of trying on until you find the style that suits you.

If you have a "bubble butt"—one that protrudes roundly in the rear—look for pants that sit on the hips. Lines and details should be simple, with the rear pockets on jeans not so tiny. Flat derrières can benefit, however, from pocket detailing such as embroidery or flaps, but stay away from tight pants. Wide behinds or large thighs look better with pants that are bigger in the waist and have untapered legs. If you have narrow ankles, look for pants that taper at the ankle and are cut shorter, like Capri pants. Disguise hips and thighs with oversized, elongated tops. Wearing one color from neck to ankle also creates an illusion of height rather than width. Women with protruding stomachs may find pants with elastic waists more comfortable, but try to avoid extra fabric around the waist and hips. Wear tops made to be worn outside waistbands.

If you believe finding the right pair of pants is a mission impossible, work with a personal shopper. She has a wealth of experience and may be able to offer you something you hadn't considered. If you do find a style that suits you, buy extras or have more made in other fabrics. Your dressmaker or tailor will cut a pattern for you, and although it will cost extra, you will have the convenience of knowing you can have pants made each season that look great on you. Remember

that fabrics of differing weights can fit differently. Larger, heavier women often look best in pants of lightweight fabric, while the thinnest women look best in pants made of substantial fabrics.

When choosing pants, try not to buy fabrics that wrinkle easily, but do look for fabrics that include stretch fibers. Even plus sizes benefit from the addition of up to 5 percent Lycra fibers. Those who previously found jeans uncomfortable now find they are living in stretch jeans.

When choosing black pants, it is especially important to find fabrics that will wear well and not become shiny. Velvets, corduroys, and faille are several of the fabrics that lose their luster over time. Wool gabardine or other lightweight wools are the best choices.

DRESSING ROOM CHECK
Use a three-way mirror. If you see a panty line, invest in a thong or sheer panties. If possible, try pants on with the shoes you'll wear with them. Some slim pants can be worn short, but most trousers need to break softly on the top of your shoes. If pants are too short, let down cuffs. If you are short, remove cuffs altogether—the longer line extends the leg. Avoid pants that tug across the stomach or thighs; try a cut with pleats, a fuller leg, or fabric that drapes. If a waistband is causing a tummy overhang, look for a lower-cut or higher-cut waist.

SHOE HEELS

There is no more feminizing influence on appearance than high heels. Even the sound of them clicking down a corridor signals "female" a mile off. Like skirt length, heel height is more a matter of taste than dictum. But heel shape is still the trendiest part of a shoe, a bellwether of shifts in style. Often, heel fashion works on the principle "It's so out, it's in." High heels have been a temptation since the dawn of style. The lead actors of Greek drama towered over their fellow thespians in platform shoes, worn to demonstrate, through exaggerated scale, their significance. Men and women wore high heels in 17th- and 18th-century Europe as a mark of social privilege; only the rich and well-born (the "well-heeled") could afford to be raised above the mud. The attractions of the high heel are obvious: a swiveling gait, a well-turned ankle, an elongated leg, and added inches—all in all, a daintier foot.

Sabrina
Sweet in an early '60s, Audrey Hepburnish way; fetching on a mule (a backless shoe).

Princess
The tapered and demure tip of the court shoe. Fine for work and evening dress.

Stacked
Provides height and solid ground.

Stiletto

A.k.a. "the spike." A force of nature, the sexiest shoe in existence, proving the adage that you have to suffer to be beautiful. Turns "walk" into "wiggle."

High Stacked

Stiletto height with better balance.

Sensible

The legal standard. Traditional. Suitable.

Louis XIV

This distinctive, courtly heel goes through cycles of being very in or very out.

> **"I almost got into trouble at that party. I think it was because of the dress."**
>
> **ILENE BECKERMAN,**
> *Love, Loss, and What I Wore*

HOW TO UPDATE YOUR PARTY CLOTHES

If you've built a wardrobe you love, it can be a sad moment when some of your favorite pieces no longer fit or look fresh. Sometimes they can be salvaged. Pull out your dressy clothes and try each one on. If it's a little tight, perhaps the seams can be let out—ask a tailor. Usually, quality clothes have enough fabric built into the seams to be let out. If you haven't worn it for a while, consider revamping the look by altering the length or removing shoulder pads. A decorative jacket or an embroidered scarf can add color, texture, and sparkle while also changing the neckline. If you need something new, invest in a dress with simple lines, in an elegant fabric, which can easily be transformed by accessories.

MASTECTOMY AND YOUR CLOTHES

When breast cancer strikes, whole worlds seem to crater. Yet today, with so many women undergoing mastectomies, the route to looking and dressing "normal" again is well established.

One of the routes to looking your old self begins before surgery. If a radical or even partial mastectomy is in your immediate future, discuss with your surgeon how your chest will look postsurgery. Surgeons have the option of fashioning "cleavage," protrusions of skin and tissue that will allow you to wear deep, even plunging necklines with the appearance of normal cleavage.

After surgery, you must wait at least six weeks before ordering a prosthesis, but there are interim means to filling out your bodices. In most areas across the country, the group Reach for Recovery visits mastectomy patients soon after surgery, bringing "fluffies"—soft, pillowy breast substitutes—booklets on exercise, and advice on how to obtain permanent prostheses.

Most insurance companies now cover the cost of prostheses, which can range from $300 to $350 and up, in addition to two basic bras. The cost comes under medical supplies. Check with your insurance company first, then ask your surgeon to write a prescription for prostheses and the bras.

While some fashion specialty and department stores may be carrying mastectomy bras, most do not. Most major cities, however, now have stores that offer special garments for mastectomy patients. Look in your phone directory under Lingerie and Corsets or Medical Supplies.

The best prostheses today are molded of silicone and are relatively heavy to match the weight of your real breasts. Unfortunately, when muscles that normally support the breast are removed, supporting a prosthesis can cause pain. You may not want to wear your prosthesis all the time, especially in the beginning.

Most insurance companies will pay for two sport-type support bras that fasten in front and contain pockets that hold the prostheses. Forget underwiring; it's no longer a part of your life. Yet many women report they look perfectly normal with their prostheses, some even better, and they don't hesitate to wear stretch Lycra tops and fitted clothing.

Many of the lingerie and corset companies supplying mastectomy bras do not normally offer black or any color besides white or buff, but usually other colors can be specially ordered.

Swim forms—lighter weight prostheses—are also available, but finding attractive swimsuits can be difficult. Many patients recommend ordering from Lands' End catalog, which includes special suits for mastectomy patients. Janet McCue, fashion editor of the *Cleveland Plain Dealer*, reports that the Lands' End suits are better made, more attractive, and less expensive than those offered in mastectomy supply stores. But don't be discouraged if finding the right suit for you requires some trial and error. When was the last time you bought the first swimsuit you tried on?

You may find that you need to freshen up your wardrobe with a few pieces that make you feel more comfortable and pretty. Work with a personal shopper at your favorite store. You are not obliged to buy anything or pay for the service, but chances are they can be enormously helpful.

If you are undergoing chemotherapy, you are likely to lose your hair, including eyebrows and eyelashes. You may want to shop for a wig before the procedure. Natural hair is more expensive, but much more natural-looking. You may also want to cut your hair short and stylish, rather than let it fall out in clumps, which may be more depressing. Some stores, like Barneys New York, have trained makeup artists in the "Beauty for Life" program, which offers private counseling.

no boundaries

In today's world the choices are overwhelming. Where do you start? Sometimes the answer is only as far away as your phone or modem—more and more designers, stores, and manufacturers are diminishing distance with catalogs and Web sites. We've listed some of our favorite places. Some are best visited in person; others can be cruised to on the Net or are just a phone number away.

ADRIENNE VITTADINI
800/785-9443
(Sportswear)

ANN TAYLOR
800/999-4554 for stores
800/342-5266 for catalog
(Clothing and accessories)

APROPO
212/725-0355
(Accessories)

ARMANI A/X
212/570-1122 for stores
(Giorgio Armani denims and basics)

BANANA REPUBLIC
888/BRSTYLE
(Casuals and classics)

BARNEYS NEW YORK
888/222-7639 for store information
(Upscale specialty store)

BARRY KIESELSTEIN-CORD
for store information,
call 212/764-6140
(Fine jewelry, bags, and belts)

BASS/WEEJUN
800/777-1790 for stores
(Shoes)

BCBG
888/636-2224
(Trendy apparel)

BERGDORF GOODMAN
800/558-1855
(Upscale department store)

BILL BLASS
for store information,
call 212/221-6660

BIRKENSTOCK
800/487-9255
(Shoes)

BLOOMINGDALE'S
212/355-5900 for stores
800/777-4999 for catalog
http://www.bloomingdales.com
(Upscale department store)

BOSOM BUDDIES
914/338-2038
(Nursing bras)

BROOKS BROTHERS
800/444-1613
(Classic womenswear)

BRUNO MAGLI
800/624-5430
(Shoes)

Barry Kieselstein-Cord

Barry Kieselstein-Cord is a designer and craftsman whose alligator bags and sterling silver belt buckles are included in the collections of the Museum of Modern Art in New York and the Louvre in Paris. A former art director in Hollywood, Kieselstein-Cord returned East to look for a more satisfying career and happened into his present field after taking an evening course in fine jewelry making. Twenty-five years later, he became a huge success after his work was spotted by a junior editor of a fashion magazine. Kieselstein-Cord is probably best known for his sterling belt buckles and handbag closures that feature curvy alligators—actually a memory of Herbert, a smelly childhood pet alligator that grew to 1½ feet in the bathtub before his mother made him give it away. See necklace, page 172.

BURBERRYS
800/284-8480 for stores
(Outerwear, clothing, and accessories)

CALVIN KLEIN
212/719-2600 for stores
(Designer clothes)

CAROLEE
800/227-6533
(Jewelry)

CAROLINA HERRERA
for store information,
call 212/944-5757

CARTIER
800/CARTIER
(Fine jewelry and watches)

CASHMERE CASHMERE
212/988-5252 for stores
(Fine cashmere clothing and accessories)

CHANEL BOUTIQUE
800/550-0005 for stores
(Clothes, accessories, and cosmetics)

CINDERELLA OF BOSTON
800/274-3338
(Petite shoes)

CLUB MONACO
800/383-9096
http://www.clubmonaco.com
(Casuals and classics)

COACH
800/262-2411
http://www.coach.com
(Bags and leather goods)

CONSUMER REPORTS
800/234-1645
http://www.consumerreports.org
(Consumer Reports magazine on-line)

COUNTRY ROAD AUSTRALIA
888/844-2045
(Casuals and classics)

CRAIG TAYLOR
800/879-4500
(Elegant man-tailored shirts for women)

CURVES
800/528-7837
(Silicone gel–filled falsies for your bra or swimsuit)

DAFFY'S
201/902-0800
http://www.Daffys.com
(Discounted women's wear)

DAYTON HUDSON/MARSHALL FIELD
800/292-2450
http://www.shop@.com
(Upscale department store)

DILLARD'S PARK PLAZA
501/376-5200 for stores
800/DILLARD for catalog
(Upscale department store)

DOCKERS
800/DOCKERS for stores
(Casual work wear)

DONNA KARAN/DKNY
800/231-0884
(Designer classics)

EASTERN MOUNTAIN SPORTS
611 Broadway
New York, NY 10012
212/505-9860
http://www.emsonline.com
(Active wear)

EDDIE BAUER
800/426-8020
(Casual and outdoor wear and gear)

EILEEN FISHER INC.
212/944-0808 for stores
(Relaxed designer clothing)

ELLEN TRACY
800/925-7979
(Designer women's clothes)

FASHION MALL
800/859-1440
http://www.fashionmall.com
(Convenient shopping on-line)

FELISSIMO
800/708-7690 for catalog
(Japanese specialty store)

FILENE'S
617/357-2601 for stores
(Upscale department store)

FIRSTVIEW
http://www.firstview.com
(Preview designer collections)

FREDERICK'S OF HOLLYWOOD
800/323-9525
(Lingerie with sex appeal)

GAP
415/777-0250 for stores
http://www.gap.com
(Clothing basics and accessories)

GEORG JENSEN
800/546-5253
(Fine silver jewelry)

GHURKA
800/225-9870
(Luggage and leather goods)

GIORGIO ARMANI
201/570-1122 for stores
(Designer clothes)

GUCCI
212/826-2600 or
800/234-8224 for stores
(Fine leather goods, scarves, and clothing)

HANES
800/994-4348
http://www.hanes.com
(Hoisery)

HENRI BENDEL
212/247-1100 for stores
(Upscale specialty store)

HERMÈS
800/441-4488 for stores
(Fine leather goods, clothes, and jewelry)

HUSH PUPPIES
800/433-HUSH
800/313-5699
http://www.netpad.com/hushpuppies
(Shoes)

ISAAC MIZRAHI
800/340-6004
(Designer wear)

JC PENNEY
800/222-6161
http://www.jcpenney.com
(Department store)

J. CREW
800/782-8244
http://www.jcrew.com
(Casuals and classics)

JOHN BARTLETT
for store information,
call 212/245-4860
(Designer wear)

J. PETERMAN COMPANY'S OWNER'S MANUAL
800/231-7341
http://www.jpeterman.com
(Casuals and classics)

J.P. TOD'S
800/4JPTODS
(Driving moccasins)

KENNETH COLE
800/KEN-COLE
http://www.kencole.com
(Shoes)

KENNETH JAY LANE
for store information,
call 212/751-6550
(Costume jewelry)

KLEINBERG SHERRILL
888/531-2002
(Finely crafted buckles, bags, and shoes)

LANDS' END
800/356-4444
http://www.landsend.com
(Clothing basics)

LAZARUS
937/439-2152 for stores
(Major retailer of better women's merchandise)

LEVI'S
800/USA-LEVI for stores
(Denim and sportswear)

THE LIMITED
800/756-4449
(Sportswear)

LIZ CLAIBORNE
800/555-9838
(Designer wear)

L.L. BEAN STORE/CATALOG
800/543-9071
http://www.llbean.com
(Outdoor wear and gear)

LORD & TAYLOR
212/391-3344 for stores
(Upscale department store)

LOUIS, BOSTON
800/225-5135 for stores
(Designer clothes)

LOUIS VUITTON
800/285-2255
http://www.vuitton.com
(Designer clothes)

MACY'S
800/45-MACYS
212/695-4400 for East Coast stores
415/393-3457 for West Coast stores
(Department store)

MALO
877/SEE-MALO
(Cashmere)

MARSHALL FIELD
800/292-2450 for stores
(Upscale department store)

MATERNAL INSTINCTS
888/MATERNAL
http://www.maternal-instinct.com
(Maternity wear)

MAXMARA
800/206-6872
(Designer clothes)

MICHAEL KORS
for store information,
call 212/221-1950
(Designer wear)

MOTHERS WORK
800/4-MOM-2-BE
(Maternity wear)

NATORI
212/532-7796 for stores
(Elegant lingerie)

NAUTICA
800/280-3368
(Active wear)

NEIMAN MARCUS
800/825-8000 for catalog
800/937-9146 for stores
http://www.neimanmarcus.com
(Upscale department store)

NINE WEST
800/260-2227
(Shoes and accessories)

NIKE
800/344-6453
http://www.nike.com
(Sportswear and shoes)

NORDSTROM
800/285-5800 for catalogue
http://www.nordstrom/pta.com
(Upscale department store)

OLIVER PEOPLES
310/657-5475 for national
and international listings
(Eyeglasses and accessories)

OSCAR DE LA RENTA
for store information,
call 212/354-6777
(Designer clothing and accesories)

PARISIAN
800/443-6856
(Upscale department store)

PATAGONIA
800/336-9090
http://www.patagonia.com
(Active wear)

PENDLETON WOOLEN MILLS
800/841-7202
http://www.pendleton/usa.com
(Wool garments)

PLAZA TOO
800/972-4179
(Head-to-toe accessories)

POLO/RALPH LAUREN
800/756-7656
http://www.poloralphlauren.com
(Classic sportswear)

QVC
800/345-1515
http://www.qvc.com
(Cable fashion television)

S & B REPORT
212/683-7613
($49 annual fee to receive monthly mailer of designer sample sales)

SAKS FIFTH AVENUE
212/753-4000
http://www.dreamshop.com/saksfifthavenue
(Upscale department store)

SALVATORE FERRAGAMO
212/838-9470 for national listings
(Designer clothing and accessories)

SANYO
800/99-Sanyo
(Quality coats and long, lightweight packable raincoats)

SEARS
847/286-5188
http://www.sears.com
(Department store)

SPEEDO
800/5-SPEEDO
(Swimwear and sportswear)

SPIEGEL CATALOG
800/345-4500
(Coats, lingerie, accessories, and clothes)

STEPHANE KÉLIAN
212/925-3077 for stores
(Designer shoes)

TALBOTS
800/992-9010
800/225-8200
(Clothing and accessories)

TARGET STORES
800/800-8800
http://www.target.com
(Basics)

TIFFANY & CO.
212/605-4612 for stores
(Fine jewelry and accessories)

TIMBERLAND
800/258-0855
http://www.timberland.com
(Active wear and shoes)

TIMEX
800/367-8463
http://www.timex.com
(Watches)

TOMMY HILFIGER
800/888-8802
(Casuals and classics)

TSE CASHMERE
800/487-3692
(Cashmere clothing)

TWEEDS
800/999-7997
http://tweeds.com
(Fashionable basics, accessories, shoes)

UNITED COLORS OF BENETTON
800/535-4491
(Casual wear)

URBAN OUTFITTERS
215/569-3131 for stores
(Casual wear)

VAN CLEFF & ARPELS
800/VCA-5797
(Fine jewelry)

Vera Wang

Vera Wang understands the shapes and moods of clothes with a keen awareness of design and an extraordinarily modern sensibility. At age 23, she began her career as an editor at *Vogue* magazine; today she is one of the most sought-after designers of evening wear and bridal gowns. Most recognized for the fluid lines she brings out in her gowns and her architectural sense of fabric and form, she eschews frou-frou formal in favor of slock columnic dresses and simple, very wearable day and evening attire. At one point in her life, she was a competitive figure skater, vying for a spot in the Olympic games. She now dresses celebrity actresses and singers from Sharon Stone to Mariah Carey—and yes, Olympic silver medalist Nancy Kerrigan. See gowns, page 107.

VERA WANG
212/879-1700 for stores
(Designer evening wear and bridal gowns)

VERSACE
800/440-8144
(Designer wear)

VICTORIA'S SECRET
800/888-8200
(Intimate apparel)

WATHNE
800/942-1166
(Elegant activewear)

STATE LISTINGS

CALIFORNIA

AAARDVARK'S
7579 Melrose Avenue
Los Angeles, CA 90046
323/655-6769
(Wide variety of secondhand clothes)

AMERICAN RAG
150 South La Brea Avenue
Los Angeles, CA 90036
213/935-3154
(Clothing and accessories)

RON HERMAN/FRED SEGAL
8100 Melrose Avenue
Los Angeles, CA 90046
213/651-3342
(Designer fashions)

HIDDEN TREASURES
154 Topanga Canyon Boulevard
Topanga Canyon, CA 90290
310/455-2998
(Vintage clothing from the 1930's to the '50's)

LEATHERS & TREASURES
7511 Melrose Avenue
Los Angeles, CA 90046
213/655-7541
(Specialty leathers)

MATTIE AND FRIENDS
44425 Town Center Way
Palm Desert, CA 92260
760/568-3576
(Maternity clothes)

MAXFIELD
8825 Melrose Avenue
Los Angeles, CA 90069
310/274-8800
(European and American designer clothes)

Stubbs & Wootton

Percey Steinhart first set up shop as Stubbs and Wootton in Palm Beach, Florida, in 1993, where he translated his love of the elegant needlepoint slipper into quirky tuxedo pumps for men and women. In velvet, suede, sisal, or tapestry, and detailed with hand-sewn embroidery, Stubbs and Woottons seasonless shoes are cut for maximum comfort and for day and evening wear. Steinhart enjoys throwing in the unexpected with each of his embroidered designs— among them Ming vases and wind-blown palm trees, monikered "El Niño." You may also request custom-designed embroidery on the front of your slipper, such as a family crest or personal initials. See leopardprint shoes, page 123.

MIO
2035 Fillmore Street
San Francisco, CA 94115
415/931-5620
(European and American designer clothes)

THE NORTH FACE
180 Post Street
San Francisco, CA 94108
415/433-3223
(Active wear)

OBIKO
794 Sutter Street
San Francisco, CA 94115
415/775-2882
(Designer clothing)

ZOE
2400 Fillmore Street
San Francisco, CA 94115
415/929-0441
(Designer clothing)

CONNECTICUT

CLINTON CROSSING PREMIUM OUTLET
20 Killingworth Turnpike, #205
Clinton, CT 06413
860/664-0700
(Barneys New York, Polo/Ralph Lauren, Saks Fifth Avenue, DKNY...)

RAZOOK'S
45 East Putnam Avenue
Greenwich, CT 06830
203/661-6603
(Designer clothes)

TAHITI STREET
11 East Putnam Avenue
Greenwich, CT 06830
203/622-1878
(Women's swimwear)

THE WILDERNESS SHOP
85 West Street
Litchfield, CT 06759
860/567-5905
(Wilderness wear and casual clothing)

DISTRICT OF COLUMBIA

UP AGAINST THE WALL
3219 M Street, NW
Washington, DC 20007
202/337-9316
(Womenswear and menswear)

BETSY FISHER
1224 Connecticut Avenue, NW
Washington, DC 20036
202/785-1975
(Young American designer clothing)

FLORIDA

CANON CHERRY
9700 Collins Avenue
Bal Harbour, FL 33154
305/861-9966
(Clothing and accessories)

MY UNCLE DECO
1570 Washington Avenue
Miami Beach, FL 33139
305/534-4834
(Vintage clothing from the 1950's to the '70's)

STUBBS & WOOTTON
323 Worth Avenue
Palm Beach, FL 33480
561/655-4105
(Embroidered shoes and bags)

GEORGIA

BOB ELLIS
3500 Peachtree Road Suite A3
Atlanta, GA 30326
404/841-0215
(Designer shoes)

TOOTSIES
3500 Peachtree Road Suite C5, C6
Atlanta, GA 30326
404/842-9990
(Fashionable clothing)

ILLINOIS

CHERNIN'S
1001 S. Clinton Street
Chicago, IL 60607
312/922-5900
(Petite shoes)

EXPECTATIONS MATERNITY
2012 North Halsted Street
Chicago, IL 60614
773/248-2048
(Maternity wear)

FLASHY TRASH
3524 North Halsted Street
Chicago, IL 60657
773/327-6900
(Vintage clothing from the 1940's to the '70's)

ULTIMO
114 East Oak Street
Chicago, IL 60611
312/787-0906
(Designer clothes)

KANSAS

PROFESSIONAL EXPECTATIONS
4687 Indian Creek Parkway
Overland Park, KS 66207
913/381-7272
(Rental maternity clothes)

LOUISIANA

FLEUR DE PARIS LIMITED
712 Royal Street
New Orleans, LA 70116
504/525-1899
(Specialty store)

MIMI
400 Julia Street
New Orleans, LA 70730
504/527-6464
(Designer wear)

UTOPIA
5408 Magazine Street
New Orleans, LA 70115
504/899-8488
(Clothing and accessories)

YVONNE LE FLEUR
8131 Hampson Street
New Orleans, LA 70118
504-866-9666
(Specialty store)

MAINE

CALVIN KLEIN OUTLET
11 Bow Street
Freeport, ME 04032
207/865-1051
(Discounted Calvin Klein apparel and accessories)

DONNA KARAN COMPANY STORE
42 Main Street
Suite 11
Freeport, ME 04032
207/865-1715
(Discounted Donna Karan apparel)

FOURTEEN CARROTS
Main Street
Northeast Harbor, ME 04662
207/276-5259
(Handknit sweaters and scarves)

THE HOLMES STORE
Main Street
Northeast Harbor, ME 04662
207/276-3273
(Classic clothing and sailing gear)

J. CREW OUTLET
10 Bow Street
Freeport, ME 04032
207/865-3180
(Discounted J. Crew apparel and accessories)

JONES NEW YORK OUTLET
58 Main Street
Freeport, ME 04032
207/865-3158
(Discounted Jones New York apparel)

L L. BEAN FACTORY STORE
150 High Street
Ellsworth, ME 04605
207/667-7753
(Outdoor clothes and gear)

THE PATAGONIA OUTLET
9 Bow Street
Freeport, ME 04032
207/865-0506
(Discounted Patagonia active wear)

MASSACHUSETTS

OONA'S
1210 Massachusetts Avenue
Cambridge, MA 02138
617/491-2654
(Vintage clothing from the 1960's and '70's)

TALBOTS' PETITE COLLECTION
100 Cambridge Side Place
Cambridge, MA 02141
617/621-1414
(Talbots store devoted to petite fashions)

MICHIGAN

PENNY PINCHER
12219 Dix Road
Southgate, MI 48195
313/281-8100
(Vintage designer clothing and accessories)

NEW HAMPSHIRE

GARNET HILL
231 Main Street
Franconia, NH 03580
800/622-6216
(Natural-fiber fabrics for home decor and clothes)

L.L. BEAN FACTORY OUTLET
Route 16
North Conway, NH 03860
603/356-2100
(Outdoor wear and gear)

NEW YORK

AGNÈS B. WOMEN
116 118 Prince Street
New York, NY 10012
212/925-4649
(Clothing and accessories)

ALIXANDRE
150 West 30th Street
New York, NY 10001
212/736-5550
(Furs designed by Oscar de la Renta, Valentino, Joseph Abboud)

ANNA SUI
113 Greene Street
New York, NY 10012
212/941-8406
(Designer clothes)

A PEA IN THE POD - NEW YORK
625 Madison Avenue
New York, NY 10022
212/826-6468
(Maternity clothes)

A.P.C.
131 Mercer Street
New York, NY 10012
212/966-9685
(Clothing and accessories)

AT HAVENS HOUSE
Madison Street
Sag Harbor, NY 11963
516/725-4634
(Vintage and new clothing)

BARBARA BUI
115 Wooster Street
New York, NY 10012
212/625-1938
(Designer clothes)

BEBE
1044 Madison Avenue
New York, NY 10021
212/517-2323
(Sportswear)

BELGIAN SHOES
60 East 56th Street
New York, NY 10022
212/755-7372
(Classic shoes)

BEST OF SCOTLAND
581 Fifth Avenue
New York, NY 10017
212/644-0403
(Women's cashmere sweaters at discount)

BOGNER OF AMERICA
821 Madison Avenue
New York, NY 10021
212/472-0266
(Skiwear)

BOTTEGA VENETA
635 Madison Avenue
New York, NY 10022
212/319-0303
(Shoes and fine leather goods)

BUFFALO CHIPS
131 Thompson Street
New York, NY 10012
212/253-2228
(Southwestern clothes and boots)

CALYPSO
280 Mott Street
New York, NY 10012
212/965-0990
(Feminine yet hip boutique offerings)

CARTIER
653 Fifth Avenue
New York, NY 10022
212/446-3459
(Fine jewelry and watches)

CELINE
598 Madison Avenue
New York, NY 10022
212/308-6262
(French specialty store)

CENTURY 21
22 Cortlandt Street
New York, NY 10007
212/227-9092
(Discounted clothing and accessories)

CHARIVARI
18 West 57th Street
New York, NY 10019
212/333-4040
(Designer collections)

COLE HAAN
667 Madison Avenue
New York, NY 10021
212/421-8440
(Shoes and leather goods)

COMME DES GARÇONS
116 Wooster Street
New York, NY 10012
212/219-0660
(Designer clothes)

CYNTHIA ROWLEY
112 Wooster Street
New York, NY 10012
212/575-9020
(Designer clothing)

DANA BUCHMAN
65 East 57th Street
New York, NY 10022
212/319-3257
(Designer clothes)

DARYL K
21 Bond Street
New York, NY 10012
212/777-0713
(Designer clothes)

DEBRA MOOREFIELD
466 Broome Street
New York, NY 10013
212/226-2647
(Designer clothes)

DETOUR
472 West Broadway
New York, NY 10012
212/979-6315
(Clothes and accessories)

DIEGO DELLA VALLE
41 East 57th Street
New York, NY 10022
212/644-5945
(Designer shoes)

DOLCE & GABBANA
434 W. Broadway
New York, NY 10012
212/965-8000
(Designer womenswear)

DOLLAR BILL
32 East 42nd Street
New York, NY 10017
212/867-0212
(Womenswear at discount)

DOMSEY'S
431 Kent Avenue
Brooklyn, NY 11211
718/384-6000
(Secondhand and vintage clothing)

EMILIO PUCCI
24 East 64th Street
New York, NY 10021
212/752-8957
(Classic womenswear)

EMPORIO ARMANI
110 Fifth Avenue
New York, NY 10011
212/727-3240
(Armani suits, casual wear, eyewear, and toiletries)

ENCORE
1132 Madison Avenue
New York, NY 10028
212/879-2850
(Designer retail shop)

FRAGMENTS
107 Greene Street
New York, NY 10012
212/226-8878
(Designer jewelry)

FREELANCE
124 Prince Street
New York, NY 10012
212/925-6641
(Hip shoes)

GEOFFREY BEENE ON THE PLAZA
783 Fifth Avenue
New York, NY 10022
212/935-0470
(Designer clothing)

GIORDANO'S
1150 Second Avenue
New York, NY 10021
212/688-7195
(Petite shoes)

H. KAUFFMAN & SONS SADDLERY
419 Park Avenue South
New York, NY 10016
212/684-6060
(Riding apparel and equipment)

HENRI BENDEL
712 Fifth Avenue
New York, NY 10019
212/247-1100
(Specialty store)

ILENE CHAZANOF
212/254-5564 (by appointment only)
(Vintage accessories from the 1880's to the '60's)

INA
101 Thompson Street
New York, NY 10012
212/941-4757
(Designer resale shop)

INDUSTRIA
755 Washington Street
New York, NY 10014
212/366-4300
(Designer clothing and accessories)

J. M. WESTON
812 Madison Avenue
New York, NY 10021
212/535-2100
(Women's shoes)

JOAN & DAVID
4 W. 58th Street, 13th Floor
New York, NY 10018
212/371-8250
(Shoes)

JOSEPH
115 Greene Street
New York, NY 10012
212/343-7071
(Great pants)

JUDITH LEIBER
987 Madison Ave.
New York, NY 10021
212/327-4003
(Handbags, belts, and accessories)

KATE SPADE
454 Broome Street
New York, NY 10013
212/274-1991
(Handbags)

LINDA DRESNER
484 Park Avenue
New York, NY 10022
212/308-3177
(Designer clothing)

LOLA
535 Eighth Avenue
New York, NY 10018
212/279-9093
(Hats)

LOVE SAVES THE DAY
119 Second Avenue
New York, NY 10003
212/228-3802
(Vintage clothing)

MANOLO BLAHNIK
31 West 54th Street
New York, NY 10019
212/582-1583
(Designer shoes)

MARC JACOBS
163 Mercer Street
New York, NY 10012
212/343-1490
(Designer womenswear)

MORGENTHAL FREDERICS
944 Madison Avenue
New York, NY 10021
212/744-9444
(Glasses)

MOTHERHOOD
1449 Third Avenue
New York, NY 10028
212/734-5984
(Maternity clothes)

MUI MUI
100 Prince Street
New York, NY 10012
212/334-5156
(Contemporary casuals)

NAUTICA
216 Columbus Avenue
New York, NY 10023
212/496-0933
(Active wear)

NORIKO MAEDA
985 Madison Avenue
New York, NY 10021
212/717-0330
(Upscale designer fashions)

OUT OF OUR CLOSET
136 West 18th Street
New York, NY 10011
212/633-6965
(Hip designer resale clothes)

PATRICIA PASTOR
19 East 71st Street
New York, NY 10021
212/734-4673
*(Vintage designer clothes
and accessories)*

PLEATS PLEASE
128 Wooster Street
New York, NY 10012
212/226-3600
(Issey Miyake's second line)

PRADA
45 East 57th Street
New York, NY 10022
212/308-2332
(Shoes and designer clothes)

REPLAY
109 Prince Street
New York, NY 10012
212/673-6300
(Italian retro clothing)

SCREAMING MIMI'S
382 Lafayette Street
New York, NY 10003
212/677-6464
(Hip vintage clothes)

SEARLE
609 Madison Avenue
New York, NY 10022
212/753-9021
212/719-4610
(Designer clothing and outerwear)

SELIMA OPTIQUE
59 Wooster Street
New York, NY 10012
212/343-9490
(Eyeglasses)

SIGERSON MORRISON
242 Mott Street
New York, NY 10012
212/219-3893
(Shoes)

SMALL WONDERS
1225 Jefferson Road
Rochester, NY 14623
716/272-0670
(Maternity wear)

ST. JOHN KNITS
665 Fifth Avenue
New York, NY 10022
212/755-5252
(Elegant classics)

STELLA DALLAS
218 Thompson Street
New York, NY 10012
212/674-0447
(European designer clothes)

STEVEN ALLEN
60 Wooster Street
New York, NY 10012
212/334-6354
(Hip clothes and accessories)

T. ANTHONY
445 Park Avenue
New York, NY 10022
212/750-9797
(Luggage and accessories)

TAKASHIMAYA
693 Fifth Avenue
New York, NY 10022
212/350-0100
(Japanese accessories and leather goods)

TENDER BUTTONS
143 East 63rd Street
New York, NY 10021
212/758-7004
(Hard-to-find buttons)

TOOTSIE PLOHOUND
413 West Broadway
New York, NY 10012
212/925-8931
(Hip shoes)

TRASH AND VAUDEVILLE
4 St. Mark's Place
New York, NY 10003
212/777-1727
(Hip shoes and clothing)

UNTITLED, INC.
26 West 8th Street
New York, NY 10011
212/505-9725
(Designer clothing)

VERA WANG
25 East 77th Street
New York, NY 10021
212/879-1750
(Wedding and party clothes)

WILLIAM DOYLE GALLERIES
175 East 87th Street
New York, NY 10128
212/427-2730
*(Auction house for vintage and designer
garments. For an excellent reference
before you attend the auction: Caroline
Rennolds Milbank's book,* Couture, the
Great Designers*)*

THE WATCH STORE
649 Broadway
New York, NY 10012
212/475-6090
(Watches and accessories)

OREGON

CASSIE'S
22000 Willamette Drive
West Lynn, OR 97068
503/656-7141
(Clothing and accessories)

CHRISTINE COLUMBUS
8 Nansen Summit
Lake Oswego, OR 97035
503/697-0968
http://www.christinecolumbus.com
(Travel clothing)

EL MUNDO
3556 SE Hawthorne
Portland, OR 97214
503/239-4605
(Clothing and accessories)

GAZELLE
4100 NE Fremont
Portland, OR 97212
503/288-3422
(Natural-fiber clothing)

PENNSYLVANIA

KNIT WIT
1721 Walnut Street
Philadelphia, PA 19103
215/564-4760
(Clothing and accessories)

MENDELSOHN
7914 High School Road
Elkins Park, PA 19027
215/635-2791
(Clothing and accessories)

PILEGGI ON THE SQUARE
717 Walnut Street
Philadelphia, PA 19106
215/627-0565
(Clothing and accessories)

TOBY LERNER
117 South 17th Street
Philadelphia, PA 19103
215/568-5760
(Clothing and accessories)

TENNESSEE

CLOTHES BY MERTIE
133 North Peters Road
Knoxville, TN 37923
423/693-8600
(Women's sportswear and formal wear)

PIECES
211 Louise Avenue
Nashville, TN 37203
615/329-3537
*(Vintage clothing from the 1950's
to the '70's)*

ZELDA VINTAGE CLOTHIERS
5133 Harding Road
Nashville, TN 37205
615/356-2430
(Vintage clothing and accessories)

TEXAS

AHAB BOWEN
2614 Boll Street
Dallas, TX 75204
214/720-1874
*(Vintage clothing from the 1940's
and '50's)*

LILLY DODSON
33 Highland Park Village
Dallas, TX 75205
214/528-0528
(Designer clothing)

STANLEY KORSHAK
500 Crescent Court
Dallas, TX 75205
214/871-3600
(Specialty store)

UNCOMMON OBJECTS
1512 South Congress
Austin, TX 78704
512/442-4000
(Vintage Western clothing)

VIRGINIA

LEVY'S
2120 Barracks Road
Charlottesville, VA 22903
804/295-4270
3198 Pacific Avenue
Virginia Beach, VA 23451
757/437-1205
(Designer casual and formal wear)

INTERNATIONAL LISTINGS

AUSTRALIA

BELINDA
8 Transvaal Avenue, Doubleday
Sydney
2/328-6288
(Australian designer clothes)

COUNTRY ROAD AUSTRALIA
Pitt Street Mall
142 Pitt Street
Sydney
2/282-6299
(Classic sportswear)

DAIMARU
21 La Trobe Street
Melbourne
3/660-6666
(Upscale department store)

DAVID JONES
Elizabeth Street
Sydney
2/266-5544
(Upscale department store)

GEORGES
162 Collins Street
Melbourne
3/283-5535
(Upscale department store)

STEPHEN DAVIES DESIGNER SHOES
65 Gertrude Street, Fitzroy
Melbourne
3/419-6296
(Custom-made shoes)

THE WITCHERY
Brisbane Myer
Shop 139
Level 1, Myer Centre
91 Queen Street
(Stylish wardrobe essentials)

GREAT BRITAIN

AGNÈS B.
35–36 Floral Street
London WC2
171/379-1992
(Clothes and accessories)

BARKERS OF KENSINGTON
63 Kensington High Street
London W8
171/937-5432
(Department store)

BROWNS
23–27 South Molton Street
London W1
171/491-7833
(Designer clothing)

BURBERRYS
165 Regent Street
London SW1
171/930-3343
(Outerwear, clothing, and accessories)

BUTLER AND WILSON
189 Fulham Road
London SW3
171/352-3045
(Costume Jewelry)

DICKINS AND JONES
224-44 Regent Street
Londond W1
171/734-7070
(Department store)

EMMA HOPE SHOES
33 Amwell Street
London EC1
171/833-2367
(Designer shoes)

FENWICKS
63 New Bond Street
London W1Y
171/629-9161
(Department store)

FLANNELS
Unit 10, Royal Exchange
Manchester M2
161/834-8669
(Designer clothing)

THE GAP
31 Long Acre
London WC2
171/379-0779 for branches
(Clothing and accessories)

GHOST
36 Ledbury Road
London W11
171/229-1047
(Designer clothing)

GUCCI
18 Sloane Street
London SW1
171/235-6707
32–33 Old Bond Street
London W1X
171/629-2716
(Designer clothes and accessories)

HARRODS
Knightsbridge
London SW1
171/730-1234
(Upscale department store)

HARVEY NICHOLS
109–125 Knightsbridge
London SW1
171/235-5000
(Upscale department store)

HOBBS
124 Long Acre
London WC2
171/836-0625
(Shoes and clothing)

JIGSAW
65 Kensington High Street
London W8
171/937-3572
(Fashionable clothing)

JO MALONE
154 Walton Street
London SW3
171/581-1101
(Citrus and floral fragrance skincare)

JONES
15 Floral Street
London WC2
171/379-4448
(Clothing and accessories)

JOSEPH
77–79 Fulham Road
London SW3
171/883-9500
(Designer clothing and great pants)

KAREN MILLEN
45 South Molton Street
London W1Y
171/495-5297
(Clothing)

KENZO
15 Sloane Street
London SW1
171/235-4021
(Designer clothing and accessories)

LIBERTY OF LONDON
210–214 Regent Street
London W1
171/734-1234
(Clothing and accessories)

LULU GUINNESS
66 Ledbury Road
London W11
171/221-9686
(Bags)

MARKS AND SPENCER
458 Oxford Street
London W1N
171/629-9161
99 Kensington High Street
London W8
171/938-3711 for branches
(Department store)

MUJI
26 Great Marlborough Street
London W1
171/494-1197 for branches
(Natural-fiber clothing)

NEXT PLC
160 Regent Street
London W1
171/434-2515 for branches
(Clothing and accessories)

NICOLE FARHI
193 Sloane Street
London SW1
171/235-0877
(Designer clothing)

OASIS
28A Kensington Church Street
London W8
171/938-4019 for branches
(Clothing and accessories)

PATRICK COX SHOES
8 Symons Street
London SW3
171/730-6504
(Shoes)

PAUL SMITH WOMEN
40–44 Floral Street
London WC2
171/379-7133
(Smart, hip fashion)

PRADA
43–45 Sloane Street
London SW1
171/235-0008
(Designer clothing and accessories)

ROBERT CLERGERIE
67 Wigmore Street
London W1
171/935-3601
(Elegant footwear)

SELFRIDGES
400 Oxford Street
London W1
171/629-1234
(Department store)

SPACE NK
37 Earlham Street
London WC2
171/379-7030
(Simple, modern clothes and accessories)

SWAINE, ADENEY, BRIGGS & SONS
54 St. James Street
London W1
171/409-7277
(Riding clothes and accessories)

WAREHOUSE
19–21 Argyll Street
London W1
171/437-7101
(Runway copies at affordable prices)

WHISTLES
12–14 St. Christopher Place
London W1
171/487-4484
(Classic, influential designs)

JAPAN

COMME DES GARÇONS
5-11-1 Minami-aoyama
Minato-ku
Tokyo
3/3207-2480
(Designer clothing)

ISETAN
3-14-1 Shinjuku
Shinjuku-ku
Tokyo
3/3352-1111
(Specialty store)

JURGEN LEHL
5-3-10 Minami-aoyama
Minato-ku
Tokyo
3/3498-6723
(Japanese-designed clothes)

NORIKO MAEDA
6-8-1 Ginza, 4th Floor
Chuo-ku
Tokyo
3/3573-6008
(Upscale designer clothing)

TAKASHIMAYA
2-4-1 Nihonbashi, Chuo-ku
Tokyo
3/3211-4111
(Designer clothing)

resources

12 DB SUIT AND BLACK SHIRT—Polo Ralph Lauren; SUNGLASSES—Calvin Klein; BLACK WATCH—Swatch; CELLULAR PHONE—Motorola; CELLULAR PHONE CASE—T. Anthony; BLACK NYLON BAG—Gap; BLACK SUEDE SNEAKERS—Private collection of Adam Glassman

13 COWL-NECK CREPE JERSEY—Jill Stuart; BLACK SATIN SANDALS—cK Calvin Klein; EVENING BAG—Nine West; PEARL CHOKER—Kenneth Jay Lane

14 LEFT: LAVENDER STRETCH DRESS—Bisou Bisou; STRAW HAT—Anne Vuille at Sola; OPEN-TOE SANDALS—Anne Klein; LAVENDER SUEDE BAG—James Corvello; NECKLACE—Fragments RIGHT: LIME-GREEN BIKINI—Gap; TURQUOISE FLOWERED PAREO—Adrienne Vittadini; LIME-GREEN TERRY HAT—Gap; LIME-GREEN SUEDE MULES—J. Crew

15 LEFT: SUEDE GLOVES—Ralph Lauren Collection; WOOL TWILL SUIT AND CASHMERE TURTLENECK—Ralph Lauren Collection; BELT—Bottega Veneta; SOCKS—Hot Sox; SUEDE SHOES—Laura Ashley; SUNGLASSES—Morgenthal Frederics RIGHT: BLACK BEADED GOWN—Halston; CLOSED-TOE HEELS—Paloma; CZ TEAR-DROP

EARRINGS—M & J Savitt; SILVER AND SATIN CLUTCH—Enzo Angiolini

16 HANDBAG—Gucci; JEANS—Levi Strauss & Co.; STRAW HAT—Gap; STRIPED BANDEAU AND BOTTOM—Calvin Klein; PALE-GREEN SUEDE CLOGS—Banana Republic; BLACK PATENT PUMPS—Bruno Magli

17 SWEATER SET—Cashmere Cashmere; BLACK MINI DRESS—Nicole Miller; SCARF—Crysallis at D.P. Accessories; "PANTHER" RHINESTONE CLUTCH—Judith Leiber; GLOVES—Reem Marra for Fragments; SUEDE BOOTS—Kenneth Cole; SANDALS—Stuart Weitzman; VENETIAN GLASS INTAGLIO, SAPPHIRE, AND GOLD BRACELET—Elizabeth Locke

18–19 GOLD-MESH FLOOR-LENGTH DRESS—Pamela Dennis; BLACK SLEEVELESS POLYESTER DRESS—MaxMara; SATIN LEOPARD-PRINT SUIT—Carolina Herrera; MANNEQUINS—Geoffrey Beene

22 SILK SHIRT—Emilio Pucci; NAVY COAT—Prada; CASHMERE SWEATER—Donna Karan; GOLD NECKLACE—Elizabeth Locke

23 RED WOOL SUIT JACKET—Ellen Tracy; MOCHA SEQUINED DRESS—Pianoforte di MaxMara

24–25 LEFT TO RIGHT: YELLOW VELVET BAG—Prada; BRONZE SILK WEB WRAP—Crysallis at D.P. Accessories; MULTI-HUED RAYON-NYLON BLEND JACKET—Giorgio Armani; CHAMPAGNE COLORED SATIN JACKET—Oscar de la Renta; EMBROIDERED ORGANZA BLOUSE—The Smiths; PEWTER SILK SHIRT-DRESS—Ralph Lauren; COPPER SATIN BROCADE EVENING JACKET—Oscar de la Renta; SILVER SEQUINED

JACKET—Bill Blass; GRAY AND BLACK BEADED WRAP SHIRT—Carmen Marc Valvo; SILK KNIT SWEATER SET—Geoffrey Beene; SILVER VELVET AND LACE DRESS—Geoffrey Beene

26 SILK CAMISOLE WITH RED BEADING—Gabriella Zanzani

27 POWDER-BLUE WOOL BOUCLÉ SUIT JACKET WITH ENAMEL FLOWER BUTTONS—St. John

29 BLACK WOOL PANTSUIT—Richard Tyler; SILK IVORY CAMISOLE—Giorgio Armani; GOLD RAYON T-SHIRT—MaxMara; BLACK FLAT-FRONT SKIRT—Ralph Lauren; SILVER SKIRT—Celine; BLACK SEQUINED CARDIGAN AND T-SHIRT—Donna Karan

30 THONGS WITH GOLD SEQUINS—Miu Miu; BLACK ALLIGATOR CLUTCH WITH GOLD BUCKLE—Kleinberg Sherrill; PEWTER LUREX WOVEN ORGANZA SCARF—Lisa Violetto at D.P. Accessories; GRAY PEARL CHOKER WITH RHINESTONE CLASP—Kenneth Jay Lane; BEADED RHINESTONE CLUTCH—Judith Leiber; RHINESTONE AND PEARL FLOWER EARRINGS—Kenneth Jay Lane; BLACK SATIN SLINGBACKS—Walter Steiger; BLACK SATIN BELT WITH RHINESTONE BUCKLE—Judith Leiber; SUNGLASSES—Dana Buchman

32 BLACK RAYON CREPE DRESS—MaxMara FAR LEFT: BLACK SUNGLASSES—Christian Roth for Optical Affairs; SILVER PENDANT—John Iverson at Takashimaya; SILVER CUFF BRACELETS—Cara Croninger at Fragments; BLACK PATENT LEATHER SANDALS—Birkenstock MIDDLE LEFT: BLACK SUNGLASSES, SILVER HOOP EARRINGS, BLACK PLASTIC CUFFS—Agatha;

HEADBAND—Wathne; BLACK NYLON TOTE—Prada from Barneys New York; SILVER AND EBONY CUFF—Ex Ovo; BLACK POLISHED-LEATHER BELT—J. Crew; BLACK CAP-TOED PUMPS AND SCARF—Chanel MIDDLE RIGHT: FAUX PEARL EARRINGS—Mish; FAUX PEARL NECKLACE—Gerard Yosca; BLACK RAYON CREPE BELT—MaxMara; GOLD LINK BRACELET—Elizabeth Locke; BLACK QUILTED-LEATHER HANDBAG—Chanel; BLACK PUMPS—Barneys New York FAR RIGHT: GOLD HOOP EARRINGS AND CHARM BRACELET—Private collection of Adam Glassman; BLACK LEATHER HANDBAG—Paloma Picasso; GOLD LINK BELT—Paloma Picasso; BLACK SUEDE PUMPS—Anne Klein

33 BLACK RAYON CREPE DRESS—MaxMara ACCESSORIES, CLOCKWISE FROM TOP RIGHT: SQUARE SILVER-MIRROR BAG—Amy Chan at Apropo; FLORAL-PATTERNED POUCH—Adriana Caras; SQUARE-HEELED PUMPS—Anne Klein; SANDALS WITH RHINESTONE BUCKLE—Stuart Weitzman; RED SILK PUMPS—Kenneth Cole; MATTE GOLD CUFF—Robert Lee Morris; RED BEADED SCARF—Urvashi at Apropo

34 BLACK LACE BUSTIER—Barneys New York

35 CAMEL-HAIR POLO COAT—Ralph by Ralph Lauren

36–37 RED LIPSTICKS—Face Stockholm, Maybelline, Prescriptives, Stila, Studio Gear, Trucco; POWDER BRUSH—MAC

38 FRAGRANCE BOTTLES—Small blue bottle—Felissimo; Large blue bottle—Barneys; All others—Brosse, USA, Inc.

42 BUTTER CASHMERE HALTER—M-A-G; NYLON ORANGE JACKET—United

Colors of Benetton; **ANTIQUE GOLD CHARM BRACELET**—Terry Rogers; **"GOLFERS" PLAID PANT**—Steven DiGeronimo

43 **PATENT APPLE-GREEN VINYL BAG**—D&G Dolce & Gabbana; **PEARL NECKLACE**—Carolee; **EARRINGS**—Ciner; **PINK JACKET**—Oscar de la Renta; **BLACK DRESS**—Barneys New York; **BLACK SATIN BAG**—Kleinberg Sherrill; **BLACK SATIN SHOES**—Bottega Veneta; **SATIN PUMP, SCARF, PEARL NECKLACE, BEADS, BRACELET**—Private collection of Jeff Stone

44 **POLKA-DOT SCARVES**—The Honey Collection

45 **YELLOW SILK SHANTUNG DRAWSTRING EVENING POUCH**—Kate Spade; **BLUE WOOL CREPE JACKET**—DKNY; **BLACK COTTON T-SHIRT**—Levi's Womenswear; **SILVER NECKLACE**—Fragments; **DRIVING SHOES**—J.P. Tod's

46–47 **GRAY GLEN PLAID DRESS**—Anne Klein II; **GRAY GLEN PLAID COAT**—Anne Klein II; **HIGH HEELS**—Manolo Blahnik; **SHOULDER BAG**—Kate Spade; **SILVER CUFFS**—Ben Amun; **SILVER EARRINGS**—Barry Kieselstein-Cord

48 **JACKET AND PANTS**—Giorgio Armani; **SILK BLOUSE**—Giorgio Armani

49 LEFT: **SILK SKIRT AND OPEN-FRONT BLOUSE**—Eileen Fisher; **SUEDE CAMEL OPEN-TOE HEELS**—Celine; **PEWTER CLUTCH WITH BEADING**—Judith Leiber; **MULTI-STRAND PEARL CHOKER**—Lisa Marinucci at Fragments RIGHT: **BUTTER SILK EMPIRE-WAIST DRESS**—Ann Taylor; **BEIGE PUMPS**—Noriko Maeda; **SATIN SHOULDER BAG**—Bottega Veneta; **GOLD-MESH CUFF**—Anne Klein; **WIDE-**

BRIM HAT WITH SILK FLOWERS—Lola

50 **BLACK PATENT MID-HEEL PUMPS**—Salvatore Ferragamo

51 **LAVENDER LEATHER BALLET FLATS**—Chanel; **SILVER OPEN-TOE STILETTO SANDALS**—Stuart Weitzman; **CANVAS SNEAKERS**—Gap; **BLACK CAP-TOE FLATS**—Bruno Magli

52 **ORANGE AND PINK WOVEN DRESS**—Noriko Maeda; **GOLD BLISTER PEARL PIN**—Lazaro; **FLOWER-PRINT SILK DRESS**—J. Crew; **WHITE LACE-UP SANDALS**—Manolo Blahnik; **NECKLACE**—Fragments; **LIGHT-BLUE SLEEVELESS DRESS**—Versace; **YELLOW CASHMERE CARDIGAN**—TSE

53 **GRAY DRESS WITH SPAGHETTI STRAPS AND MATCHING JACKET**—Jill Stuart; **BLACK BAG WITH PURPLE AND YELLOW POPPY FLOWER TRIM**—Kate Spade; **OPEN-TOE SANDALS**—Kenneth Cole; **HEART-SHAPED LAVENDER PENDANT**—Kazuko

54 **LAVENDER SILK CREPE SUIT**—Carolina Herrera; **SILVER LEATHER OPEN-TOE HEELS**—Freelance; **SILVER LEATHER CLUTCH**—Kleinberg Sherrill

55 **PEARLS**—CIRO

56 **PINK WOOL SUIT**—Chanel; **ALLIGATOR CLUTCH**—Kleinberg Sherrill; **TRIPLE-STRAND LARGE PEARL NECKLACE**—Jay Strongwater; **WATCH**—Cartier

57 LEFT: **BLAZER**—Calvin Klein; **POLYESTER T-SHIRT**—Tahari; **KHAKI PANTS**—J.Crew; **LAVENDER ULTRA-SUEDE BAG**—Kate Spade; **PATENT LEATHER LOAFERS**—Charles David RIGHT: **LIGHT-BLUE RAYON CARDIGAN AND MATCHING CAMISOLE**—Rampage; **BLACK AND WHITE POLKA-DOT DRAWSTRING**

MINISKIRT—Rampage; **SILVER NECKLACE WITH SQUARE LINKS**—Nine West; **FLAT BLACK LEATHER LOAFERS**—Ralph Lauren

58–59 **STRAW HAT WITH SILK FLOWERS**—Lola

60 **PANTSUIT**—Ralph by Ralph Lauren; **SHEER BLUE CAMISOLE**—Giorgio Armani; **BLUE SEQUINED TOP**—Searle; **STRAPPY SANDALS**—Vanessa Noel; **SILVER CLUTCH**—Neiman Marcus; **SILVER RING WITH LARGE OPAL**—M & J Savitt; **SILVER CHAIN-LINK BELT**—Bottega Veneta

61 **TAFFETA PANTS**—Searle; **IRIDESCENT TAFFETA JACKET WITH PYTHON TRIM**—Searle; **POLISHED STRETCH HALTER**—Searle; **TAN LEATHER HANDBAG**—Bindya

62 **WHITE SHIRT**—Polo/Ralph Lauren

63 LEFT: **WHITE COTTON SHIRT**—Agnès B.; **BLACK WOOL PANTS**—Agnès B.; **STRAW BOATER**—Helen Kaminski; **CINNABAR-RED BEAD NECKLACE**—Leekan; **STRAW BAG WITH CHERRIES**—Morgan & Clyde; **BLACK POLISHED-LEATHER BELT WITH SILVER BUCKLE**—Ralph Lauren; **BLACK PATENT LEATHER SANDALS**—J. Crew RIGHT: **WHITE COTTON SHIRT**—Agnès B.; **BLACK WOOL PANTS**—Agnès B.; **TURQUOISE WOOL TURTLENECK**—SportMax by MaxMara; **BLACK SUNGLASSES**—Optical Affairs; **BLACK POLISHED-LEATHER BACKPACK**—Ralph Lauren; **SILVER LINK BRACELET**—Ralph Lauren; **SILVER RINGS**—Erica Courtney; **BLACK POLISHED-LEATHER BELT WITH SILVER BUCKLE**—Robert Lee Morris; **OXFORDS**—DKNY

64 **BLACK KNIT TOP AND PANTS**—Eileen Fisher; **GOLD**

CHARM BRACELET AND GOLD NECKLACE WITH LARGE JEWELED DROP—Stephen Dweck; **TAN PATENT LEATHER LOAFERS WITH BLACK TASSEL**—Bottega Veneta

65 **MINT AND NAVY SHORT-SLEEVED TWINSET**—Chanel

66 **CHARTREUSE CASHMERE SWEATER SET**—Hermès; **JEANS**—Levi Strauss & Co.; **SUEDE THONGS**—DKNY; **LEOPARD-PRINT SCARF**—Echo; **TORTOISESHELL AND GOLD BRACELETS**—Ben Amun

67 LEFT: **JACKET AND FLATS**—Chanel; **T-SHIRT**—Levi's Womenswear; **KHAKI PANTS**—Dockers for Women RIGHT: **PERIWINKLE CASHMERE MOCK TURTLENECK**—M-A-G; **BLACK SILK SHANTUNG HIP-HUGGER CLAMDIGGERS**—Cynthia Rowley; **SUNGLASSES**—Calvin Klein; **BLACK LEATHER BALLET FLATS**—Enzo Angiolini; **SILVER MATTE SQUARE PENDANT CHOKER**—Fragments; **BEADED METALLIC PURSE**—Amy Chan at Apropo

68 **CORAL TAFFETA GOWN**—Amsale

69 **SLEEVELESS BLACK POLYESTER DRESS**—MaxMara; **MANNEQUIN**—Geoffrey Beene

70 LEFT: **GOLD DRESS AND REEFER COAT**—Michael Kors; **VELVET AND SATIN HANDBAG AND PUMPS**—Bottega Veneta; **EARRINGS**—Janice Girardi at Fragments RIGHT: **RUFFLED LAVENDER SILK CREPE WRAP BLOUSE**—Anne Klein II; **SLATE-PURPLE SILK WIDE-LEG DRAWSTRING PANTS**—A Line Anne Klein; **SILVER THONGS**—Gucci

71 LEFT: **GOLD BEADED AND WOVEN DRESS**—Carmen Marc Valvo; **GREEN ACCORDION WRAP**—Jane

Steinberg; **GOLD STACKED HEELS**—Calvin Klein; **SQUARE HANDBAG**—Adrienne Vittadini RIGHT: **BEADED DRESS**—Katherine Hamnett; **NECKLACE**—Fragments; **SILVER STILETTOS**—Stuart Weitzman

72 **UMBRELLA**—Shanghai Tang

73 **BLACK POLYESTER JACKET**—Burberrys; **YELLOW RUBBER BOOT**—Gates Boot Company; **BLACK LEATHER BOOT**—Chanel

78 **COTTON SUNDRESS**—Ralph Lauren; **HOOP EARRINGS**—Zima at Fragments; Trifari; Carolee; Erwin Pearl; Private collection of Lisa Werthheimer; **WHITE DENIM JEANS**—Gap; **BAG**—Nine West; **GOLD OPEN-TOE MULES**—DKNY; **LIME-GREEN AND WHITE SNEAKERS**—cK Calvin Klein

79 **MULTI-COLORED WOVEN BAG**—Inca at Apropo; **STRAW HAT**—Helen Kaminski; **SUNGLASSES**—Gap; **BLACK DRESS**—Barneys New York; **BLACK PATENT BAG**—Ralph Lauren; **GOLD CUFF**—Salvatore Ferragamo; **BLACK AND WHITE POLKA-DOT BATHING SUIT**—Adrienne Vittadini; **FUCHSIA BIKINI WITH LIGHT-PINK BORDER**—Tiziano

80–81 **FLORAL-PRINT BIKINI**—Adrienne Vittadini; **PINK COTTON-BLEND DRESS**—Laura Urbinati at Staff

82–83 **PALE-YELLOW COTTON DRESS**—Miu-Miu; **T-STRAP BEIGE SHOES**—Manolo Blahnik; **GOLD NECKLACE**—Ben Amun

84 **UNLINED BEIGE TROPICAL-WEIGHT WOOL JACKET**—Donna Karan; **BEIGE RAYON PANTS**—Clements Ribeiro at Bergdorf Goodman; **COPPER BRACELET**—Jay Strongwater; **SNAKE BRACELETS**—Roxanne Assoulin; **EARRINGS**—Fragments; **SUNGLASSES**—Morgenthal Frederics; **BAG**—

Louis Vuitton; **SANDALS**—Kenneth Cole

85 **FLORAL DRESS**—Anna Sui; **CORDUROY JACKET**—K-189 by Daryl K; **STRAPPY SANDALS**—Sigerson Morrison; **PINK TOTE**—Kate Spade; **SUNGLASSES**—Silhouette;

86–87 **BEIGE SABRINA-HEEL MULE**—Manolo Blahnik; **FLAT LAVENDER MULE**—Manolo Blahnik

88 LEFT: **KHAKI JACKET AND SHORTS**—J. Crew Collection; **BROWN/GRAY/WHITE-STRIPED LYCRA POLO**—J. Crew; **PALE-YELLOW PATENT LEATHER LOAFERS**—J.P. Tod's; **THREE SQUARE COLLAPSIBLE LEATHER BAGS**—DKNY; **SUNGLASSES AND CHAIN**—Bottega Veneta RIGHT: **ASYMMETRICAL BATHING SUIT**—Calvin Klein; **BEIGE LINEN DRAWSTRING PANTS**—TSE Cashmere; **BROWN SUEDE THONGS**—J. Crew; **CARDIGAN**—TSE Cashmere; **GOLD CUFF**—Chanel

89 LEFT: **BAMBOO-PRINT SILK HALTER DRESS**—Liz Claiborne; **KHAKI COTTON SAFARI JACKET**—J. Crew Collection; **STRAW HAT**—Lola; **NECKLACE AND BRACELETS**—Ben Amun RIGHT: **LIME-GREEN COTTON HALTER TOP**—J. Crew; **KHAKI FLAT-FRONT LONG SHORTS**—J. Crew Collection; **FISHBOWL-PRINT CHIFFON SCARF**—Echo; **MOTHER-OF-PEARL CIGARETTE CASE**—Bottega Veneta; **TURQUOISE "BABY G-SHOCK" WATCH**—Casio; **NECKLACE**—Fragments

90 **BLUE STRAW HAT**—Patricia Underwood; **WATCH**—Skagen at Steven Alan; **SUNGLASSES**—Oakly

91 **ALL ITEMS**—Private collection of Laurel Elder

92 **BLUE STRAW HAT**—Patricia Underwood; **SQUARE TURQUOISE EARRINGS**

WITH GOLD EDGE—Jay Strongwater; **PALE-GREEN SUNGLASSES**—Arnette; **PALE-GREEN MAILLOT**—J. Crew; **LILAC PAREO**—Eres at Bergdorf Goodman; **GREEN STRAW BAG**—Old Navy; **LILAC SANDALS**—J. Crew

93 **DUCKS**—Ad Hoc Softwares

94 LEFT: **NAVY AND WHITE COTTON STRIPED SAILOR SWEATER**—Barneys New York; **WHITE PIQUÉ PANTS**—Ralph by Ralph Lauren; **SILVER HOOPS**—Agatha; **RED SUEDE THONGS**—Celine; **BLACK PATENT BAG**—Celine RIGHT: **BLACK COTTON T-SHIRT**—Saks Fifth Avenue; **WHITE COTTON-SILK BLEND PANTS**—Searle; **SUNGLASSES**—Dana Buchman; **SILVER BANGLES**—M&J Savitt; **ANIMAL-PRINT LOAFERS**—Stubbs & Wootton

95 LEFT: **GOLD-HAMMERED CUFF**—M.E. Stewart at D.P. Accessories; **SILVER DISK BELT**—Sarah Cavendar at D.P. Accessories; **COTTON AND SILK PANTS**—Searle; **GOLD SILK KNIT SLEEVELESS TANK**—MaxMara; **STRAPPY LEATHER FLATS**—Freelance; **VELVET AND GOLD CRUSHED VELVET BAG**—Fendi RIGHT: **PINK SATIN FLORAL BLOUSE**—The Smiths; **WHITE PANTS**—Ralph Lauren; **BLUE NYLON BAG**—Prada; **LAVENDER SUEDE THONGS**—Celine; **PEWTER AND PEARL EARRINGS**—Kenneth Jay Lane

96 **GRILL**—Weber Grills

97 **APRON**—Chic Simple

98 LEFT: **HANDBAG WITH SILVER HANDLE**—Apropo; **GOLD HAIRPIN WITH BLUE BUTTERFLY**—Collette Malouf; **FAUX SNAKESKIN OPEN-TOE SLIDES**—Ralph Lauren; **LIME-GREEN LEATHER STRAPPY SANDALS WITH SILVER BUCKLE**—Stuart

Weitzman; **GREEN AND BLUE EMBROIDERED DAISY DRESS**—Barbara Kramer RIGHT: **DARK BROWN KNIT DRESS**—Donna Karan; **CELADON SCARF**—DKNY; **BROWN ALLIGATOR HIGH-HEEL SANDALS**—Manolo Blahnik; **GOLD CUFF BRACELET AND NECKLACE**—Fragments

99 LEFT: **BLUE SILK BUTTON-DOWN**—Emilio Pucci; **SILK SHANTUNG CAPRI PANTS**—Emilio Pucci; **SILK SCARF**—Emilio Pucci; **PEARL WITH GOLD EARRINGS**—Kenneth Jay Lane; **FLAT HONEY THONGS WITH CROCODILE STRAPS**—Ralph Lauren; **GOLD LIZARD MULES**—Manolo Blahnik RIGHT: **"RING LIZARD" CLUTCH WITH RHINESTONE CLASP**—Judith Leiber; **SILVER FLOWER CUFF**—Stephen Dweck; **TAUPE SUEDE THONGS**—Stuart Weitzman; **EIGHT-STRAND PEARL CHOKER WITH SILVER AND PEARL DETAIL**—Fragments; **WHITE COTTON T-SHIRT**—Express; **SEAFOAM-GREEN PANTS WITH BEADING**—Anne Klein II

100 **SHEER DRESS WITH SLIP**—Calvin Klein; **GOLD NECKLACE WITH YELLOW BERYL PENDANT**—Elizabeth Locke; **BAG**—Bottega Veneta; **SLINGBACK PUMPS**—Chanel

101 **GOLD BEADED ORGANZA SCARF**—Adrienne Landau

106 TOP LEFT: **GLOVES**—Hermès; **HAT**—Matsuda; **OATMEAL CASHMERE TURTLENECK**—Malo; **BROWN SUEDE JODHPUR BOOTS**—Manolo Blahnik TOP MIDDLE: **GARMENT BAG**—Private collection of Jeff Stone TOP RIGHT: **BARN JACKET**—J. Crew MIDDLE LEFT: **ORANGE SUEDE BACKPACK WITH BAMBOO HANDLE AND SILK SCARF**—Gucci MIDDLE RIGHT: **SILVER PEN**—Dunhill; **BLACK PEN**

Uni-ball; **AGENDA** Coach BOTTOM MIDDLE: **ANKLE BOOTS**—Bruno Magli

107 TOP LEFT: **GOLD COLLAR NECKLACE**—Carlo Weingrill CENTER: **WOOL SUIT**—J. Crew; **NECKLACE**—Erwin Pearl TOP RIGHT: **BLACK DRESS**—Vera Wang; **PALE-GREEN GOWN**—Vera Wang

109 **GREEN PEACOAT**—Michael Kors; **MULTI-STRIPE TURTLE-NECK SWEATER**—Gap

110–11 **SWEATER**—Isaac by Isaac Mizrahi; **TWEED PANTS**—Isaac Mizrahi; **LEATHER JACKET**—MLC; **LEATHER DRIVING SHOES**—J.P. Tod's; **SHOULDER BAG**—Ralph Lauren; **SUNGLASSES**—Adrienne Vittadini; **KNIT HAT**—Bottega Veneta; **GLOVES**—Naomi Misle; **WATCH**—Timex

113 LEFT: **GRAY GLEN PLAID DRESS AND JACKET**—Ralph by Ralph Lauren; **BAG**—Banana Republic; **PUMPS**—Manolo Blahnik; **GOLD BRACELET**—Elizabeth Locke; **NECKLACE**—Jay Strongwater RIGHT: **GRAY GLEN PLAID PANTSUIT**—Ralph by Ralph Lauren; **LAVENDER COTTON SHIRT**—Ralph by Ralph Lauren; **BAG**—Private collection of May Kim; **NAVY DRIVING MOCCASINS**—J.P. Tod's; **SCARF**—Echo; **SUNGLASSES**—Morgenthal Frederics; **BELT**—Banana Republic; **SOCKS**—Ralph Lauren; **SILVER MESH BRACELET**—Sarah Cavendar for D.P. Accessories; **WATCH**—Timex

115 **ASSORTED MAKEUP**—Aveda, Kiehl's, Origins, Prescriptives, Studio Gear

116 LEFT: **BROWN WOOL DOT DRESS AND JACKET**—Jennifer George; **BROWN CROCODILE SLINGBACKS**—Manolo Blahnik; **BAG**—DKNY; **NECKLACE**—Sarah Cavendar for D.P. Accessories; **GOLD CUFF**—Ben Amun;

BRACELETS—Fragments; **SUNGLASSES**—Morgenthal Frederics RIGHT: **SILK WRAP DRESS**—Diane Von Furstenberg; **BROWN HEELS WITH ANKLE STRAPS**—Walter Steiger; **GOLD CHAIN NECKLACE WITH CHARM DROP**—Stephen Dweck; **WOVEN HANDBAG**—Via Spiga

117 LEFT: **DOUBLE-BREASTED WOOL HERRINGBONE COAT DRESS**—Ralph by Ralph Lauren; **BEIGE SHORT-SLEEVED BLOUSE**—Banana Republic; **QUILTED HANDBAG**—Chanel; **ANTIQUE HAMILTON WATCH**—Time Will Tell; **TALL BROWN SUEDE BOOT**—Kenneth Cole RIGHT: **TWEED CHECK DRESS, GOLD MESH BRACELET, BROWN SATIN PUMPS**—Chanel; **CITRINE BEADED NECKLACE**—Elizabeth Locke; **BEADED HANDBAG**—Bottega Veneta

118 **HEIRLOOM BAG**—Gucci; **"PRINCESS DI" QUILTED HANDBAG**—Christian Dior; **KELLY BAG** Hermès; **LEATHER SHOULDER TOTE**—Louis Vuitton

119 **SHOULDER TOTE**—Coach

120 **GRAY LIGHTWEIGHT WOOL SUIT**—Marc Jacobs; **BEADED ORGANZA SLEEVELESS BLOUSE**—Pamela Dennis; **PEWTER MESH SLEEVELESS TANK**—Giorgio Armani; **STERLING CLUTCH**—Neiman Marcus Collection; **GRAY SNAKESKIN MULES**—Marc Jacobs; **BLACK LEATHER PUMPS**—Manolo Blahnik

121 LEFT: **TAUPE SILK KNIT CAMISOLE AND CARDIGAN**—Bill Blass; **CHARCOAL-GRAY WOOL PINSTRIPE SUIT JACKET AND MATCHING PANTS**—Giorgio Armani; **VELVET ANIMAL-PRINT LOAFERS**—Stubbs & Wootton; **LEATHER HANDBAG**—Bottega Veneta; **WATCH**—Ecclissi RIGHT:

TAUPE SILK KNIT CAMISOLE AND CARDIGAN, GRAY SEQUINED SKIRT—Bill Blass; **METALLIC BROWN LEATHER WALLET**—Via Spiga; **BROWN LEATHER PUMPS**—Manolo Blahnik

122–23 **BLACK SILK STILETTO SLINGBACKS**—Stuart Weitzman; **BLACK CALF STILETTO PUMP**—Manolo Blahnik; **LEOPARD-PRINT SLIPPER**—Stubbs & Wootton

124 **KNIT ANIMAL-PRINT SWEATER**—D&G Dolce & Gabbana; **SLIM CASHMERE PANT**—TSE; **BROWN NYLON BAG**—Kate Spade

125 **VINTAGE CASHMERE SWEATER WITH PEARL BEADING**—Private collection of Kim Johnson Gross; **LOOSELY CROCHETED CARDIGAN**—DKNY

126 **PLUM KNIT TANK AND V-NECK CARDIGAN SET**—Adrienne Vittadini; **BLACK VELVET WITH GOLDEN-BRONZE LOWLIGHTS KNEE-LENGTH SKIRT AND COAT**—Searle; **BROWN NYLON BAG**—Kate Spade; **BROWN SATIN HEELS**—Chanel

127 **GRAY SLEEVELESS MOCK TURTLENECK AND MATCHING PANTS**—Ralph by Ralph Lauren; **GRAY VELVET JACKET**—Ralph by Ralph Lauren; **ANTIQUE LONGINES WATCH**—Time Will Tell; **GRAY JERSEY AND SUEDE GLOVES**—Bottega Veneta; **BROWN SUEDE BOOTS**—Bottega Veneta; **GREEN ULTRASUEDE TOTE**—Bottega Veneta

128 **BLACK WOOL TURTLENECK**—J. Crew; **BLACK WOOL PANTS**—Carolina Herrera; **PYTHON JACKET**—Carolina Herrera

129 LEFT: **MULTICOLORED WOOL SWEATER**—Old Navy; **BROWN LEATHER PANTS**—Ralph Lauren; **BROWN LEATHER BOOTS**—Joan and David RIGHT: **BEIGE SUEDE**

JACKET AND MATCHING PANTS—Holland & Holland; **MERINO WOOL SWEATER**—Kors by Michael Kors; **ALLIGATOR FLATS**—Manolo Blahnik; **LEOPARD-PRINT HANDBAG**—Banana Republic

130 **BLACK BLAZER**—Donna Karan

131 LEFT: **BLACK CREPE SINGLE-BREASTED JACKET AND PANTS**—Anne Klein II; **WHITE COTTON NOTCHED-COLLAR BLOUSE**—Anne Klein II; **LAPEL PIN**—Elizabeth Locke; **BURGUNDY CASHMERE SHAWL**—Bergdorf Goodman; **WATCH**—Georg Jensen; **BLACK LEATHER GLOVES AND BELT**—Hermès; **MOCK CROCODILE LOAFERS**—Adrienne Vittadini RIGHT: **BLACK CREPE BLAZER**—Anne Klein II; **SWEATER VEST**—Anne Klein II; **GINGHAM BUTTON-DOWN SHIRT**—Anne Klein II; **JEANS**—Levi Strauss & Co.; **BLACK ANTIQUE-CALF LOAFERS**—Adrienne Vittadini; **TROUSER SOCKS**—J. Crew; **WATCH**—Timex

132 **LEATHER OXFORDS**—cK Calvin Klein, **MARKET BAG**—Ghurka; **CASHMERE TURTLE-NECK**—TSE; **JEANS**—Levi Strauss & Co.

133 LEFT: **RED CASHMERE SWEATER SET**—TSE Cashmere; **GRAY FLANNEL TROUSERS**—Polo/Ralph Lauren; **PEARLS**—CIRO; **GRAY FLANNEL SHOES**—Chanel; **BELT**—Gucci RIGHT: **MICROFIBER JACKET WITH VELVET COLLAR**—Hermès; **SCARF**—Echo; **WOOL BLAZER**—Hermès; **BLACK CASHMERE SWEATER**—Michael Kors; **BLACK TROUSERS**—Hermès; **BLACK LOAFERS**—J. Crew; **PLAID KNEE SOCKS**—Ralph Lauren for Hot Sox

134–35 LEFT TO RIGHT: **BALLET SLIPPER**—Bottega Veneta;

PATENT LEATHER LOAFER—J. Crew; **BROWN LEATHER SPLIT-TOED OXFORD**—J.M. Weston; **BROWN SUEDE JODHPUR BOOT**—J.M. Weston

136 LEFT: **PEACOAT**—Schott; **TURTLENECK**—The Limited; **GLOVES**—Coach; **BOOTS**—Bruno Magli **LEGGINGS**—The Limited; **BACKPACK**—Takashimaya RIGHT: **BLACK TURTLENECK SWEATER**—Maria di Ripabianca; **BLACK LEATHER JACKET** MLC; **SUNGLASSES**—Adrienne Vittadini; **GRAY WOOL PANTS**—Chanel; **BROWN LEATHER BAG**—Ralph Lauren; **BELT**—DKNY; **WATCH**—Timex; **SHOES**—J. Crew; **SOCKS**—Hot Sox

137 LEFT: **BEIGE COTTON CREWNECK**—Ralph by Ralph Lauren; **BEIGE SUEDE COAT AND MATCHING SKIRT**—Ralph by Ralph Lauren; **SUNGLASSES**—Morgenthal Frederics; **NYLON TOTE**—DKNY; **SHOES**—DKNY; **GOLD BRACELETS**—Chanel RIGHT: **BLACK VISCOSE PULLOVER**—Hermès; **BLACK CREPE PANTS**— Anne Klein II; **BLACK BAG**—Banana Republic; **SILVER CUFF BRACELET**—Ben Amun; **LEATHER AND SILVER NECKLACE**—Barry Kieselstein-Cord; **BLACK SANDALS**—Manolo Blahnik

138 **BLACK COTTON-LYCRA PANTS**—Gap

139 LEFT: **STRIPED KNIT BOAT-NECK PULLOVER**—Adrienne Vittadini; **CARDIGAN**—Chic Simple; **BEIGE MULES**—DKNY; **SILVER BANGLES**—Monet; **WHITE COTTON BUTTON-DOWN**—J. Crew; **CORNFLOWER-BLUE JACKET**—Ralph Lauren; **OPEN BANGLE SILVER WATCH**—Georg Jensen RIGHT: **BLACK SLINGBACKS**—Adrienne Vittadini; **BLACK LEATHER BELT**—Hermès; **BLACK QUILTED ZIP JACKET**—DKNY;

WHITE HIGH V-NECK T-SHIRT—Donna Karan Essentials; **RED NYLON TOTE BAG**—Kate Spade; **SUNGLASSES**—Optical Affairs; **PATENT LEATHER LOAFERS**—Hermès

140 FROM TOP: **BELTS**—Barry Kieselstein-Cord; Barry Kieselstein-Cord; Hermès; Hermès

141 **APPLE-GREEN PULLOVER**—Hermès; **BELT**—Gucci at Bergdorf Goodman; **SUNGLASSES** Christian Roth; **PINSTRIPE PANTS**—Anne Klein II; **BLACK LEATHER BOOT**—J. Crew

142-43 **BLACK JUMPSUIT**—Geoffrey Beene

144 **SILVER COCKTAIL SHAKER**—Pedrini; **MARTINI GLASS**—Crate & Barrel

145 **BLACK SILK TUXEDO DRESS**—Ralph Lauren; **BLACK AND SILVER BROOCH**—Monet; **RHINESTONE-ENCRUSTED CLUTCH**—Judith Leiber; **BLACK SILK HEELS**—Susan Bennis/Warren Edwards; **BLACK CLUTCH**—Bottega Veneta; **BLACK GLOVES**—Fownes; **LIPSTICK**—Chanel

146 **BLACK WOOL-CASHMERE COAT**—Searle

147 LEFT: **REVERSIBLE MINK COAT**—Oscar de la Renta for Alexandre; **BLACK CREW-NECK SWEATER**—Gucci; **BLACK KNIT PANTS**—Kors by Michael Kors; **BROWN HANDBAG**—Judith Leiber; **BROWN LEATHER GLOVES**—Bottega Veneta; **LEATHER BOOTS**—Ralph Lauren RIGHT: **PANNE VELVET COAT**—Bill Blass; **BLACK VISCOSE DRESS**—Michael Kors; **OSTRICH CLUTCH**—Judith Leiber; **BLACK VELVET T-STRAPS**—Manolo Blahnik; **VENETIAN GLASS INTAGLIO AND CARNELIAN BROOCH, GOLD AND CITRINE RING, GOLD AND SAPPHIRE BANGLE**—Elizabeth Locke

150 TOP RIGHT: **BLACK BEADED GOWN**—Halston; **SHOES**—Paloma; **CZ EARRINGS**—M&J Savitt; **SQUARE CLUTCH**—Enzo Angiolini BOTTOM LEFT: **CHRISTMAS SWEATER**—Eagle's Eye BOTTOM MIDDLE: **BOOTS**—Robert Clergerie

151 TOP LEFT: **RED VELVET PANTS**—John Bartlett TOP RIGHT: **SKI SUIT WITH FAUX BEAVER COLLAR**—Bogner; **SNOWFLAKE MITTENS**—J. Crew; **WALKIE-TALKIE**—Motorola; **BLACK BEARING SENSOR WATCH**—Casio BOTTOM LEFT: **FUR HAT**—Kaitery BOTTOM RIGHT: **CZ AND SILVER EARRING**—Ralph Lauren

152-53 **RUST SHEARLING COAT AND SLIP DRESS**—Searle Blatt

154 **BLACK VELVET DRESS**—Gap; **PEARLS**—Kenneth Jay Lane; **RED VELVET COAT WITH LEATHER COLLAR**—John Bartlett; **BLACK STRETCH BOOTS**—Robert Clergerie; **BLACK VELVET EVENING BAG**—Kenneth Cole

155 LEFT: **BLACK TURTLENECK**—TSE; **PALAZZO PANTS**—Giorgio Armani RIGHT: **CRYSTAL BEADED SHIRT JACKET**—Giorgio Armani; **GRAY CHIFFON PANTS**—Giorgio Armani

156 **BLACK EVENING PUMPS**—Noriko Maeda

157 **MATTE GOLD LAMÉ STILETTO PUMPS**—Stuart Weitzman

158 LEFT: **VELVET DRESS WITH BOA TRIM**—Carolina Herrera RIGHT: **TAFFETA GOLD PANTSUIT**—Pamela Dennis

159 LEFT: **RED AND FUCHSIA DUCHESS SATIN SKIRT SUIT**—Oscar de la Renta RIGHT: **SILVER VELVET AND LACE FLOOR-LENGTH GOWN**—Geoffrey Beene

160 **PLATINUM PAVÉ DIAMOND**

EVENING WATCH WITH RUBY CABOCHON DETAIL ON RED GROSGRAIN BAND—Van Cleef & Arpels; **GOLD AND PAVÉ DIAMOND THIN BANDED EVENING WATCH**—Van Cleef & Arpels

161 **RHINESTONE AND GOLD CLUTCH**—Judith Leiber; **SILVER KITTY-CAT MINAUDIÈRE WITH BEADING**—Judith Leiber

162 **CHRISTMAS SWEATER**—Eagle's Eye

163 LEFT: **SWEATER**—Ralph Lauren; **WOOL PANTS**—Donna Karan; **PEARL NECKLACE**—Kenneth Jay Lane; **BLACK SATIN BAG**—Kleinberg Sherrill; **BALLET SLIPPERS**—Bottega Veneta; **EARRINGS**—Kenneth Jay Lane RIGHT: **CASHMERE SWEATER SET**—TSE Cashmere; **SKIRT**—DKNY; **PEARLS**—CIRO

164 LEFT: **SLIP DRESS**—BCBG Max Azria; **BEADED EVENING BAG**—Vanessa; **RHINESTONE CHOKER**—Fragments; **STRAPPY STILETTO SANDALS**—Stuart Weitzman RIGHT: **GRAY COTTON SHAKER SWEATER**—Zoran; **GRAY PALAZZO PANTS**—Zoran

165 LEFT: **BLACK ACETATE JUMPER WITH SPAGHETTI STRAPS**—Ralph Lauren; **FUR-TRIMMED COAT**—Ralph Lauren; **BLACK VELVET BAG**—Gap; **SILVER LINK CHOKER WITH PEARL DROP**—Fragments RIGHT: **BLACK VELVET DRESS**—Gap; **CASHMERE CARDIGAN**—Pamela Dennis; **DARK GRAY PEARL CHOKER**—Kenneth Jay Lane; **VELVET STRAPPY PUMPS**—Target; **GOLD PEARLIZED STONE AND RHINESTONE RING**—Apropo

166 **SKI SUIT WITH FAUX BEAVER COLLAR**—Bogner; **SNOWFLAKE MITTENS**—J. Crew; **WALKIE-TALKIE**—Motorola; **BLACK BEARING**

SENSOR WATCH—Casio

167 **FUCHSIA SKI JACKET**—Polo Sport; **SUNGLASSES**—Epaulette; **BLACK G-SHOCK WATCH**—Casio

168 LEFT: **TAUPE COAT WITH FAUX FUR COLLAR**—MaxMara; **GRAY WOOL TURTLENECK**—Ralph Lauren Jeans; **GRAY FLANNEL BOOT-CUT PANTS**—Express; **BLACK SATIN BACKPACK**—Sisley by United Colors of Benetton; **SUEDE BOOTS**—J.P. Tod's; **TORTOISESHELL SUNGLASSES**—Kenneth Cole; **TAN MOHAIR GLOVES**—Sisley by United Colors of Benetton; **SILVER WATCH**—Giorgio Armani RIGHT: **CASHMERE HOODED ZIP-FRONT SWEATER WITH MINK-TRIMMED HOOD**—TSE Cashmere; **PANTS**—TSE Cashmere; **BROWN WOVEN LEATHER GLOVES**—Naomi Misle, **ANKLE BOOTS**—Banana Republic; **ANTIQUE HAMILTON WATCH**—Time Will Tell

169 **TAUPE CABLE-KNIT CARDI-GAN WITH FUR COLLAR**—Blumarine at Crespi Manani; **SILK GOWN**—Agnès B.; **RED SHIRT**—Cynthia Steffe; **CRUSHED-VELVET ORANGE CLUTCH**—Industria; **TANK**—Calvin Klein; **CITRINE RING**—Fragments; **SILVER CHOKER WITH PEARLS AND SMOKY CRYSTALS**—Fragments

170 **WHITE LONG-SLEEVED MESH COVER-UP**—D&G Dolce & Gabbana; **NAVY-BLUE TANK WITH LACE TRIM**—Moschino

171 LEFT: **NAVY RAYON SHIRT**—Anne Klein II; **NAVY WOOL PINSTRIPE PANTS**—Anne Klein II; **WHITE HAL-TER BODYSUIT**—Donna Karan; **SILK FLOWERED SCARF**—Old Navy; **SILVER BRACELETS AND EARRINGS**—Alejandro Toussier at D.P. Accessories;

SHOES—Manolo Blahnik RIGHT: **NAVY SILK PEA-COAT**—Ralph by Ralph Lauren; **JUMPSUIT**—Barneys New York; **SANDALS**—Kenneth Cole; **GOLD EVENING BAG**—Judith Leiber; **BELT**—DKNY; **NECK-LACE**—Elena Shovider Houper for Accessory Resource Gallery

172 **GOLD LOCKET WITH PAVÉ DIAMOND BAND**—Barry Kieselstein-Cord

173 **BLACK VISCOSE HALTER TOP**—Ralph Lauren

174 **SILK V-NECK NIGHTGOWN**—Christine and Company; **WHITE TERRY-CLOTH BATHROBE**—Barneys New York

175 **LIPSTICK**—Orlane; **ATOMIZ-ER**—Muji; **COMPACT**—Private collection of Hope Greenberg

178 **STATIONERY**—Mrs. Strongwater at Barneys New York; **PENS**—Parker, Mont Blanc, Waterman; **INK AND STAMP**—Private collection of Jeff Stone

180 LEFT: **WOVEN BEADED DRESS**—Carmen Marc Valvo; **GREEN ACCORDION WRAP**—Jane Steinberg at Fragments; **YELLOW AND BROWN SILK SCARF**—Noriko Maeda; **SQUARE GOLD HANDBAG**—Adrienne Vittadini; **GOLD SANDALS**—cK Calvin Klein RIGHT: **BLUE LEATHER SUIT**—Ralph Lauren; **BLACK CAMISOLE**—DKNY; **SILVER CHOKER**—Fragments; **BLACK LEATHER BAG**—Patrick Cox; **BLACK SLIDES**—Patrick Cox

181 LEFT: **SCARF**—Christian Lacroix; **EARRINGS**—Erwin Pearl; **LIGHT-BLUE CASH-MERE SWEATER SET**—Burberrys; **WATCH**—Baume & Mercier; **KHAKIS**—Gap; **LOAFERS**—J.M. Weston RIGHT: **WHITE DRESS**—Marc Jacobs at Bergdorf Goodman; **ROSEBUD TOTE AND MATCHING MULES**—

Manolo Blahnik; **NECKLACE AND BRACELET**—Fragments

182 LEFT: **BEADED DRESS**—Katherine Hamnett; **BEAD NECKLACE**—Fragments; **SIL-VER STILETTOS**—Stuart Weitzman RIGHT: **RED-ON-TAN FLORAL VELVET DRESS**—Searle Blatt; **BEAD FRINGE NECKLACE**—Ben Amun

183 LEFT: **DOUBLE-BREASTED SUIT**—Ralph Lauren; **SHAWL**—Anichini; **WHITE SHIRT**—Ralph Lauren; **BRACELETS**—Fragments; **CUFF**—Ben Amun; **GLOVES**—Coach; **BAG**—Polo Ralph Lauren; **BLACK FLATS**—Cole • Haan RIGHT: **PANTSUIT**—M-A-G; **BLACK SATIN BAG WITH COLLAPSIBLE SILVER HANDLE**—Fendi; **SATIN HEELS**—Vanessa Noel

184 LEFT: **WHITE BLOUSE**—Donna Karan; **GRAY WOOL SUIT**—Agnès B.; **STERLING SILVER BRACELET**—Agatha; **GRAY BAG**—DeVecchi; **BLACK PUMPS**—Bottega Veneta; **STOCKINGS**—DKNY; **EARRINGS**—Private collec-tion of Lisa Werthheimer RIGHT: **EVENING COAT WITH FUR TRIM**—D&G Dolce & Gabbana; **BLACK WRAP JERSEY DRESS**—Susan Lazar; **SATIN HEELS**—cK Calvin Klein; **SILVER CHOKER**—Robert Lee Morris; **BLACK HOISERY**—Oroblu

185 LEFT: **BLACK VELVET JACK-ET AND MATCHING SKIRT**—Searle Blatt; **PLUM TANK AND V-NECK CARDIGAN SET**—Adrienne Vittadini; **BROWN SATIN HEELS**—Chanel; **BROWN NYLON HANDBAG**—Kate Spade RIGHT: **TAFFETA NAVY TOP**—Michael Kors; **WHITE SILK CAMISOLE**—Giorgio Armani; **SILK PANTS**—Michael Kors; **FLAT GOLD PATENT LEATHER THONGS**—Celine

186 LEFT: **BLACK LEATHER**

JACKET—Agnès B.; **JEANS**—Levi Strauss & Co.; **ONE-SHOULDER CASHMERE TOP**—Malo; **NECKLACE**—Me and Ro RIGHT: **PRINTED DRESS WITH SHEER OVER-LAY**—Chanel; **RED EVENING BAG**—Kenneth Cole; **SHOES**—Kenneth Cole; **NECKLACE**—Chan Luu at Fragments

187 LEFT: **YELLOW SATIN DRESS**—M-A-G; **CITRUS-STONE DOUBLE-STRANDED NECKLACE**—Fragments; **PINK BEADED HANDBAG**—Nina Gill at Metropolitan Design; **SILVER STILETTO SANDALS**—Stuart Weitzman RIGHT: **TWEED SKIRT SUIT AND TURTLENECK**—Isaac Mizrahi; **BLACK LEATHER BAG WITH SILVER BUCKLE**—Calvin Klein

188 LEFT: **BLACK OFF-THE-SHOULDER CROCHETED DRESS**—A.B.S.; **HAIRPIN**—Colette Malouf; **BRACELET**—Richard Minadeo at Fragments; **HANDBAG**—Bindya; **SANDALS**—Joan & David Halpern Signature Shoes RIGHT: **BLACK KNIT DRESS**—Chanel; **GOLD SQUARE BRACELETS, GOLD EARRINGS**—Fragments; **ANKLE-STRAP PUMPS**—Chanel

189 LEFT: **NAVY PINSTRIPE COAT-DRESS**—Michael Kors; **BEAD NECKLACE**—Elizabeth Locke; **BLACK PUMPS**—Manolo Blahnik RIGHT: **BABY-BLUE KNIT JACKET**—Noriko Maeda; **BLACK KNIT DRESS**—Michael Kors; **PEARL NECKLACE**—Ben Amun; **BLACK PATENT LEATHER SLINGBACK PUMPS**—Adrienne Vittadini

190 LEFT: **BEADED EVENING GOWN**—Searle Blatt; **JET EARRINGS**—Ben Amun; **RHINESTONE-ENCRUSTED CLUTCH**—Judith Leiber; **BLACK SATIN EVENING SHOES**—Manolo Blahnik RIGHT: **RED WOOL SUIT**—Ellen Tracy

quotes

2 Ann Richards, in *What Is Beauty?* by Dorothy Schefer (Universe, 1997).

6 Australian aboriginal saying.

17 Donatella Versace, in *What Is Beauty?* by Dorothy Schefer (Universe, 1997).

19 Janeane Garofalo as Heather Mooney in the movie *Romy and Michele's High School Reunion* (Touchstone Pictures, 1997).

20–21 Carrie Fisher, *Postcards from the Edge* (1987; Pocket Books, 1990).

22–23 Mae West, quoted in "Anything for Oscar" by Amy Fine Collins, *Vanity Fair* (March 1998).

33 Gene Kelly to Nina Foch in the movie *An American in Paris* (MGM, 1951).

34 Helen Fielding, *Bridget Jones's Diary* (Viking, 1997).

36 Jacqueline Susann, *Valley of the Dolls* (1966; Grove/Atlantic, 1997).

38 Mercedes de Acosta, describing her sister, Rita Lydig, quoted in *The Power of Style* by Annette Tapert and Diana Edkins (Crown Publishers, 1994).

40–41 Charles Dickens, *Great Expectations* (1907; Alfred A. Knopf, 1992).

41 Langston Hughes, *Simple Speaks His Mind* (Aconian Press, 1983).

43 Carrie Donovan, *Women's Wear Daily* (February 1, 1995).

44 Isaac Mizrahi, *Vogue* magazine (July 1998).

46 Logan Pearsall Smith, from *The Portable Curmudgeon Redux*, Jon Winokur, ed. (Dutton, 1992).

51 Sue Grafton, *"I" is for Innocent* (Crest, 1994).

56 Rev. Kevin W. Cosby, in "An Easter Bonnet with Frills Upon It Is Decidedly Old Hat" by Angelo B. Henderson and Robert McGough, *Wall Street Journal* (April 7, 1998).

64 Betty Halbreich with Sally Wadyka, *Secrets of a Fashion Therapist* (HarperCollins, 1997).

72 Katherine Whitehorn, from *The Portable Curmudgeon Redux*, Jon Winokur, ed. (Dutton, 1992).

75 Colette, *Cheri* (1926; Seeker & Warburg, 1968).

76–77 Anaïs Nin, *The Diary of Anaïs Nin*, vol. 2 (Swallow Press, 1966).

77 André Gide, *Journal*, from *The International Thesaurus of Quotations*, Eugene Ehrlich and Marshall De Bruhl, eds. (1930; HarperCollins, 1996).

79 Cybill Shepherd, *In Style* magazine (March, 1995).

85 Tony Brown, from *Just Joking*, Donald L. Smith and Jon Winokur, eds. (WordStar International, 1992).

97 Henry James, as quoted by Edith Wharton in *A Backward Glance* (1934; Scribner, 1985).

101 Elsie Janis, from *Encyclopedia of Women's Wit, Anecdotes and Stories*, Cathy Handley, ed. (Prentice Hall, 1982).

103 Dustin Hoffman as Ratso in the movie *Midnight Cowboy* (United Artists, 1969).

104–105 Hal Borland, "Autumn Is for Understanding—October 25," in *Sundial of the Seasons*, quoted in *The International Thesaurus of Quotations*, Eugene Ehrlich and Marshall De Bruhl, eds. (1964; HarperCollins, 1996).

105 Bonaro W. Overstreet, "Mists and Mellow Fruitfulness," in *365 Meditations for Women*, Jean Beaven Abernethy, ed. (1947; Abingdon Press, 1989).

108 Sue Grafton, "Long Gone," from *Sisters in Crime*, Marilyn Wallace, ed. (Berkley Pulishing Group, 1995).

107 The Bible, *The Sayings of the Bible*, selected and translated by Michael Grant (Ecco Press, 1998).

111 Dianne Feinstein, *Time* (June 4, 1984).

112 David Letterman, from *1,911 Best Things Anybody Ever Said*, Robert Byrne, ed. (Ballantine Books, 1988).

115 John Donne, "The Autumnal," from *Bartlett's Familiar Quotations*, Justin Kaplan, ed. (Little, Brown and Company, 1992).

117 Sophia Loren, from an interview on *Good Morning, America* (ABC TV, 1979).

118 Inès de la Fressange, quoted in "Ines's City Planning" by Jennifer Soruby, *Elle* (March 1995).

124 Bill Blass, describing the elegance of C. Z. Guest in Paris in the 1950s, quoted in *The Power of Style* by Annette Tapert and Diana Edkins (Crown Publishers, 1994).

128 Claudia Shear, *Blown Sideways Through Life* (Dial Press, 1995).

133 Lisa Birnbach, *The Official Preppy Handbook* (Workman, 1980).

135 Ilene Beckerman, *Love, Loss, and What I Wore* (Algonquin Books, 1995).

136–37 Jay McInerney, *Bright Lights, Big City* (Vintage Contemporaries, 1984).

139 Edith Head, in "Body by MacLaine—In Originals by Edith Head," C. Robert Jennings (*Saturday Evening*

Post, 1963).

144 Cocktail waitress in the movie *The Parallax View* (Paramount/Gus, 1974).

148 George Herbert, "Jacula Prudentum," from *The International Thesaurus of Quotations*, Eugene Ehrlich and Marshall De Bruhl, eds. (1651; HarperCollins, 1996).

149 Anne Sexton, quoted in *Anne Sexton: A Self-Portrait in Letters*, Linda Gray Sexton and Lois Ames, eds. (Houghton Mifflin, 1977).

151 Bonnie Hunt as Kate Corvatch in the movie *Only You* (Tri-Star/Yorktown, 1994).

156 Cynthia Heimel, *Sex Tips for Girls* (Fireside Books, 1983).

160 Jean-Paul Sartre, from *The Harper Book of Quotations*, Robert I. Fitzhenry, ed. (HarperPerennial, 1993).

162 Katherine Whitehorn, "Keeping Cool," from *Quotations by Women*, Rosalie Maggio, ed. (Beacon Press, 1976).

164 Toast given by Derrill Osborn, Vice President, Divisional Merchandise Manager, Neiman Marcus, Dallas.

165 Helen Fielding, *Bridget Jones's Diary* (Viking, 1997).

166 Erma Bombeck, from *The Portable Curmudgeon Redux*, Jon Winokur, ed. (Dutton, 1992).

167 Shelley Winters, from *An Uncommon Scold*, Abby Adams, ed. (Simon & Schuster, 1989).

170 Fran Lebowitz, from *The Portable Curmudgeon Redux*, Jon Winokur, ed. (Dutton, 1992).

173 James Thurber, *New Yorker* cartoon caption, from *Bartlett's Familiar Quotations*, Justin Kaplan, ed. (Little, Brown and Company, 1992).

174 Geoffrey Beene, from an original Chic Simple interview, 1993. Also in *Chic Simple: Clothes* (Alfred A. Knopf, 1993).

176 Anita Loos, quoted in *New York Times*, from *Simpson's Contemporary Quotations*, James B. Simpson, ed. (Houghton Mifflin, 1988).

177 Cyra McFadden, *The Serial: A Year in the Life of Marin County* (Knopf, 1977).

178 Barbara Howar, quoted in *The Party: A Guide to Adventurous Entertaining* by Sally Quinn (Simon & Schuster, 1997).

179 Gabriel García Márquez, *Love in the Time of Cholera* (Penguin Books, 1988).

180 Bill Blass, quoted in *The Beautiful People* by Marylin Bender Altschul (Coward-McCann, 1967).

187 Florynce R. Kennedy, in *Sappho Was a Right-on Woman: A Liberated View of Lesbianism* by Sidney Abbott and Barbara Love (Stein and Day, 1972).

189 Joan Rivers, quoted in *New York Times Magazine*, from *Quotations by Women*, Rosalie Maggio, ed. (Beacon Press, 1996).

192 Rita Rudner, "The New Stand-Up Comics," from *Quotations by Women*, Rosalie Maggio, ed. (Beacon Press, 1996).

203 Dodie Kazanjian, *Icon: The Absolutes of Style* (St. Martin's Press, 1995).

204 Agatha Christie, "The Dressmaker's Doll," in *Double Sin* (1986; G.K. Hall, 1990).

205 Molly Ringwald as Samantha Baker in the movie *Sixteen Candles* (Universal, 1984).

207 Ilene Beckerman, *Love, Loss, and What I Wore* (Algonquin Books, 1995).

224 Susan Brownmiller, *Femininity* (Linden Press/Simon & Schuster, 1984).

endp.2 Diana Vreeland, *D.V.*, George Plimpton and Christopher Memphill, eds. (Knopf, 1984).

endp.4 George Sand, *Pearls of Wisdom*, Jerome Agel and Walter Glaze, eds. (Harper Collins, 1987).

PHOTOGRAPHY BY DANA GALLAGHER

page 93 RUBBER DUCKS

PHOTOGRAPHY BY GENTL & HYERS

pages 36–37 LIP COLORS page 37 POWDER BRUSH page 39 ROSES page 74 PINK FLOWER pages 102–03 CITRUS RIND pages 104–05 LEAF page 114 APPLE page 115 MAKEUP

PHOTOGRAPHY BY MARIA ROBLEDO

pages 148–49 CANDLES

PHOTOGRAPHY BY ROBERT TARDIO

page 15 SUIT AND ACCESSORIES page 45 JACKET, T-SHIRT, AND NECKLACE page 67 CASHMERE CARDIGAN AND PANTS OUTFIT page 107 SUIT AND NECKLACE page 132 TURTLENECK pages 134–35 SHOES

PHOTOGRAPHY BY KENJI TOMA

page 38 FRAGRANCE BOTTLES

PHOTOGRAPHY BY JAMES WOJCIK

page 12 SUIT AND ACCESSORIES page 16 BAG, CASE, JEANS, AND SHOES page 17 SWEATER SET AND BRACELET page 22 PUCCI SHIRT page 23 RED SUIT page 32 BLACK DRESS AND ACCESSORIES page 33 BLACK DRESS page 34 BUSTIER page 42 CHARM BRACELET page 43 PINK JACKET, DRESS, AND ACCESSORIES; PUMPS AND ACCESSORIES page 44 SCARVES page 45 POUCH page 48 ARMANI SUIT page 51 CAP-TOE PUMPS page 55 PEARLS page 62 WHITE SHIRT page 63 BOTH WHITE SHIRT AND PANTS OUTFITS page 73 BOOTS page 78 FLORAL DRESS AND HOOP EARRINGS page 79 DRESS WITH HAT page 90 SUNGLASSES AND WATCH page 91 ACCESSORIES page 106 BARN JACKET, BACKPACK AND SCARF, LEATHER AGENDA, ANKLE BOOTS page 107 GOLD CHAIN, DRESSES, AND DRESS FORMS page 118 HEIRLOOM BAG, KELLY BAG, VUITTON BAG page 119 SHOULDER BAG page 132 MARKET BAG, JEANS page 133 RED SWEATER AND PANTS OUTFIT page 136 RED PEACOAT OUTFIT page 145 HEELS, LIPSTICK, GLOVES, CLUTCH page 151 CZ EARRING AND TRAPPER'S HAT page 163 RED SEQUINED CARDIGAN OUTFIT AND SWEATER AND LONG SKIRT OUTFIT page 174 WHITE NIGHTGOWN AND BATHROBE page 175 LIPSTICK, ATOMIZER, COMPACT page 181 LIGHT BLUE SWEATER AND KHAKIS OUTFIT page 183 SUIT AND ACCESSORIES page 184 SUIT page 186 JEANS, BLACK LEATHER JACKET page 190 RED WOOL SUIT page 193 TURTLENECK page 206 HEELS

ACKNOWLEDGMENTS

Special thanks to: Giorgio Armani; David Bashaw; Barneys New York; Bergdorf Goodman; Geoffrey Beene; Gayla Silva Bentley; Paul Boccardi; Paul Bogaards; Claire Bradley Ong; Amanda Burden; Aretha Busby; Gabrielle Brooks; Tony Chirico; Jill Cohen; Cass Davies; Diana De Rosa at the Hampton Classic Horse Show; Marilou Stannard Doyle at The Events Registrar; Hal Foster; Bradley Friedman; Jane Friedman; Stefan Friedman; Patrick Gates; Gayle Gathercole at the National MS Society, NYC; David, Glenna, and Carolyn Gross; Toby and Morton Gross; Margaret Hedberg at the International Debutante Ball; Debra Helfand; Allan Kannof; Laura Kininmonth; Eleanor Lambert; Owen Lasster; Susan Levy; John Ludlam; Katherine Hourigan; Andy Hughes; Carol Janeway; Evelyn Johnson; Pat Johnson; Donna Karan; Calvin Klein; DeDe Lahman; Nicholas Latimer; Ralph Lauren; Paul Marshall; Anne McCormick; Janet McCue at the *Cleveland Plain Dealer*; Becky McDermott; Sonny Mehta; Keibun Miyamota; Amanda Monogue Burch; Susan Penzer; Marcy Posner; Sugar Rautbord; Julia Reed; Mona Riley at Paul Stuart; John Shore; Lisa Stephano at the Pennsylvania Horticultural Society; Morgan Stone; Dylan Stone; Larry Studnicky; Style Consel of Australia; Anne Summers; Julia Sweeney; Marian Temesvary at Weber Grills; Jonathan Trumper; Diane Von Furstenberg; Shelley Wanger; Helen Watt; Thomas West; Robb Wilgoren; Effie Young; Amy Zenn; Zoran; Damon Zucca.
A very special thanks to: Hervé Contesse-Baudard; Madame C. Contesse-Baudard; the William Morris Agency.

INVALUABLE RESOURCES

• Sally Quinn, *The Party: A Guide to Adventurous Entertaining* (Simon & Schuster, 1997)
• Marylin Bender Altschul, *The Beautiful People* (Coward-McCann Inc., 1967)
• Joan Crawford, *My Way of Life* (Simon & Schuster, 1971)
• Betty Halbreich with Sally Wadyka, *Secrets of a Fashion Therapist* (Cliff Street Books, Harper Collins, 1997)
• Judith Martin, *Miss Manners' Guide for the Turn of the Millennium* (Fireside, Simon & Schuster, 1990)

Please contact The Events Register for information on annual special events and fundraisers:
THE EVENTS REGISTER
P.O. Box 98
Hastings-on-Hudson, NY 10706-0098
800/587-6005
EventRegis@aol.com
www.members.aol.com/EventRegis

CHIC SIMPLE STAFF

PARTNERS Kim & Jeff
PRESIDENT Steve Diener
SENIOR VICE PRESIDENT Jim Davis
ASSOCIATE EDITOR Carolina Kim
ASSOCIATE EDITOR Gillian Oppenheim
PRODUCTION ASSOCIATE Andrea Weinreb
EDITORIAL PRODUCTION Borden Elniff, Eve Bowen
OFFICE MANAGER Joyce Fisher
INTERN Lystra Batchoo

COMMUNICATIONS

In our earlier books we asked for your feedback, and you responded from all over—Ecuador to Malaysia, Hong Kong to Edinburgh, Seattle to Miami—and every day we receive more. So thanks, and please keep on writing, faxing, and e-mailing your comments, tips, suggested items, topics, stores, and various insights that occur to you. Since a lot of the questions we get are about what else is in the Chic Simple book series, we created a catalog. If you would like to receive one for FREE, please send us an invitation to a really swell simple party of good friends and food—like a White House dinner (Hillary) or the Academy Awards party (Wolfgang)—or just your address, to:

**CHIC SIMPLE
84 WOOSTER STREET
NEW YORK, NY 10012**
Fax: **(212) 343-9678**
e-mail address: **info@chicsimple.com**
Web site address:
http://www.chicsimple.com
Stay in touch because . . .
"The more you know, the less you need."

A NOTE ON THE TYPE

The main text of this book was set in New Baskerville. The ITC version of **NEW BASKERVILLE** is called Baskerville, which itself is a facsimile reproduction of types cast from molds made by John Baskerville (1706–1775) from his designs. Baskerville's original face was one of the forerunners of the type style known to printers as the "modern face"—a "modern" of the period A.D. 1800. Additional display and text fonts used in this book are the **HELVETICA** family, **BAUER BODONI**, and the **FUTURA** family.

SEPARATION AND FILM PREPARATION BY

PROFESSIONAL GRAPHICS
Rockford, Illinois

PRINTED AND BOUND BY

BUTLER & TANNER, LTD.
Frome, England

HARDWARE

Apple Macintosh Power PC 8100, Quadra 800 personal computers; MicroNet DAT Drive; SuperMatch 21" Color Monitor; Radius PrecisionColor Display/20; Radius 24X series Video Board; Hewlett-Packard LaserJet 4; Supra Fax Modem; Iomega Zip Drives.

SOFTWARE

Quark XPress 3.31; Adobe Photoshop 3.0.5; Microsoft Word 6.0; FileMaker Pro 2.0; Adobe Illustrator 6.0.1

MUSICWARE

Air (*Moon Safari*); Brigitte Bardot (*The Best of BB*); Gilbert Becaud (*40 Ans en Chansons*); Andrea Bocelli (*Romanza*); Francis Cabrel (*Quelqu'un de L'Intérieur*); Chemical Brothers (*Dig Your Own Hole*); The Cherry Poppin' Daddies (*Zoot Suit Riot*); John Coltrane (*Blue Train*); Harry Connick Jr. (*Blue Light, Red Light*); Cornelius (*Fantasma*); DJ Cam (*The Beat Assassinated*); Miles Davis (*Volume 1*); Desmond Dekker (*The Best of Desmond Dekker*); Dmitri From Paris (*Sacrebleu*); Nick Drake (*Pink Moon*); Cesaria Erora (*Cabo Verde*); St. Etienne (*Good Humor*); Fantastic Plastic Machine (*Fantastic Plastic Machine*); Serge Gainsbourg (*Couleur Cafe*); Garbage (*Version 2.0*); Al Green (*Anthology*); Francoise Hardy (*Yeh Yeh Girl from Paris*); Freddie Hubbard (*Hub Cap*); Lenny Kravitz (*5*); Sean Lennon (*Into the Sun*); Little Eva (*The Best of Little Eva*); Tina Louise (*It's Time for Tina*); Madonna (*Ray of Light*); Mix Master Mike (*Anti-Theft Device*); Mogwai (*Kickingadeadpig*); Mongo Santamaria (*Mambo Mongo*); Lee Morgan (*The Sidewinder*); Photek (*Modus Operandi*); Semisonic (*Feeling Strangely Fine*); TransAm (*The Surveillance*); McCoy Tyner (*The Real McCoy*); Sonny Rollins (*Volume 2*); Nina Simone (*After Hours*); Frank Sinatra (*The Capitol Years*); Elliot Smith (*Either/Or*); Yma Sumac (*Voice of Xtabay*); Various Artists (*Roots of Reggae, Volume 1*); Various Artists (*Head 22*); Various Artists (*Night and Day—The Cole Porter Collection*); Barry White (*Can't Get Enough*)

CHIC
SIMPLE®
library

MEN'S WARDROBE CLOTHES BODY HOME

COOKING WOMEN'S WARDROBE WOMAN'S FACE WORK CLOTHES ACCESSORIES

EYEGLASSES SCARVES PACKING COOKING TOOLS DESK SHIRT AND TIE

BED LINENS SCENTS TOOLS BATH PAINT NURSERY STORAGE

66 Who said that clothes make a statement?
What an understatement that was.
Clothes never shut up. 99

SUSAN BROWNMILLER, *Femininity*

Business Trip Checklist

- ❏ address and appointment books
- ❏ airline tickets
- ❏ briefcase
- ❏ business cards
- ❏ calculator
- ❏ computer (accessories, batteries, power and modem cords)
- ❏ confirmations (car, hotel)
- ❏ correspondence
- ❏ credit cards
- ❏ expense forms
- ❏ files
- ❏ highlighters, markers, pencils, pens
- ❏ letter(s) of credit
- ❏ meeting material
- ❏ money
- ❏ notebooks
- ❏ paper clips
- ❏ passport
- ❏ portfolio
- ❏ price lists
- ❏ presentation materials
- ❏ proposals
- ❏ publications
- ❏ purchase order forms
- ❏ reading material
- ❏ reports
- ❏ rubber bands
- ❏ samples
- ❏ stapler
- ❏ stationery, envelopes, stamps
- ❏ tape recorder and blank cassettes
- ❏ time records
- ❏ work pads

Before you leave home

- ❏ arrange care for your pets, plants, and lawn
- ❏ arrange to have your mail and newspaper held at the post office or collected by a friend
- ❏ empty refrigerator and turn it on low
- ❏ leave a house key with a friend
- ❏ lock all doors, windows, and car
- ❏ notify your neighbors of your absence and how to reach you
- ❏ reconfirm your airline ticket and other reservations
- ❏ set timers or leave lights on
- ❏ stop all deliveries to your home
- ❏ turn off hot water
- ❏ unplug all major appliances

Carry-On

- ❏ address book
- ❏ aspirin
- ❏ batteries
- ❏ camera and film
- ❏ confirmations
- ❏ credit cards
- ❏ electronic equipment
- ❏ eyeglasses (prescription, sunglasses)
- ❏ foreign language dictionary
- ❏ headphones
- ❏ identification
- ❏ keys
- ❏ light sweater
- ❏ medicine
- ❏ mints/gum
- ❏ money
- ❏ outerwear
- ❏ passport/visa
- ❏ portable stereo
- ❏ reading material
- ❏ sleep mask
- ❏ ticket
- ❏ toothbrush/paste
- ❏ water

International Checklist

- ❏ addresses for correspondence
- ❏ auto registration
- ❏ cash, including some of the currency of the country to which you are traveling
- ❏ credit cards
- ❏ emergency contacts
- ❏ extra prescription glasses and contact lenses
- ❏ health certificates
- ❏ insurance papers
- ❏ international driver's license
- ❏ lightweight tote bag for purchases
- ❏ medical information
- ❏ passport
- ❏ phrase book or dictionary
- ❏ prescriptions and medications
- ❏ sunglasses
- ❏ tickets and travel documents
- ❏ travel itinerary
- ❏ traveler's checks and personal checks
- ❏ visa

Instant Summer

- ❏ cotton gabardine
- ❏ poplin
- ❏ seersucker
- ❏ super-light worsted wool
- ❏ tan or off-white linen
- ❏ big gold hoop earrings or diamond studs—both wear well at the beach
- ❏ water-resistant watch
- ❏ sun hat
- ❏ sunglasses—check the UV rating

SIZE CONVERSIONS

SHIRTS

American/English:

14	14 ½	15	15 ½	16	16 ½	17

Continental:

36	37	38	39	41	42	43

SWEATERS

American:	Small	Medium	Large	X-Large
English:	34–36	38–40	42–44	46
Continental:	44–46	48–50	52–54	56

SUITS/COATS

American/English:

36	38	40	42	44	46

Continental:

46	48	50	52	54	56

SHOES

American/English:

5	6	7	8	9	10	11	12

Continental:

38	39	40	41	42	43	44	45

- ❏ summer tote—canvas, straw, or nylon
- ❏ lipstick—gloss or summer colors, pinks, frosted colors
- ❏ fragrance: light (try citrus)

Summer shoes:

- ❏ leather day sandals
- ❏ beach shoes (espadrilles or rubber thongs)
- ❏ sneakers
- ❏ evening sandals (high-heeled and strappy)

Summer extras:

- ❏ jewelry in colorful, cheap plastics
- ❏ colorful ballet slippers

The Beach

- ❏ bathing suit
- ❏ beach blanket
- ❏ flip-flops